Rod Mengham is author of several poetry publications, including *Unsung* (Salt, 2006), *Chance of a Storm* (Carcanet, 2015), *Grimspound & Inhabiting Art* (Carcanet, 2018), *2019 the vase in pieces* (Oystercatcher, 2019) and of translations, including *Speedometry* [poems by Andrzej Sosnowski] (Contraband, 2014) and *Flatsharing* [poems by Anne Portugal] (Equipage, 2021). He was also co-editor and co-translator of the anthology *Altered State: The New Polish Poetry* (Arc, 2003) and co-editor with John Kinsella of the anthology *Vanishing Points: New Modernist Poems* (Salt, 2005). Between 1992 and 2002, he was co-organiser of the annual Cambridge Conference of Contemporary Poetry and since 1992 has been the publisher of Equipage, which has published over 120 pamphlets of contemporary poetry. Rod is Reader in Modern English Literature at Cambridge University, and a Fellow of Jesus College. He has published monographs on Dickens, Emily Bronte and Henry Green; and *The Descent of Language* (1993); has co-written with Sophie Gilmartin *Thomas Hardy's Shorter Fiction* (EUP, 2007); has edited essay collections on contemporary fiction, violence and avant-garde art, fiction of the 1940s, and Australian poetry. He has also curated many exhibitions of contemporary art since 2003, and has made several films with the artist Marc Atkins (soundingpolefilms) as well as the text + image publication *Still Moving* (London: Veer Publications, 2014). He was a recipient of the Cholmondely Award for poetry in 2020.

MIDNIGHT
IN
THE
KANT
HOTEL

Art in Present Times

ROD MENGHAM

LITTLE ISLAND PRESS

in collaboration with Carcanet

First published in Great Britain in 2021 by
Little Island Press / Carcanet
Alliance House, 30 Cross Street
Manchester M2 7AQ
www.carcanet.co.uk

A CIP catalogue record for this book is
available from the British Library.
ISBN 978 1 80017 147 3

Book design by Andrew Latimer
Printed in Great Britain by SRP Ltd, Exeter, Devon

Supported using public funding by the National Lottery
through Arts Council England.

CONTENTS

MIDNIGHT IN THE KANT HOTEL

These essays were all written in the last twenty years. For much of that time I have been curating exhibitions of contemporary art. There is no more productive engagement with someone else's artworks than finding the right way to show them, since artworks are always direct statements or questions about articulations of space, and the curator's job obviously is to enhance such questions and statements.

Of course, you can write about art from a distance after a single visit but nothing compares to living with art. Visiting an exhibition or installation several times and layering your perception of a painting or sculpture through acquaintanceship confirms one thing at least – that in your own life experience, what really gives substance and complexity to individual artworks comes out of the history of your relationship with them.

For my own part, I have made friends with the oeuvres of certain artists over the years, and this kind of relationship has aspects of both continuity and discontinuity. I am attached to the familiar, and to the strength of feeling that comes with a certain kind of fidelity. But the relationship grows when it takes unexpected turns, when the work itself takes on a new bearing – because I am seeing it from a different point in time, from a different juncture in my own history, or in a much broader history.

I began living with art as a deliberate form of behaviour when a teenager, making repeated visits to the National Gallery in London. But this did not involve contemporary art. As a student of literature, I was fascinated by the twentieth-century

avant-gardes, but my main focus was poetry – writing poetry and editing poetry magazines – and so the visual art of these avant-gardes was something I recognised only as an accompaniment to literary practice. I was not really grasping it on its own terms.

This did not come until I moved to Poland in October 1984, remaining there until October 1987. I had been hired to teach English literature at the university in Łódź , which was then Poland's second-largest city and home to the National Film School. The latter was the institutional base for members of the 'Workshop of Film Form', a focus for radical experimentation in the visual arts. Many of its members were political activists who had lost their jobs when martial law was imposed during 1981–1983. Official disapproval was met by an upsurge in art-making and in clandestine forms of art-sharing. One-off performances were staged in cellars, pop-up exhibitions were held in the communal attics of housing blocks, films were projected onto the walls of people's apartments. Times and places were conveyed by word of mouth, often on the day of the event; and events were nocturnal – by morning, all signs of what had taken place would be gone. Within a few weeks of settling in Poland, I fell into the middle of all this.

And what could not fail to strike a new arrival was the urgency with which it was pursued. Art was not a leisure activity but a daily necessity, at a time when daily life was a challenge for the ordinary citizen. There were shortages of almost everything and queueing, often in atrocious weather, took up a significant proportion of anyone's spare time. I had to queue for paper if I wanted to have anything to write with. The first thing I was given when I arrived was an identity card. The second thing was a ration card: it was rectangular, with component sections for different foodstuffs, such as meat, flour, sugar, milk, dripping, bones. The different sections were

cut out with a pair of scissors when the relevant foodstuff was collected. I never did collect my bones.

Łódź was built in the nineteenth century on a grid plan dominated by textile factories, owners' mansions and workers' housing. Much of it looked like it was still in the nineteenth century. The infrastructure was very long in the tooth – many of the trams were pre-war – and the acute shortage of petrol meant there were almost as many horses and carts on the streets as veteran cars. There were no spare parts available for most vehicles – if you needed a replacement, it would be fabricated somewhere in a backstreet. The forest of factory chimneys turned the brickwork black in every direction. The addition of chemical factories in the twentieth century tinted the sky purple when the sun went down on miles-long, dead-straight avenues with names like 'Revolution of 1905 Street', 'Gagarin Boulevard', 'Defenders of Stalingrad Street'. (I was especially drawn to the latter, which had a slight kink about halfway down.)

Strange to say, I sometimes ache for the dismal beauty of those worn-down urban canyons with their long, gloomy vistas where the limits of the visible melt in a shroud of pollutants. There has never been any way of lessening the impact of that first encounter when I drove into town feeling I had crossed a border in time. It was breathtaking – no irony unintended – the sheer accumulation of surly industrial architecture; at every point of the compass was the ebbing perspective of a ghastly urban artistry on a lavish scale. Small wonder that the avant-garde art movement Unism based in Łódź during the 1930s was intent on remodelling everything: architecture, sculpture, clothes, transport – not just art and literature – according to the same criteria, in order to produce a total urban environment unified by the same constructivist design principles. The effective leader of that movement, Władysław

Strzemiński, had taught in the building attached to the block of flats in which I lived. If I propped myself up in bed in my two-room flat, my back would be resting against the wall on the other side of which Strzemiński gave lessons fifty years earlier.

Strzemiński was one inspiration for the Workshop of Film Form and the anarchist grouping Łódź Kaliska. Both took as their subject matter daily life: its apparent absurdity under Polish state socialism and its potential as the fundamental basis for developing a different reality – literally a home-made reality – as the beginning of a psychological and social reordering of existence that was both independent and collectivist. The making and showing of art became a form of direct action with strong political implications. Cooperation was the oxygen of both movements, which overlapped, and communication with artists and audiences abroad was a crucial encouragement and stimulus. As a native English speaker, I was able to write critiques of films that were sent or taken abroad for screening in Western Europe or the USA. My first attempts in the analysis of visual and plastic, as opposed to verbal, artefacts were made inside a milieu of art-making. It was a form of cooperation that taught me the value and effectiveness of collaboration. Writing out of collaborations with other artists and writers is something I have sought out ever since, and has been reflected in films and exhibitions, as well as in many of the essays gathered here.

My three years in Poland were punctuated by trips back to England twice a year. These would be undertaken by car over two or three days, with long waits at the border between Poland and East Germany, and sometimes between East and West Berlin. I would reach West Berlin by nightfall and would stay in the Kant Hotel in Kantstrasse, not far from the Kant-Garagen, the classic modernist building used by Andreas Baader and Gudrun Ensslin to store weapons; a few blocks

down from the location of the political cabaret, Wilde Bühne, and the Theater des Westens, where Marlene Dietrich first gave voice to the song 'Falling in love again / Never wanted to'. The hotel was close to the bookshop Hedayat, run by Abbas Maroufi, and a few doors down from the site of the notorious prison housing women members of the *Rote Kapelle*, the anti-Nazi resistance movement. It was also where Franz Hessel stayed. Hessel was the friend who helped Walter Benjamin translate Proust; who even, after returning to Germany, stayed imaginatively in Paris, as Franz Blei records: 'I meet him in Munich, the sun is shining but he's got his umbrella open and his trousers rolled up. But why, Herr Hesssel? – It's raining in Paris, he says'. Hessel looked both ways at once – and the Kantstrasse became the staging post from which I looked in both directions, East and West. By stages, it became correlated in my mind with an ethical imperative – or perhaps it was more of an emotional imperative – to look both ways in art, and to think about how the fundamental urgencies of art-making in the East might be translated into Western European conditions and forms of expression. Much of Western art had seemed to me unpressured and even desultory; but that was partly because there was so much of it out there on show. I now tried to find where real art was hiding, even when it was hiding in plain sight. When I finally returned from Poland to work in Cambridge, I started trying to keep up with developments in art at a time when Britain seemed to have become the display cabinet for everything going on worldwide. It took me a while to get my aim in.

From first to last, the essays here are the outcome of another form of cooperation; of a dialogue with generous editors and gallerists (often people combining both roles) whose encouragement and guidance has been vital. My biggest debts are to the brilliant Tim Marlow and Jill Silverman, who presented me with opportunities to write on art that I

really care about, and who have talked me through the process before, during and after the actual writing has taken place. This book would be a hell of a lot shorter if we had not found one another.

INNER VISIONS:
CONTEMPORARY ART AND DOMESTIC SPACE

One of the most persistent and pervasive fascinations of the public art of the last decade of the twentieth century involved an assault on, a redefining of, and an effective relocating of the idea of domestic space. By the end of the nineties, work in this area had been carried out by numerous artists on both sides of an East-West divide, but the cultural differences between the capitalist First World and the countries of the former Soviet bloc produced widely divergent representations of the domestic interior. Nowhere was this more evident than among the installations of *Documenta IX* at Kassel in 1992.

Situated in a yard at the rear of the Museum Fridericianum, Ilya Kabakov's installation consisted of a small whitewashed building that looked exactly like a simply constructed public toilet. Windowless, turned in on itself, available to any member of the public but designed to offer a temporary privacy of a highly personal nature, the purpose of this amenity, and of its very public sort of privacy, was effectively turned inside out for the visitor who stepped over its threshold. The interior was fitted out not with water closets and basins but with the conventional furnishings of a small Russian apartment. At a glance, domestic privacy was shattered by the exercise of public access, putting the viewer momentarily in the position of uninvited intruder, of the potential housebreaker who might even urinate over the furniture. This confusing of the categories of public and private space was further complicated by an awareness of the reproducibility of the basic two-room

housing unit across Russia and other countries in Eastern Europe, of the extent to which the concept of 'home' may be standardised, de-privatised, rendered anonymous.

This critique of domestic space in Soviet culture has lost none of its force and urgency in the years since. A different tone was set in Kabakov's subsequent *Palace of Projects*, installed at the Roundhouse during March and April 1998 and at the Reina Sofía Centre in Madrid later that year; however, the cultural historical coordinates remained surprisingly unchanged. The *Palace*, built with lightweight woods and plastics, resembled externally other spiraliform structures such as the Tower of Babel and Tatlin's Monument. These emblems of ambition were alluded to in order to ironise the relations of communal and individual, and in order to question the grounds of cultural unity and disunity. The very title *Palace of Projects* recalls Soviet usage in reference to institutions such as the Palaces of Culture, designed to relocate power and authority in the culture of the people, or rather to produce the illusion of the people's control over their own history and way of life. Inside the monumental shell, Kabakov's installation was composed of a sequence of small rooms, each room housing one or more of the total of sixty-five projects intended to either 'make yourself better' or 'make this world better'. The overwhelming majority of plans stemmed from, and sought to alleviate, the conditions of single lives lived out in extremely cramped quarters. The idea of the palace was made to collide with the claustrophobic *habitus* of the Moscow apartment block. The stereotype emerging from the viewer's comparison between projects was that of a life lived entirely within doors. A number of projects even sought to make a virtue of confinement, by devising means of withdrawal even further within the space of the room; identifying recesses, corners, closets, to inhabit or to concentrate on. The palace itself was conceived of as an indoors installation, as a container that should itself be contained, 'inside an enormous exhibition hall'.

Although a certain number of projects envisaged life within the family, or some element of communality, an extremely high proportion took for granted a life of solitude. Contact with others outside the apartment would be minimal, including the proverbial lowering of a basket containing money in exchange for food (*Project* 8). Time and again, the specifications for individual projects would stress the advantage of being able to realise the project's aims 'without leaving the confines of your room'. The counterpointing of private and public spheres took the form more often than not of counterpointing domestic interiors with a scale of operations that was nothing less than global, the latter including plans for the equal distribution of energy across the entire planet, proposals for the resurrection of all the dead (of all those who have ever lived) and schemes for the development of a common language that would unite humanity 'with the environment from which we have been torn away'. This oscillating between the individual and the universal left no room – literally no space – for the elaboration of the social.

The most important principle of organisation across the whole range of projects was verticality. Doors in the ceiling and free-standing ladders typified the desire for upward movement that was a common response to the spatial restrictions of Soviet domestic life. *Project* 16 envisaged the use of a ladder 1,200 metres high, in an hyperbolical expression of resistance to the reality principle whereby the space above a Russian apartment was likely to be occupied by another apartment of exactly the same dimensions, and beyond that another, and another, and so on. *Project* 24 represented a compromise with the reality principle in its siting of paradise just below the ceiling, the paradisial inhering in a collection of objects of devotion placed on a narrow shelf running right the way round the tops of the walls. A down-to-earth paradise, approachable only by ladder.

A popular substitute for the ladder was a pair of wings, ideally angel's wings, stored symbolically 'under lock and key in a special soft case in a mirrored closet': flight and restraint, held together in a perpetual tension. This fantasy of angelic flight came at the tail end of an eighties' preoccupation with transcendence, figured most powerfully in Wim Wenders' film *Wings of Desire*, where the all-seeing, all-knowing eyes and ears of surveillance were transfigured into a benign watchfulness. Kabakov's dreams of winged flight were correlated ultimately with a much more Russian solution to the problem of dealing imaginatively with architectural forms of discipline. A surprising variety of the projects were captivated by the experience of the cosmonaut; the cosmonaut became an object of contemplation only ever referred to indirectly, but this obliquity of reference allowed the development of an astonishing equation between domestic space and outer space, confined space and infinite space. The cosmonaut's rocket ship – specifically, his capsule – represents the ultimate in restriction: a situation of extreme claustrophobia which is paradoxically the condition of an unparalleled scope of movement. And the cosmonaut is also a rare source of national pride, an heroic figure who functions brilliantly as the means of glamourising the very principle of enclosure.

The imaginative necessity of verticality, of upward movement, was incorporated into the basic design of Kabakov's *Palace*, which required the visitor to progress gradually up and around the spiral structure. Intriguingly, the same climbing motion was the primary means of experiencing Louise Bourgeois's installation *I Do, I Undo, I Redo* at Tate Modern in 2000. But Bourgeois's understanding of the dynamics of the spiral, of the forces it brings into play, is fundamentally different. In a series of numbered statements first published in 1992, the year of *Documenta IX* (at which she exhibited *Precious Liquids*), Bourgeois represents engagement with the spiral

form as an instance of the inescapable ambivalence affecting all movement into and out of personal and social space:

> 9. The spiral is an attempt at controlling the chaos. It has two directions. Where do you place yourself, at the periphery, or at the vortex? Beginning at the outside is the fear of losing control; the winding in is a tightening, a retreating, a compacting to the point of disappearance. Beginning at the centre is affirmation, the move outward is a representation of giving, and giving up control; of trust, positive energy, of life itself.
> 10. Spirals—which way to turn—represent the fragility in an open space. Fear makes the world go round.[1]

At the Tate Modern installation, the spirals did not tighten and loosen in quite the way Bourgeois had in mind in 1992, but the use of a spiral staircase did keep in view that question of which way to turn, the question of retreat or advance, fear or trust, which the towers produced and kept in suspense. Fear or trust: the vocabulary is part of Bourgeois's rigorous psychologising of domestic space which encrypts a personal history into the disposition of both vertical and horizontal dimensions. As with Kabakov, verticality, movement upwards, expresses a desire for escape, but escape this time is from the legacy of a classic bourgeois family romance. Bourgeois herself has constantly stressed the way her work concentrates on the inner spaces of fear, insisting on the encounter with the sources of trauma. And yet her first studio was reputedly on the roof of her own house, and her early work is frequented by images of women exiting a house through the roof, and even via the chimney.

1 Louise Bourgeois, 'Self-expression is Sacred and Fatal', in *Destruction of the Father / Reconstruction of the Father: Writings and Interviews 1923–1997* (London: Violette Editions, 1998) pp.222–3

Bourgeois's longevity (she was ninety-eight at time of death) contributes to the authority of her work which depends entirely on psychological roots reaching back to a time contemporary with the first great ascendant phase of psychoanalysis. The family relations of her childhood conform recognisably to the same sorts of permissions and prohibitions that comprised the Viennese culture in which Freud developed his theories. It is partly because the understanding of modern art has derived so much from this tradition, and partly because it is a tradition that may be about to crumble, that we invest Bourgeois's work with as much significance as we do. Its vividness at the end of a long life and at the end of a long century makes it seem like the distillation of everything we might withdraw into or move away from.

The inner spaces of Bourgeois's installations are inside the body itself. The interdependence of house and psyche predicates an aesthetic realised in a whole series of variations on the theme of the house with organs, or of the body with architectural prostheses. The early drawings are obsessed with versions of the 'femme-maison'. Later installations, such as the *Red Rooms* of 1994, not only saturate the furnishings with blood- and flesh-colours, but also substitute organic forms for household objects. The titles which Bourgeois uses to link her installations in series preserve the sense of fragility and dilemma referred to in her statement on spirals. The frequently used title 'cell' connotes both vitality and confinement, since it is both an organism, the basic building block for life, and the basic unit of imprisonment, a space in which one is condemned to solitude. The alternative title 'lair' seems actively to express a desire for solitude, yet this involves a retreat imposed by the threat of danger, a desire born of fear.

Unlike Kabakov's installations, that one must enter, traverse and leave, Bourgeois's cells, lairs and rooms rarely permit entry. They are often almost closed spaces, with sight lines

obstructed or arranged in a way that requires spectators to contort themselves and become peeping Toms; less intruders than voyeurs. The room becomes an historical tableau, an exhibition of personal history, which means that the viewer does not gaze into space as much as into time. The intimacy, the secrecy even, of what is so blatantly advertised effectively relocates the threshold between public and private. For Bourgeois, the private is embedded deep within the psyche, its perimeter marked by the body and its functions. The dividing line between one domestic space and another is identified with the violation of bodily integrity, as Bourgeois's extraordinary statement for *Documenta IX* makes clear:

> I remember when we were living at Stuyvesant.
> There were two young girls who lived in the building. The mother was drunk
> and the father had died.
> The girls were loose in the building, looking for other children to play with.
> They rang our bell and my husband opened the door. Suddenly there was a puddle
> on the floor.[2]

That involuntary breach, that failure of all one's defences, allows the absorption of the private into the public. Against the supposition of Robert Frost that good fences make good neighbours, Bourgeois opposes the sentiment that good fences are obsolete. Her installations reconfigure the moment of invasion, the capitulation of the private, yet re-present the moment, restage it endlessly, rendering it inescapable. Bourgeois's art is meant to confront fear and rebuild trust, yet the restoration of a perimeter, the repair of all the breaches in

2 Ibid, p.221.

the fabric, is a work that is ravelled and unravelled repeatedly, like Penelope's weaving. Bourgeois associates the project of reconstruction with the figure of her mother, who performed physically the family business of repairing tapestries. But tapestries are not executed on a domestic scale, they are works of art designed for display, in the kinds of houses where private life is lived in public. The demolition of the family home at Choisy allowed Bourgeois to reconstitute its spaces on her own scale, or rather on a variety of scales, where she could control the terms of a negotiation between private and public meanings that endlessly subvert each other.

The demolition of Rachel Whiteread's *House* (1993–1994), by contrast, triggered a crisis of interpretation, where control over the meanings of 193 Grove Road was contested by art critics, local politicians and tabloid reporters, but not by the artist herself. Local residents were divided into those who wished to preserve the project, and those who wished to destroy it, often for identical reasons: it was felt that the terrace of which it had once formed a part epitomised a model of communal living that was now disappearing, and that *House* either commemorated this, or repudiated it. The issue of commemoration produced rival claims about what was being remembered: a cohesive, unified culture, or one that had always been under revision and hybridised. Paradoxically, this competition of meanings was the inevitable outcome of *House*'s formal resistance to interpretation; it served as a foil to Kabakov's hectic, prolific devising of schemes to occupy and animate space, and represented the polar opposite to Bourgeois's psychologically layered interiority. *House*'s brilliance inhered in the total inaccessibility of its content.

Its blankness and solidity refused all access to signs of personal history or social relations. Even though the casting process required demolition of the exterior walls, the result was a complete sealing off of the interior. The monumental

solidity of the structure was, of course, an illusion, since in reality it consisted of a thin concrete shell, and this permitted fantasies of entombment, of horrors such as those of 10 Rillington Place. Nevertheless, the impermeability of the shell rendered the history of the house inaccessible to all but its former inhabitants. Whiteread's solution to the problem of invasion was to hermeticise the private. Verticality was replaced by truncation, the pointed roof space being omitted from the plan; its absence contributing to the overall effect of compression. *House* was remarkably disturbing because it argued for the necessity of burying the familiar and the familial, of preventing the escape of dark forces, psychic toxins. The homely was precisely what was going to disappear. This was a project which forced us to identify the places to which we belonged, and from which we were excluded, demonstrating the extent to which the one could be found within the other. The disappearance of *House* itself, of course, only served to reinforce the sense of conflict between longing and belonging, between exclusion and evocation: awakening and augmenting memories of a missing space.

THE ATROCITY EXHIBITION

There are two masterpieces in the Hungarian National Gallery, both of them anonymous. One is a fifteenth-century panel of the Holy Trinity, in which the crucified Christ is lifeless in the arms of a panic-stricken God the Father; the flesh has begun to decompose under the skin, feels like mulch to the fingers of the Creator whose eyes fill with misgiving. The other is a fourteenth-century carving of the Mother of Sorrows, as tall as a Masai tribeswoman, her arms elongated between wrist and elbow and held diagonally across most of her torso. The face is angular, dominated by the ridge of the nose, a face which remembers the Annunciation and regrets it. Both these works seem to me profoundly secular in inspiration, since they refuse consolation. Their view of history is of a gaping lack, an irreparable human loss; their sorrow is unsusceptible to any redemptive scheme, and their achievement is an admission of bewilderment. Theirs is an art which cannot cope, an art imbued with melancholy; neither of these depictions of grief shows any inclination towards mourning, since that would imply an acceptance of loss, a survivor's negotiation with agony.

The representation of atrocity in European art since the 1970s has often worked in terms of a similar deflection. Art concerned with the Holocaust, in particular, has had to combine the urgency of commemoration, the need to bear witness, with an inability to disclose the sheer weight of suffering involved. According to Lisa Saltzman, in her study *Anselm Kiefer and Art After Auschwitz* (Cambridge, 1999), Adorno's famous dictum appearing to place an embargo on art after the Holocaust

echoes a contradiction in Hebrew ethics, a conflict between the prohibition against making graven images and the injunction to bear witness, a tension that reflects an aspect of post-war art historically motivated by the workings of repression; certain artists have been obsessed by a subject matter they cannot properly represent. Kiefer's is an art of compulsion that has revolved around the burden of history, but what is most interesting and most troubling about his repertoire of images and inscriptions is the way it has combined both German and Jewish mythic sources. Both in his iconography and in the naming of his canvases, Kiefer has conflated the two traditions whose historical convergence, or collision, has afforded the primal instance of twentieth-century atrocity. *Sulamith* (1983), for example, is a painting whose depiction of a cavernous interior evokes Nazi monumental architecture, while its title refers to something else entirely: Sulamith is the dark-haired woman of the *Song of Songs*, an object of desire whose absence from the painting epitomizes the loss of European Jewry. Kiefer's work is memorialising the victims of the Holocaust, although their fate was so terrible it does not bear expression except in the most indirect of ways. At the same time, the artist is struggling with the memory of an antithesis, with a reserve collection of images which enshrine a cultural legacy now under prohibition. Those elements of German tradition promoted by the Nazis are now contaminated by the association, yet their presence in the German psyche is still formative despite, or even because of, the fact they are under denial. Kiefer's paintings seem to construct the very space of that denial, in all its ambivalence: grandiose yet oppressive, monumental in scale yet claustrophobic. The most arresting images he has painted are of vast, windowless, often smoke-blackened interiors, their vistas closed off, the air running out. A particularly powerful example is *To the Unknown Painter* (1983). These spaces are crypts, tombs, catacombs: oubliettes,

where a mingled sense of shame and pride has been consigned to oblivion; they are cultic dungeons, where the German sense of self has been locked away and buried alive. The spectator's relationship with their menacing geometries is one of futile mastery. An architectural experience of order and control, seen from a commanding position, yields to the recognition of a final resting place, to a premonition of cultural asphyxia, of death in a bunker.

Curiously enough, the work of Christian Boltanski has attracted the use of a similar vocabulary to describe the effects of his spatial practice – Donald Kuspit has referred to his installations as 'catacombs of consciousness' – despite the fact that his sensibility is not that of a post-war German, but of a post-war child whose parents were victimized by Nazi ideology. Boltanski's Jewish father spent an extended period of time during the war hiding in a windowless basement. Yet if the crypt of Boltanski's family history was a domestic cellar, the 'catacomb' of cultural history that his work seems projected towards is conceived of on a much more daunting scale. The geometries of Kiefer's paintings are not unconnected with the ceremonial use of space employed in several Boltanski installations. As with all art that alludes to the Holocaust, the question of scale in relation to the spectator is absolutely fundamental. To enter an installation like *Reserve: The Dead Swiss* (1990) is to be overpowered by a sense of infinite regression, by the feeling that the relationship between the details of the work can never be grasped. There is no way of taking the measure of art that observes the principle of cellular multiplication when each cell of meaning is unique and incommensurable. Boltanski's use of photographs of the dead is intended to focus the viewer's attention on 'small memory', on those details that ensure the differentiation of one individual from another. Yet the impulse to memorialise each of these 'small' lives is frustrated by an awareness that

the only information provided is of a visual nature. Moreover, Boltanski reuses many of the same anonymous photographs in successive installations; and he believes that they have a generic anonymity in being photographs of the Swiss: 'I chose the Swiss because they have no history. It would be awful and disgusting to make a piece using dead Jews – or dead Germans for that matter.' It is not uncommon to experience Boltanski's work in terms of a constant oscillation of scales: an initial focus on detail gives way to a perception of volume, and the viewer is soon caught up in the alternation of choice between 'small' and 'large', between individual and crowd, between the Swiss and the Jews. The perspectival arrangements of Kiefer's paintings, grasped at once from a fixed point, are exchanged for an experience of systematic derangement, since the viewer's itinerary through the sequence of spaces that compose the installation involves a kind of ritual of commemoration where the aims of remembering and the objects of memory are uncertain. The duration of the experience (one enters, ponders, exits) seems to offer closure, as if the ritual had a purgative function; and yet the unsettling of focus, and its recapitulation at various moments of Boltanski's career, do not turn that movement through time into a movement through historical time, but into an abeyance of history, in the entombment of melancholy.

The oscillation of scales was the central and defining aspect of the Chapman brothers' scandalous exhibit, *Hell*, at the Royal Academy's *Apocalypse* show (2000). The size of the assemblage as a whole, and the sheer number of figurines involved, was intimidating; on the other hand, the physical posture required to focus on the microscopic details of the individual tableaux placed the viewer in a situation of dominance. The achievement of close-up allowed one to identify the targets of cruelty as Nazis; this satisfied a crude vengefulness but also allowed an imaginative complicity with

the situation of one who has victims at his disposal. The use of children's toys allowed the viewer to indulge in fantasies of dismemberment and mutilation (after all, if this was the stuff of childish daydreams, it wouldn't lead anywhere) while at the same time forcing recognition of the facility with which such ghastly scenarios could be entered into, shared and perhaps even enacted, by almost anyone. The slippages were multiple, between childhood and adulthood, between fantasy and reality, between dominance and subjection, between art history and the history of brutality; most crucially, between tonalities, between the tones of play and pathos. The crowds who lingered around the vitrines were fascinated by the sheer intricacies of torture, the appalling craftsmanship of murder; there was that same medieval ingenuity of persecution that holds in its grip the kind of visitor to the art gallery who, ignoring the portraits and landscapes, cannot get enough of the paintings of Hieronymus Bosch or the drawings of Pieter Bruegel the Elder; but we are all of us that kind of visitor. We have all stood mesmerised before Bruegel's drawings with their viciously intertwined, barbarically copulating and mutilating figures. This fascination with the endlessly slight variations on a basic model of subjection is undoubtedly libidinal; and yet it is that aspect of our fixation on atrocity that we dismiss as infantile. Perhaps the only adequate response to atrocity adjusts to precisely this mix of categories, this confusion of scales.

When you visit the actual locations of the Holocaust – when you go to Auschwitz-Birkenau – it is not the abominable excess of evidence of the Nazis' callousness that brings home to the viewer the scale of the outrage; it is not the piles of spectacles or dental plates or human hair, since you are always to some extent prepared for these by the images already in circulation; it is rather the unspectacular details of how the victims lived before they died, of what the conditions were in

even their quietest, calmest moments. At Birkenau, only one of the wooden dormitories has been left standing; it contains no displays of savagery, only the original wooden beds. But those beds are the most disheartening of all the relics of mass murder; they are not beds as most of history has designed them, meant for the comfort of only one or two people – they are industrial stacking pallets, intended to hold as many bodies as could possibly be crammed into them. They are absolute denials of intimacy and domesticity, and everything that is most fearful about the Holocaust is there in the inhumanity of their scale.

In some ways, the most moving elegy for the victims of Nazi atrocity was the installation *Concert for Buchenwald*, created by Rebecca Horn for the old tram depot at Weimar during 1999. Typically for this artist, the installation was time-based, involving a small wooden railway truck, shunting backwards and forwards between a brick wall and a pile of musical instruments. These were all stringed instruments, violins, guitars, mandolins, all without their strings, all bespeaking a certain longevity, a history of use now ended, now followed by silence, except for the repeated percussive effect of the railway truck. The period of their soundingness, of their giving voice, would be roughly commensurate with that of individual human speech. But behind the railway lines on which they were stacked, awaiting symbolic deportation, stood an immensely eloquent structure, consisting of parallel walls of glass filled with ash. This ash had taken Horn a year to collect; the amount of burning and reducing involved, exhausting to contemplate, the amount of material that had to be destroyed to produce enough layers of compressed dust to fill the designated space, provided a measure, in terms of individual human effort, for the perfunctoriness with which the industrial process had been carried out more than fifty years earlier. Horn's labour supplied a human scale with which

to calibrate the atrocity of Buchenwald, inverting the process of destruction into a means of creating a monument that would memorialise those whom Buchenwald had destroyed. Perhaps only an art that moves through time and works with it as scrupulously as this, can do justice to the action of memory and repression, begin the process of mourning, and finally leave behind the scenes of melancholia.

THE REFUGEE AESTHETIC

The destruction of the Berlin Wall in 1989 marked a change in the course of several histories – not least the history of art – but it is equally true that the wall came down several times in the 1980s, just as much as it has remained standing in a certain fashion ever since. Throughout the 1980s, it was extremely difficult for artists living on the far fringes of European communism to set up and maintain genuine contact with artists and cultural institutions in the West, but in Poland, Hungary, Czechoslovakia and parts of the former Yugoslav Republic, the clandestine exchange of films, photographs and publications reached an almost frenzied pitch. The networking was so extensive that for a considerably large proportion of Eastern European artists there were very few barriers left to abolish when it came to their awareness and understanding of Western theory and practice. The major distinctions between the situations of art on either side of the Iron Curtain concerned its place and occasion, audience and duration.

When I was living in Poland between 1984 and 1987, art was makeshift. It took shape in performances and 'happenings' more often than in exhibitions. These tended to be one-offs, staged in venues that could not be reused. Whenever a space was found that could be turned into a gallery, it would be difficult to access and invisible from the street. Publicity was virtually unknown: a vernissage would be announced by word of mouth only days – sometimes only a few hours – before the event. Inevitably, the same faces would turn up. The art would change – change was of its essence – but the audience

would not. The audience often became the subject matter, and the venues became the locations in a whole series of films, videos and sequences of stills. Polish artists in the 1980s were obsessed with documentation, driven by a will to document with an exhaustiveness and an exhaustingness often more durable that their equipment. Films and slides were projected routinely on the whitewashed walls of people's flats. One of those flats, the one I was drawn to most of all, housed the Galeria Wymiany (Exchange Gallery) of Józef Robakowski, doyen of several successive avant-garde groupings in Torun and Łódź.

Łódź was Poland's second-largest city (it has since been overtaken by Kraków) and home to the State Film School and Muzeum Sztuki, the museum of modern art whose collection memorialises Polish Constructivism and its legacies; the Bałuty section of the city is also the site of the second-largest Jewish ghetto in Europe. It was the Muzeum Sztuki that in 1998 allowed Robakowski to curate an exhibition based on the Exchange Gallery and on the history of its activities. And it was this exhibition that marked truly the distance crossed by Eastern European art in the period since November 1989 – from a culture in which art is forced to hide away to one in which the hiding place itself is fetishised, where the cult of the private fills all the available space. Several works in the exhibition itself provided critical reflections on this refugee aesthetic. Absent however was Robakowski's masterpiece of the 1980s, *Dinner with Lutosławski*. In this film, shot in proverbially grainy black-and-white and in slow motion, a group of Polish artists (the same old faces) climb several flights of stairs to a series of attic rooms (one of the same old gallery spaces). After excessive consumption of the national product, hot potatoes and vodka, the protagonists fall to making music with an assortment of simple domestic implements and a squeeze box that is eventually pulled to pieces. The soundtrack,

which consists entirely of music by Lutosławski, epitomises that richness that Polish art is capable of, while the images indicate the poverty of the resources it has at its disposal. One by one, the artists drop into exhausted sleep, the expressions of cheerful camaraderie on their faces being replaced by portraits of hopelessness and disappointment: refuseniks visibly converting into *refuses*. The eagerness with which they mount the stairs in the opening sequence is offset by the painful slowness of their decelerated progress; they seem to be going nowhere, not even very fast. The dogged attentiveness of the handheld camera is extremely disconcerting – if this is navel-gazing, it is completely unsparing, and if there is something incestuous about it, that is part of the point. Polish art of the 1980s was an art of confinement, aerated by international contacts, certainly, but ultimately forced to do everything – performing, recording, projecting, exhibiting – in the same limited space. In this it echoed the conditions of Polish families forced to inhabit three-roomed housing units in their millions. *Dinner with Lutosławski* sums up brilliantly the artistic culture of an entire epoch; as far as I am aware, it had not been shown in this country before becoming available on twenty-first century DVD.

It was the topology of Eastern European art that went missing, inevitably, from showcase exhibitions in the West, including the huge survey *After the Wall: Art and Culture in Post-Communist Europe* shown at the Moderna Museet in Stockholm in 1999. In other respects, the Stockholm show was invaluable, featuring artists from twenty-two countries and revealing certain common strategies across national, religious and political divides. What was remarkable was the thoroughness with which many of the artists used their opportunity to exhibit by mounting a deliberate parody of Western modes of presentation, accentuating the distance that still separates the two very different traditions of spatial practice.

Measuring this distance and satirising the illusion that it could be dissolved at a touch was in every sense the business of the Riga Acquaintance Office, a project devised by Latvian artists Gints Gabrans and Monika Pornale. The plan was to run a dating agency that used Western gallery space as a means of blatant product placement. Larger-than-life photographs and confidential details of Latvian men and women were displayed with as much banality as possible. The client status of the Latvian artist, dependent on Western patronage, was amplified in the inequalities of a personal services bureau where all the sellers were from one side of the former Iron Curtain, all the buyers from the other. The spectator at the exhibition could not avoid being implicated economically rather than aesthetically in its propositions.

An even more striking expropriation of the space at their disposal was effected by the duo comprising the Bulgarian Plamen Dejanov and the Czech Svetlana Heger. They contracted out both their gallery and catalogue allocations to BMW for the entirety of the year 1999. In place of their own artworks they exhibited nothing but advertisements for BMW cars, revealing very little about Eastern European art except for its total capitulation to Western commercial values in the aftermath of the demise of state sponsorship. The forfeiting of control over the image posed a question for Western artists about the claims of sponsorship and the way in which it drew them into a power structure, at the same time as the Western galleries were identified as an alien context for Eastern European artists whose work in some sense did not belong there. This perception was monumentalised by the Bulgarian artist Kalin Serapionov, whose *Kunst in Everywhere* project of 1996 made the principle of exclusion the condition of his response to Western institutions. His works did not actually enter the museums and galleries conscripted into the project; instead, he projected his own silhouette on to the exterior walls, expressing

an ambivalent desire for prestige while recognising the need to resist absorption: a simultaneous attraction and repulsion. This simple trope has been repeated on numerous occasions by a variety of artists, such as the Czech sculptor, David Černý, who exhibited at the Czech embassy in London in 2000. Černý transferred the condition of being expelled from the figure of the artist to that of the standard subjects of communist public statuary. His *Man Hanging Out* (1996) was a composite Lenin, Freud and Masaryk, hanging on by his fingernails to the end of a long beam projecting from the embassy's façade; it was if he had just been forced to walk the plank.

An almost ubiquitous unease among Eastern European artists over the dislocating of their practice during the 1990s had the effect of returning them time and again to some form of direct confrontation with material conditions in the East and West; with the growing discrepancies between economic zones. There is an obscene logic behind the decision of Bulgarian and Czech artists to eclipse their own creativity with the promotion of a top-of-the-range German car; the use of BMW's advertising slogan, 'Quite normal luxury', gave a bitingly sarcastic inflection to a typically wry Slavonic gesture of self-effacement.

The loss of atmosphere in Eastern European culture resulted partly from the invasion of commerce, partly from the disappearance of the spiritual, all the more surprising given the latter's key symbolic role during the 1980s. In Estonia, where the liturgical experiments of the composer Arvo Pärt had the effect of lengthening the pedigree of artistic dissidence, allowing the development of a kind of antiquarian avant-garde, the visual artist Jaan Toomik has expressed cogently his dismay that 'communist ideology has been defeated, but in the East European countries society has become much more materialistic, and the Western art scene, with its frighteningly pragmatic attitude, does not offer any consolation to an artist

who concentrates on the categories of spirit and mind'. It would be more accurate, however, to say that the spiritual has appeared everywhere anamorphically, viewed from an angle that always makes it resemble something else; it is almost too much of a paradox that the closest resemblance is actually to business. Luchezar Boyadjiev's installation *Neo-Golgotha* (1994) consisted of three outsized businessmen's suits pinned up to create a trio of crucifixions. This was another Bulgarian project enshrining business as the cultural cement of the 1990s. Its retrieval of the symbolic languages of the past confirms the withdrawal of their original meanings, making way for a set of new meanings that remain unsubstantiated (the suits were vastly flattened and empty). The photographs of Piotr Jaros make an equivalent point about the eliding of religious culture in Poland. *Modern Hero* (1998) shows a form of Holy Communion being transacted in a solarium. A half-naked youth rises from his sunbed to dispense a gold coin in the manner of a priest offering the host to a communicant. This prompted the Polish critic Marek Goździewski to remark: 'Consumption here seems to be the only way people have of communicating with each other, and the only means for them to meet and unite.' These artists were trapped in a double bind, making their assault on consumption liable to be interpreted as a calculated offence to the sensibilities of the pious. This was the risk chosen by Ukrainian artists Arsen Savadov and Oleksandr Kharchenko, who staged fashion shoots in cemeteries, disposing their models among mourners, allowing one ritual to interfere with the other.

The spatial practices of many artists who showed in the Stockholm exhibition are radically ambivalent, arising from and inducing a species of double vision. The Russian sculptor Tatyana Antoshina creates maquettes for unrealisable projects, ceramic groups that continue to dwell on the standard iconography of state communism. Miniature Kremlins are

dwarfed by relatively monumental statuary, with political leaders replaced by posturing sportsmen, icons of aggressive male chauvinism. There is both change and continuity here, a suggestion that either role model should be seen as the virtual image of the other. The rapid transit from obverse to reverse is also proposed by Zofia Kulik's installation *From Siberia to Cyberia* (1999), which locates itself between substance and shadow, copy and original, arguing homophonically for a reciprocal relationship between totalitarian and postmodern systems of surveillance. The precocity of Hungarian trade during the 1980s may account for the more advanced state of cynicism in which certain of its artists have employed the relevant information technology to construct imaginary locations and objects. Antal Lakner has specialised in persuading users of the Istanbul subway of the existence of a transcontinental metro and potential buyers of the existence of a designer 'plant' that requires no sunlight. The subterranean growth of this imaginary product renders it totally invisible, ensuring that the marketing slogan 'the ideal house plant' is accurate in the technical sense that it requires ideation.

Positing a subterranean reality for its representations of contemporary culture, Eastern European art locates this quite precisely in respect of both space and time. The truncation of the Marxist grand narrative in 1989 was of course incomplete; surely it must continue to operate at some level in the psychology of post-communism, existing subcutaneously for those whose lives were lived according to its sense of scale and temporal regulation throughout a period of forty or more years. This subcutaneous narrative has been given an extraordinarily graphic, explicitly physical manifestation in the photographic series *Children who have had a thyroid operation* (1996) by the Belorussian artist Galina Moskaleva. Taken ten years after the disaster at Chernobyl, the photographs consist of portraits of children whose necks bear the scars of their

radiation-induced operations. Their expressions conjure up a narrative of aspirations, of dreams and expectations; but the pictures also convey the understanding of the adult artist that these lives are also being lived according to another, much more destructive narrative whose terms have been dictated well in advance. The physical quandary of these children's lives corresponds to fundamental questions of historical identity in the East. A slightly more abstract but powerful version of a similar point was made in the installation *The Register* by Croatian artist Dalibor Martinis. This involved the display of several open birth registers with their lists of names, on to which were projected a series of names taken from the death notices in Croat and Bosnian newspapers during the conflict of 1993.

If the exchange of one version of history for another is inevitable, it is also often taken for granted rather than thought about, its revisionism mechanical rather than analytic. Zbigniew Libera's *Lego Concentration Camp* (1996) was a peculiarly Polish response to this process. The 1990s may have offered the chance for a new perspective on totalitarianism, but we are all too often satisfied with a rudimentary version that fosters the belief that we are at the political centre of our world and have the direction of it – a perspective we might one day outgrow. Libera's work is brutally disorientating, but probably the most disturbing experience in Stockholm's *After the Wall* was provided by the photographic fantasies of the Ukrainian Fast Reaction Group, which systematically confused the history of Ukrainian relations with Nazi and Soviet occupiers. The infantile desire to shock initially repels the viewer, but the interrelationships between the photographs in the series gradually disclose a questioning of the roles of invader, victim, collaborator, German, Russian, Ukrainian, male and female, caricatured precisely because it is far too painful genuinely to answer. The most electrifying of the images that distinguish

Eastern European art from its equivalents in the West involve this virtual historical memory: an art that inhabits parallel worlds and times, deploys parallel styles. The stray dogs in Iosif Király's *Indirect-Bucharest* photographic series of 1993–1997 are haunting because of their documentary status, but also because they simultaneously inhabit a metaphorical world of various other kinds of unleashed violence.

The Berlin Wall itself had been an historical document, a graffitied projection screen for the fears and desires of successive generations. Its loss made all the more apparent the existence of a human wall, of the kind reflected in the faces of the Friedrich Engels Guard Regiment, whose highly individual portraits hang shoulder to shoulder in the photographic assemblage by East German artist Frank Thiel. Thiel's other major project, illustrating the constructing of the fabric of the post-Wall Berlin, overcharges the picture area with images of spatial and temporal change, rendering inescapable that sense of migration between social contexts and artistic frames; history as the coefficient of a refugee aesthetic and transition as the only permanent state.

THE ART OF TAKING HOSTAGES

Since terrorism is at the centre of our world, why not at the centre of our art? The use of terror against civilians has been practised since prehistoric times, but it is only in the last six decades that its impact has been deep enough and pervasive enough to become unignorable in our representations of what constitutes present-day social reality. That impact has been made possible, in turn, by changes in the scope of representation itself. One of the most authoritative discussions of the mutual imbrication of terror and representation was published in English translation nearly forty years ago in Jean Baudrillard's *In the Shadow of the Silent Majorities* (Semiotexte, 1983). Baudrillard subsequently became so fashionable that it has also become the fashion to dismiss him as a superficial opportunist. His work is of variable quality, there is little doubt about that, but it may be that this book-length essay is his most thought-provoking contribution to postmodern social critique, and it certainly raises a number of issues that must be reckoned with in any account of the ways in which terror has interacted with contemporary art.

Baudrillard's basic premise is that present-day terrorism claims to be targeting one thing, while really targeting another. Whenever it identifies its target as capitalism, global imperialism, its real enemy in fact is what Baudrillard himself calls 'the social'. What he means by this is nothing less than the entire social order constituted by the demands of the 'simulacrum', a form of society whose order is not imposed by overt means of repression and violence, but introduced

subtly by the infiltration of models of subjectivity through the media, in a proliferation of minor instances of deterrence and persuasion. It is this kind of society, the 'society of the spectacle', in Guy Debord's phrase, with its reduced possibilities of representation, consciousness and critical distance, to which certain kinds of present-day terrorism correspond. Terrorism often perpetrates acts as senseless and indeterminate as the system they are designed to combat.

It is as if the 'society of the spectacle' operates with a form of 'white magic' – the 'white magic of social abstraction' – encircling everyone with a form of anonymous and random control, while terrorism acts with a form of 'black magic': the 'black magic of a still greater, more anonymous, arbitrary and hazardous abstraction'. Where the behaviour of terrorists correlates with the behaviour of the masses is in their parallel denial of the historical possibilities of representation. They both stand outside of the entire representational system: outside of political representation, but also outside of representation as an artistic practice. Or do they? This question was raised as an issue in several key artistic projects of the 1970s and 1980s.

With regard to political representation, it is clear that terrorism effects a dramatic, and spectacularly violent, denial of all the existing institutions of representation. Ulrike Meinhof, in her essay 'Armed Anti-Imperialist Struggle', makes this denial an intrinsic part of the programme of the Baader-Meinhof Group: 'Anti-Imperialist struggle... politically means destroy state and non-state bureaucracies, organizations and power structures – parties, unions, media – which rule the people.' Baudrillard points to the contrast between the established means of political representation and the effects of terrorist violence. He draws attention to the historical precedents of representative systems in the relationship between the Revolutionary Assembly, for example, and the French people, or between the Bolshevik party and the Russian proletariat,

arguing that a kind of energy passes from the smaller to the larger groups, effecting genuine social transformation. Whereas, what passes between the corresponding groups of present-day terrorists and the masses is something that is moving in the other direction: a 'reverse energy', that results in the destruction of political representation, the annulment of political discourse, the abolition of politics itself.

Perhaps the most striking implication of this situation is revealed in Baudrillard's contention that present-day terrorism does not really intend any revolutionary consequences, does not seriously expect to alter the course of political history. To make good this claim, he would have to be thinking of certain kinds of terrorist activity rather than others: he could not afford to consider in this respect terrorist campaigns which do have specific economic or martial objectives and determinate enemies; he cannot be thinking of the IRA, for instance, or the PLO (his text predates the emergence of Al-Qaeda and IS); he must be thinking rather of groups like the Red Army Faction, the Red Brigades, or the Symbionese Liberation Army. What Baudrillard is concerned with are certain recurrent features of the terrorism of the 1970s and 1980s, such as the taking and holding of anonymous hostages, for no stated reason, with no stated objective, and without reference to any identifiable enemy. This form of terrorism is reckoned to be 'the exact replica of the system's lack of differentiation... In its deadly and indiscriminate taking of hostages, terrorism strikes at precisely the most characteristic product of the whole system: the anonymous and perfectly undifferentiated individual, the term substitutable for any other'. By striking at anyone, anywhere, at any time, terrorism confirms and reproduces the conditions of subjectivity in the postmodern social world. Moreover, in not even attempting to secure repercussions in history, in not really attempting to pursue specific political ends, this brand of terrorism shows

itself more interested in that which simultaneously and fundamentally prevents the pursuit of political ends: and that is, or those are, the operations of the media. Terrorism of this kind is seen as being less concerned with history than with its own story. 'This story,' says Baudrillard, 'no more belongs to an objective and informative order than terrorism does to the political order. Both are elsewhere, in an order which is neither that of meaning nor that of representation.'

In the most startling development of his argument, Baudrillard attempts to demonstrate the intimacy, the complicity, of terrorism with the contemporary global social order by pointing out that the effects of natural disasters can be identified with the conditions produced by acts of terrorism. He cites the great blackouts in New York, in 1965 and 1977 (not exactly 'natural' disasters, more like massive failures of technology, but still the point is worth taking); the effect was that of a gigantic act of sabotage. The power failure of 1977, in particular, might have been planned by a highly organised terrorist group, because it would have made no difference at all to the outcome. The same acts of violence, of pillage, the same undermining, the same suspension of the social order would have ensued. In subsequent years, we have seen on our screens the same kind of havoc wreaked on the streets of New York by impacting asteroids in *Armageddon* as by invading aliens in *Independence Day*. And we have all met people who turned on their TVs on 11 September 2001, without having heard the news announcements, believing that the spectacle on screen belonged to a film of the same genre.

The correspondence between the effects of terrorism and of natural disasters serves to reinforce the view of terrorism as a meaningless, non-representable phenomenon. By a rather staggering paradox, catastrophe is to be regarded as the symptom of, indeed even the incarnation of, the present state of the global social order; the state of society is nothing short

of catastrophic, liable to the imminent and total collapse of every representation supporting it.

Baudrillard's arguments are compelling chiefly by virtue of the manipulated neatness of his hypotheses, and by means of the structural resemblances he partly finds and partly invents between the, in other ways separate, phenomena of terrorism, natural disasters and the social order. Several artistic projects of the 1970s and 1980s, in investigating the phenomenon of terrorism, still pose important questions about this triad of forces, as well as about the relationship between history, representation and avant-garde art practice. The parallel between the activities of terrorist cells and those of artistic avant-gardes is one that should be approached cautiously, not least because it is a relationship that has too often been glibly asserted. One of the most serious challenges to the scope of art mounted during this epoch was that of the Symbionese Liberation Army. The SLA was famous for a while for capturing, holding to ransom and apparently converting to its cause, Patty Hearst, daughter of the millionaire press baron Randolph Hearst. In an immensely provocative article published in a volume of essays entitled *Performance in Postmodern Culture* (Coda Press, 1978), Cheryl Bernstein made the daring claim that the SLA was in actual fact a group of postmodern performance artists. She cited the surrealistic character of their politics, their carefully timed releases of information and instructions, geared to the most skilful manipulation of the mass media, their nice sense of irony in kidnapping the daughter of a media mogul, and the sophisticated ambiguities of their baffling communiqués. In sum, Bernstein proposed that the SLA was a highly self-conscious group of experimentalists who had chosen as their medium prime-time national network TV news. At the time of its first appearance, her article made astonishing reading, but now it no longer seems quite as far-fetched. We

shall probably never know all the facts of the case, but the point is, once doubt has been sown in our minds, it becomes impossible ever fully to resolve that doubt. What can be said is that, whether intentionally or not, the SLA undoubtedly accentuated a certain crisis of judgement; its activities disclosed very powerfully the moral and political bankruptcy of all available institutions of representation which became virtually dominated by the SLA's creation of its own story, its own spectacle, its occupation of 'all the available space' with a performance of revolutionary gratuitousness.

We can be on slightly safer interpretative ground – or at least I hope we can – thinking about the contemporaneous projects of the German painter Gerhard Richter. Richter's sequence of paintings 18. *Oktober* 1977 commemorates the deaths, whether by suicide or murder, of Andreas Baader, Gudrun Ensslin and Jan-Carl Raspe, three prominent members of the Red Army Faction, who died in Stammheim prison on the same day, 18 October 1977. The paintings consist of treatments of enlarged black-and-white press and police photographs, the photographs having been overpainted with black and white pigment. They were shown at the ICA in London in November 1989, and before that at galleries in Krefeld and Frankfurt am Main. It was Richter's initial intention never to sell them – he did not want their value to be set at a price in the international art market, so that to some extent at least they would be able to remain in the context of avant-garde art practice, resisting commodification and achieving some distance from the receiving apparatuses of the typical West European state. However, they were eventually sold to a museum, the Museum of Modern Art in New York in 1995. Their subject matter appears startling in the context of this history, as does their style. On the one hand, they bely the conventional view of avant-garde art as having little directly to do with the depiction of a social historical reality; on the

other hand, in their insistence on painterly distortion they are registering their distance both from that reality and from the photographs on which they are based. In this situation, viewers are left uncertain as to what position exactly to take up, uncertain about the degree of distance from or closeness to the subjects represented they are supposed to assume. Confusion arises over the relations of representation set up by the tensions between event, photograph and painting. According to Stefan Germer, in a catalogue essay written in 1989, 'In this process, every one-sided decision – whether for close aesthetic examination or a distanced political interpretation – is immediately counter-acted by its positional opposite.'

Richter's decision to make his canvasses so obviously treatments of photographs is partly a comment on the general historical significance of photography as a development which simultaneously gave painting a greater autonomy and freed it more readily to follow the path of pure abstraction, while also condemning it to a corresponding loss of relevance or function in sociocultural terms. By making the paintings adhere more or less to the forms given by the photographs, Richter is proposing that the avant-garde autonomy of art is an illusion, while at the same time his modifications of texture stress the constructed nature of the images created by the photographer. Richter stresses the mediating role of both the photographer and of the camera itself in their methods of placing a construction on the bare events – indeed, his paintings argue that there is never any moment or any sense in which events are 'bare' or should be perceived as such.

Despite their sense of reduction and loss, the eerie vacancy of many of their images, and their tone of impersonal mourning, the paintings also reanimate in a vital fashion the very complex problem of the relations of representation that hold between historical events, constructions in the media, and personal response. In this, they offer a powerful

and quite rigorous analogy for the dynamics of composition to be found in Douglas Oliver's *Diagram Poems* (Ferry Press, 1979). Oliver's text sprang from a series of meditations on the operations of the Tupamaros guerrillas in Uruguay, in particular 'Operation Pando', in which the guerrillas seized control, simultaneously, of police and fire stations, telephone exchange and three banks. Unlike Richter's paintings, which inhabit the same representational space as the photographs they are based on, Oliver's poems occupy only one space alongside three others which together record a variety of apprehensions and treatments of the same data.

The first space is taken up by a prose introduction which makes clear the nature of the original moment of reception of the data, when the poet was working as a journalist at a press agency in Paris, editing foreign news service transmissions. The second space is filled with the diagrams that give the text its name. These plot the movements of the guerrillas, but the patterns they begin to trace soon become liable to fantastic distortions, turning into whimsical essays in figurative representation that resemble crude caricatures. The distortions register the spurious, because heavily biased, value of the information that reaches the agency. The third space consists of italicised headnotes to the poems. In a staccato prose, these attempt to provide a summary of the action covered in each poem, but they also combine to form a quite separate narrative with its own rules and proportions. In the fourth and last space are the poems, comprising the most substantial part of the text. In these, the germ of original material is overlaid with the author's personal preoccupations, as he struggles with a set of stubbornly moral categories to establish the grounds for making a political judgement.

The diagram which accompanies the poem 'U' provides a good example of the overlap in modes of representation. The abstract plan of the guerrillas' movements slides into a figurative

drawing of two magnets, one broken in two. This combines with the poem to suggest how both banks and guerrillas are locked into the same field of forces, capable only of absolute convergence and divergence, attraction and repulsion, each defining itself by antithesis to the other, yet enclosed in the same circuit. The poem explores how that positionality, that tendency to polarise, is betrayed unselfconsciously in children's games, although in other respects children remain outside the adult force field, by virtue of their radical, inscrutable innocence. The poet's ambition is to bring the quality of that innocence to bear, somehow, on the conduct of politics in the adult world, while recognising how much is lost in transit across the barrier of language. As children learn the language of adults, they absorb an ideology ('ear knowledge') that erodes their unique innocence. As in all his work, Oliver cherishes an almost Wordsworthian belief in the child as source of values that are simultaneously incomparable and inaccessible.

Oliver's juxtaposition of different media and techniques bears a remarkable resemblance to the procedures adopted by Art & Language in the construction of their *Hostages* series of paintings (1988–1989). Typically, these square canvases depict artistically parallel universes. A layer of extremely free brushwork, applied with deliberate abandonment, is intercut with narrow sections illustrating decorated walls and ceilings of a kind found in public buildings like museums. The sections themselves fall into a pattern that is reminiscent of an architectural plan. The implication is that a virtually meaningless art, or rather, one that defies the imposition of meaning, is trapped inside the range of interpretations conferred by the institutions of art. If we compare Baudrillard's assertions about the modern subject as lacking in individuality, meaningless except when taken hostage by the meaning-systems of others, then art itself begins to look like the ultimate hostage, prone to meaning only when it can be made to mean almost anything.

FILM OF FOLLY

≈ FILM OF FOLLY

stuffed with the vermin of
numbers
which explain nothing[3]

Europa II[4] is the renewal of a lost film, of an earlier version
that was itself a victim of war. The reconstruction, based on
fragments, memories, and hindsight, stands as an epitome of
the way in which conflict is always represented: incompletely,
either because it is close in time to the events considered,
without knowledge of the final outcome; or because it is a
postscript, a backward view that has forgotten what it felt like
at the time. What both versions of *Europa* share is their close
relationship to the poem of the same title by Anatol Stern, and
what that relationship allows us to realise is that the origin of
the twentieth-century avant-garde, or at least its early history,
is linked to the language of conflict. The Themersons' film of
1930 is often referred to as the beginning of Polish avant-
garde cinema, and that description is accurate both historically
and terminologically, since the phrase 'avant-garde' is from
a military register, signifying the leading unit in a military
force. This association between artistic experimentalism

3 Anatol Stern, 'Europa', translated by Stefan Themerson and Michael
Horovitz (London: Gaberbocchus, 1962)
4 A single copy of the original *Europa* film by Franciszka and Stefan
Themerson was found in 2019 in the Bundesarchiv in Berlin.

and armed subversion, which conceives of the avant-garde as a revolutionary cell, engaged in guerrilla warfare against bourgeois philistinism, is derived ultimately from French thinking about the uses of violence in political life, expressed most clearly in Georges Sorel's *Réflexions sur la violence*, first published in 1908. Sorel's central tenet was that the ethical life is inseparable from violence. He makes a distinction between violence proper, since its agents are 'producers', and force, which is the means employed by the state to impose a false consciousness of social unity. Since the reality is disunity and a conflict of interests, violence is not only the recourse of the revolutionary, but also the guarantee of their integrity. A successful act of violence is supposed to represent a defeat of hypocrisy. The ethical life is only preserved in small groups whose violence detaches them from the state. What makes Sorel's ideas particularly amenable to the practice of an artistic avant-garde is the insistence on the need for splinter groups, social fractions, cadres, cells, small nuclei of enemies of the state; separation and autonomy is not only a tactical expedient but also a form of moral insurance.

The tone and vocabulary of *Europa* are unmistakeably combative, and the systematic deployment of energetic montage, placing unrelated images into abrupt juxtaposition, gives an aggressive rhythm to the film and also reflects the philosophical principles of antagonism that motivated avant-garde activity in the years 1925–1930, between the writing of Stern's poem and the making of the Themersons' film. Their shared project of condemnation, identifying and pillorying the causes of war and the corporate desires and political ambitions that fuel it, is fundamentally belligerent in both conception and execution.

Something of the same delight in iconoclasm, and of belief in the power of small-scale acts of contradiction, is reflected in Gordon Matta-Clark's film essay on the Berlin Wall. This

material instance of state force is used as a kind of screen on which to project a subversive montage. Matta-Clark's original conception was to commit an act of violence by blowing up a section of the wall. When this scheme was ruled out by sheer impracticality, the artist substituted an act of symbolic violence, an antithetical gesture that refused to acquiesce in the common assumption that freedom was to be located on only one side of the Wall. Matta-Clark suggested that it was not be found on either. Since the only side of the Wall available to the artist in 1976 was in the West, Matta-Clark directed his message towards a West German audience, juxtaposing the German word for freedom with familiar advertising images, implying that the public was affected by ideological pressures in both East and West, whether blatant or subtle, whether issued as a series of commands or rendered more palatable by techniques of seduction. The project was completed after the fall of the Wall and the conclusive failure of communist ideology, but this did not diminish the scope of Matta-Clark's gesture, it rather augmented it, since the montage of slogan and image now referred to conditions in both West and East, and served as a reminder of the ever-increasing strength of corporate monologism.

Martha Rosler's film, *Chile on the Road to NAFTA*, is a powerful reminder of the close relationship between the culture of persuasion perfected by the 'society of the spectacle' and the exercise of state force. The saturation of everyday life by the imagery, music and language of American consumer culture is shadowed unavoidably in *Chile* by the memory of the CIA-backed military coup of 1973. Rosler impregnates the Coca-Cola logo and the soundtrack to *Star Wars* with the menace of a dictatorial brutality that American policy opposes but secretly underwrites. The advertising hoarding in the form of a giant hand grasping the Coca-Cola can is parodic of the raised fist salute of the radical left, which it can be mistaken for

at a distance. The icon of revolutionary violence is supplanted by the icon of cultural hegemony. Rosler's satirical purpose is achieved in a soundtrack which captures the Chilean National Police Band performing a theme tune that invites identification with those who oppose an 'evil empire', despite being part of the armed forces dedicated to stamping out opposition.

Köken Ergun's tactic in the two films *I, Soldier* and *The Flag* is to expose the monologistic crassness of the state by letting it speak for itself. Both films revolve around the language of allegiance, in which the individual becomes submerged in a shared experience of identification with the Turkish nation and people. The scripted language mystifies the nature of this relationship in a seemingly elevated, quasi-poetic fashion that promulgates martyrdom and endorses an hysterical degree of hostility towards detractors. The performance of this language during a ceremony that stages episodes of unity, regimentation and patronage has an evidently seductive effect on participants while producing acute discomfort for viewers of the film. Ergun never interferes in the state's presentation of its case, although he leaves the viewer in no doubt about his own position as dissenter. The frequent use of the split-screen device is a simple but highly effective means of signalling the need for a dialogistic approach towards these patriotic rituals of integration.

The language of the state reflected in Ergun's films is contractual, binding the individual to an act of political ventriloquism. Perhaps the most significant form of language presented in films about conflict, certainly in the documentary tradition of the second half of the twentieth century, is testimonial language: the language of the eyewitness. In representations of civil war, and of ethnic or religious conflicts within the nation-state, the use of the *vox populi*, the spontaneous direct speech of ordinary people, suggests that there are as many different ideas of community as there are people to be interviewed. Dragana Žarevac's film about the destruction of the bridge at Mostar replaces the stone and mortar of the missing bridge that once joined together physically the divided halves of a Bosnian community with the imaginary bridge formed by desires, memories, fantasies, theories, exchanging the fact of proximity with the need for connection. The use of the imagination becomes an act of defiance with which the idea of home as originary, rooted in the past, is overtaken by the idea of home as destination, located in the future.

For Mona Hatoum, a multiple exile, the ever-widening distance, both geographical and historical, between different versions of home, has meant an attenuation of the idea of community and a corresponding distortion in the attachment to family. The film-maker is heard reading aloud letters from her mother, in an effort of identification that underlines the fact of physical separation. In their content, the letters indicate the mother's social and psychological distance from her own husband, the film-maker's father, a distance that is guaranteed by attitudes towards the boundary between private and public experience in Islamic culture, and which is compounded by the film-maker's awareness of differences of attitude towards the female body in Islamic and Western culture. Her use of

video clips with imagery of her mother's body in a public document challenges still further the concealment of female experience in Islamic culture while ensuring that her work will only be screened for Western audiences. A film that could speak most eloquently to those at home in Lebanon must be addressed elsewhere. The work is exiled no less than its author. Against the background of a protracted civil war, Hatoum's film proposes that the grounds of disunity and conflict go beyond religious and ethnic diversity to encompass unbridgeable distances between genders and within families that sustain the illusion of cohesive relations.

≈ CARELESS TALK

The opposition of public and private, of official and independent voices is offset by the circulation of stories, rumours and mythologies in the gossip that creates its own networks of connection and representation in situations of conflict. Official attempts to control the mixture of facts, suppositions and fantasies reflecting the shared imaginary response to the unusual pressures of wartime has the effect of encouraging still further the flow of 'careless talk' that searches for the truth behind the censored version. Walid Raad's extraordinary composition, *The Dead Weight of a Quarrel Hangs*, assembles a number of the stories circulating during the Lebanese civil war, evoking the public desire for narrative patterns that encapsulate the frustrations, projections and hypothetical resolutions of a conflict that cannot be reduced to order in the official accounts. The first and last of these parable-like distillations of the desire to grasp and make sense of the movement of history are perhaps the most revealing. The rumour about the historians who bet on the horse races every Sunday, not in order to predict the winner of the race, but

in order to predict the split-second timing of the photograph that records the winning moment, speaks volumes about the absurdity of assuming that any given mode of representation will capture the truth of history. The story's choice of the profession of historian, its focus on the wager as the pivotal action, and its reflection on an obsessive desire to control the range of possible outcomes (the historians bet on whether the photo finish will capture the moment before, during or after the crossing of the line) is a recognition of the impossibility of representation itself, even with the modern cultural advantages of professionalisation and technological accuracy, and is especially a confession of disbelief in the power of film and photography, which have assumed the premier roles in the representation of history, and especially of warfare, during the last two centuries. Raad's film ends with the anecdote concerning the subversion of surveillance photography on the Corniche in Lebanon. The transgressive behaviour of Camera Operator no.18, who switched from his surveillance role to record the sunset on numerous occasions during 1995, has an unexpected scope for Waad's critique of representation during wartime. The film-maker's use of the anecdote proposes that any medium of representation, no matter how neutral or transparent it may appear, cannot be divested of agency; that all uses of photography and film have an aesthetic dimension, perhaps especially when attempts are made to suppress it; that framing is a part of the camera's function, so that the selection of subject matter is as much an act of exclusion as an act of inclusion; and that finally, both film-maker and audience require closure, an event that gives motivation to the preceding series of events recorded. The sunset brings closure to the day, but the context suggests a desire for closure in the experience of conflict, suspicion and repression.

Dominique Comtat's use of news footage covering an unspecified Middle Eastern conflict in his film *Disasters of the War* echoes Goya's commemoration of atrocities in the Iberian peninsula in 1808, but it also creates loops of film using clips that record the confusion and disorientation of ordinary people caught up in the repercussions of ongoing fighting. The repeated actions and images suggest historical impasse, condemnation to a limbo-like state of irresolution. It is a small-scale dramatisation of Santayana's warning that 'those who cannot remember the past are condemned to repeat it'. Comtat's authoritative meditation on the conditions of memory in *A Few Notes on the Art of Memory* is not overtly concerned with war, but has clear implications for its interpretation, especially when seen in conjunction with his *Disasters* film. The film is punctuated by repetitions of the same passage from Cicero's *De Oratore* concerning the training of memory according to a system that calls for the visualisation of a building and its structural subdivisions. The passage is read eight times by the same child over an extended period of time in which he shows a marked improvement in reading skills and an increasing understanding of what the passage means. The rest of the material is diverse, discontinuous and without an immediately obvious thread of connection; it calls for the exercise of memory but without a clear indication of the difference this would make to the viewer's need to sort the relevant from the irrelevant. One sequence which shows a hand opening and closing rapidly on a succession of different objects is clearly alluding to a common game designed to test the viewer's memory. Cicero's conceptual scheme, designed to be of practical use for lawyers in Augustan Rome, was developed into a much more ambitious system in the so-called 'memory theatres' of Renaissance Europe, but the film-maker is clearly

sceptical about this highly influential model, which takes the objects of memory and removes them from one context to another, cutting the links with their origin in personal, lived experience. The memory theatre is a construction in the mind's eye that excludes as much as it includes, that obliterates all those circumstances that fall outside the focus of the rational mind. The rest of his film dwells on the expanding and contracting sense of time lived from moment to moment, on the evocation of random sights, sounds, smells and the presence to touch of everyday phenomena; on all those aspects of an embodied reaction to the world that the intellectual mechanisms of memory are content to discard. If Comtat had an architectural model, it would be the irregular labyrinth, not the symmetrical theatre, and the way to retrace the steps in the labyrinth is not through the visualisation of ordered structures, but through feeling a way with the aid of fragile thread that connects one's body with the spaces it has passed through. Together, Comtat's two films seem to be calling for a phenomenology of cinema as an adequate response to the experience of conflict which is above all a vulnerable, embodied experience whose immediacy is impossible to transmit. The extraordinary range of conceptions, methods, and subject matter in this exhibition[5] is a collective response to the complexity of that challenge.

5 *Memory Labyrinth: Faces of Evil* 1939–2009 (Ars Cameralis: Katowice, 2011)

ART & LANGUAGE

Feasibility Study for a Large Object across Art History
The idea of ideas as discursive items, *as art…* required that the
hypothesized object be seen not as 'the art', but as the object of an
inquiry for which the status of art was more-or-less strategically
claimed. The conviction that characterized Art & Language was
that it was the inquiry which had to be the work and which
therefore had to become 'the work'.
— Charles Harrison, *Essays on Art & Language* (Oxford:
Blackwell, 1991) p.49

Thus, Charles Harrison introduces the moment in the
history of Conceptual Art when Art & Language begin to
distinguish their own practice from that of a largely American,
post-Minimalist tradition in which objects are conceived of,
proposed and described only as illustrations of ideas without
those ideas being given concrete form, while still taking form
as objects in the mind, rather than as discursive procedures.
The very earliest works marking this critical initiative predate
the launch in 1969 of the journal *Art-Language,* with its mix
of artists' statements and responses, but the provocations
and prescriptions of that occasional publication, as well as
its versatility, are anticipated in the abstrusely controversial
and theoretically speculative sequence of works co-authored
during 1966 and 1967. These all seem to derive much of
their intellectual energy from a commitment to writing as
displacement from painting and object-making, a substitution
whose polemical intent is flaunted in the application of the
term 'painting' to verbal artefacts.

To be more precise, the generic term 'painting' is applied to objects that recall the conventions of painting in their shape, dimensions and manner of presentation, while offering clear objections to the assumption that paint should be considered the vital component in painting, when the latter is understood in relation to the whole ensemble of activities involved in any serious art practice. In the *Paintings* series of 1966 no paint has been used. In the place where we might expect to find it, there is text instead; typewritten text, not handwritten, since a distinctive graphic style would accommodate a considerable degree and extent of individual authorial expressiveness.

With the *Paintings* series, the articulation of individual mood and temperament is being intentionally suppressed so as to focus the viewer's attention elsewhere. While the majority of notable paintings in the modern era have been identified as issuing from the hands, brains and sensibilities of individual artists, this association has replaced an earlier understanding of artworks as the products of workshops, manufactories where shared attitudes towards style and technique render participants in the process of production more or less interchangeable. The studio practice of Art & Language represents a withdrawal from the modern tradition that values artworks with secure individual attributions. The effect of this withdrawal is to place greater emphasis on generic constraints, discursive conventions, institutional codes and the general conditions of knowledge.

Art & Language is organized around a central core of collaborative activity, with individual artworks being no more than corollaries of this process of collaboration. The early typewritten text-works do not reflect individual agency. That said, it is true that the irregular inking patterns consequent on the condition of individual typewriter keys signals the forensic possibility of establishing connections between the text and its reproductions on the one hand, and the historic

use of a specific, indeed unique, graphic mechanism on the other. And this awareness of the paralinguistic features of the text-work highlights the extent to which even the most 'conceptual' engagement with painting is grounded in material circumstance.

The text-work *Paintings* 1. *N.7* is divided into a single-sentence citation and a short paragraph of commentary. The speech marks around the citation suggest the weight of authority, suggest the same kind of focalising value that a competent reader would lend to an epigraph. But the speech is unattributed and aimed at nothing and no one in particular. The 'situation' referred to could be that of art, but might equally extend beyond art, and begs the question of how the extent of art should be determined; how its field should be defined, and where the limits of that field should be set. The following commentary appears to circumscribe the 'situation' with reference to the art world, and seems to want to localise it to a turf war. In other words, it appears to 'contract' a situation that has just been proposed in terms of its 'expansion', except that 'contraction' is the outcome of behaviour and attitudes evinced by 'artists who see themselves as iconoclasts', with the clear implication that what they see, or rather how they see, is subject to misperception. This misperception is owing to an outdated allegiance to 'the cubist aesthetic', outdated because its first article of faith installs the object at the centre of its art practice, an insistence on the value and importance of art *without* language. This aesthetic is held at arm's length and identified with third persons – 'those artists' – by an artwork whose primary means of engaging the viewer is *through* language, making its reception impossible without it, in fact; insisting on the passage from visual to cognitive and turning viewers into readers. It is an obsolescent form of modernism that would regard the typewritten text as 'bland' and 'neutral-looking' while simultaneously regarding its substitution for a

painted or sculpted object as a 'hostile or aggressive' act. To assert that something tame is aggressive, something neutral is hostile, is to embody a contradiction asking to be replaced by a critical form of art practice. It supplies the pretext for a display of text, and in fact becomes the very subject of that text.

The text of *Paintings* 1.*N*.8 offers more resistance to interpretation. It begins by introducing the question of the relationship between the 'unit' and the 'whole', and proceeds to complicate its own internal relations precisely by making conspicuous its hesitancy over the management of its various units of sense. These exist in an uneasy relationship with one another and cannot be said to settle into an order that unifies them into a 'whole'. This incompleteness has been contrived deliberately – 'There were no mistakes' – precisely in order to demonstrate the potential for reconfiguring the relations of the artist and his or her public. The public habituated to an object-based art practice is used to attending to a final product, an artefact that is only the outcome of a complex set of relations and sequence of actions. More often than not, the object bears little obvious trace of this prehistory and of the institutional and commercial hinterland behind its appearance in a gallery context. The function to which the public is confined by this eliding of most of the circumstances surrounding object-production is that of consumer. An art practice defined by its critical activity, such as the practice that this text has arisen from and which it reflects, is clearly aimed at engaging the public in its function as co-producer. In fact, for the time it takes to read the text of *Paintings* 1.*N*.8 there is a 'transfer of experience', a strategic reversal of roles between artist and public, since the evidence for 'composition' has been 'crossed out', leaving the reader in the position of having to devise ways of making sense of these obliquely cross-referring sentences, persuading them into the most useful form of relationship, and in the process reflecting on their own relationship to a

continuum of art-making that involves many more agencies than that of object-maker alone.

It is important to recognise that the reader's activation of the text, a process that involves feeling one's way, making trial of different interpretative methods, choosing one collocation of elements over others, does not involve an irresponsible licence, an effective appropriation of the material for one's own purposes, according to impulse or predisposition. The difficulty presented by the text stems partly from the experience it allows of being thrust *in medias res* into an elaborate structure of relations and into an ongoing set of transactions. As soon as the viewer starts to become a reader, they are made aware of being outside an ongoing conversation and having to pick up threads that would lead back to the missing information whose absence vitiates their understanding of the issues at stake. What a reading of the text brings into view are the terms of argument, the range of potential action, the ideas that are in contention. Productive reading feels like a leap in the dark only if it is wilful and self-indulgent; the transfer of responsibility from artist to public is not absolute but conditional, and the condition is that the reader recognise how the text's flexibility is limited by its conceptual focus.

Paintings I. *N.*9. is concerned with the single most common vehicle of painting as an aspect of art practice: the canvas stretched on a picture frame providing a rectangular-shaped surface for the application of paint. The conventionality of the medium puts it beneath notice as a format that might be departed from on every occasion the artist takes up a brush, or palette knife, or squeegee, with which to paint. The text considers the defining characteristics of the vehicle with the express purpose of refusing to take for granted everything that is normally taken for granted. It therefore considers size and shape in relation to the spatial experience of the viewer, and notes how the canvas inhabits three dimensions although

viewers commonly behave as if it exists in two. They fail to register the literal depth of the object before them although they are more than ready to enter the illusion of depth presented on its surface. This illusion may lead towards reflections on the historical circumstances of the painting's production, but in practice it more often leads away from them. The primacy that is given to surface is therefore a limiting factor in the object's capacity to articulate this history. And even allowing for the specific usefulness of surface, the surface of the canvas is only one among a range of possible surface options: 'There is no singly appropriate system for asserting surface.' The value we place on one surface option is weighed in relation to the number of times this option has been chosen before, but does the value alter in relation to the exact number of times, as logic dictates that it should? The text works to pose a range of questions about the relationship between painting and the shaped canvas, enough to demonstrate how every question is the leading edge of a broadening field of inquiry. It stops when it is clear that this process is already well under way; when it is clear that every question about technique or materials leads to a question about conformity; about the risk of complicity.

Paintings 1. *N*.2. is a set of statements divided into thirteen separate parts, although certain of these parts are grouped into subsets. The first subset includes three parts; the second subset seven parts; the third subset three parts. However, the second subset has its own subset of three parts. The principle on which division has been made is unclear, and one can conceive of ways in which it might have been handled differently. The complex relationship between the thirteen units into which the text has been divided is ironic, since the subject matter of the text is the 'relational nature of painting': the question of how much or how little any example of painting should be regarded as either 'relational' or 'autonomous'. The irony is doubled when we reflect on the extent to which the subject

matter of this text relates to that of other texts in the *Paintings* series. A relationship clearly exists, but the extent to which each text should be read in the light of others is uncertain and the relationship is therefore unstable. The textual echoes enforce a relationship where the absence of text in conventional paintings helps to suspend it, granting the individual example of painting a more significant degree of autonomy. The Art & Language agenda is dedicated to rendering visible that which has a tendency to vanish from conventional painting; rendering concrete that which commonly remains nebulous: the relations from which examples of painting derive their significance. These are not just the internal relations of the picture plane, but the three-dimensional relations within which the art object is presented, the serial relations of the single object to those of equivalent status in terms of materials, subject matter, genre, tradition, and the external relations of production and utilisation, interpretation and reception, evaluation and consumption.

The layout of *Paintings* 1.*N*.2, and aspects of the idiom in which its language is couched, suggest another form of relation, that of an abutment onto the discursive field that is occupied by analytical philosophy; other of the early works generated by Art & Language adumbrate with the language of dialectical materialism. It may be that these are the discourse structures most regularly implicated in the textual components of the project, but there is also a more widely ranging attempt to resituate the language of art in relation to the vocabularies and procedures of other disciplines, especially scientific disciplines. This has the general purpose of capturing the elements of translatability between one mode of knowledge and another, but also a more specific purpose of proclaiming the value of experimental inquiry in art by demonstrating its parity with the role of laboratory experiments in the sciences. Works such as the *Potato Print Models* 1 and 2 (1967) wittily combine

emulation of the exactitude of scientific observation and description with a parodic exposure of its detachment from the way in which demotic language makes sense of the world. *Model* 1 sets out the methods and aims of the experiment in a completely po-faced manner: 'TWO POTATOES SET-UP IN EXPERIMENTAL SITUATION FOR MEASURING CHANGES IN THEIR CONFIGURATION'; while *Model* 2 begins with the same quasi-clinical register – 'THIS MODEL MEASURES THE TEMPORAL CHANGES IN ITSELF' – only to collapse into expostulation: 'THE IDEA OF A TEMPORAL CHANGE IS NONSENSE! ONE DOES NOT HAVE ONE KIND OF TIME AND THEN ANOTHER!' The language moves seamlessly from one statement to another while it inhabits the register of science, stepping outside it suddenly in order to highlight the need to challenge the privileged position of science within a technocratic culture. The challenge comes from the language of everyday life, just as the apparatus for the experiment comes from domestic reality. The wittiness of the artwork derives in significant measure from the point made in the title shared by both 'models': these are not 'Potato Change' models, but 'Potato Print' models, the point being that print-making with potatoes is an everyday experience for children during art lessons at school – it is everyone's first experience of the meeting-place of art with technology, and a key moment in everyone's awareness of art as a discipline that has its own technics, with direct consequences for an understanding of aesthetics.

The simplicity of the imagined experiment belies the complexity of the artwork, complexity in this instance residing not in linguistic difficulty but in the difficulty of grasping the nature of time-space relations. The artwork is built around a spatial account of a temporal experience, with the relationship between the two determined by a reading of the changes that take place in both dimensions. Science can provide an accurate

reading of the relevant data, but it cannot provide a reading of itself, cannot provide a critique of the questionable value of its own measuring systems. Since those measuring systems are commonly accorded a high degree of power and authority, a challenge to the measure is a challenge to those in power, as Brecht pointed out in relation to Galileo – in relation to the position of science within a social structure of vested interests, where scientific research depends on selective sponsorship. It might not be far-fetched to detect an agit-prop enthusiasm in Art & Language's use in this work of denunciatory exclamation marks (!).

In many ways, the concerns of the *Temperature Print* series (1967) run parallel to those of the *Potato Print Models*, exploring the scope of the formulation 'simplicity is hard to describe' by proceeding to show just how hard. These works consider an aspect of the experiencing of artworks that might seem of secondary or even peripheral importance but which is nevertheless a constant factor in establishing the conditions for their storage, conservation, maintenance and display: temperature. Heat output affects the chemistry and thus the physical structure and appearance of artworks. Some degree of change is inevitable and is not uncommonly built into the life cycle of twentieth-century and twenty-first-century sculptures and paintings (see Beuys and Kiefer, for example) and yet for the majority of professionals and dealers involved in the museology and commercialisation of art, there is still a code of practice, amounting to an ideology, designed to arrest it. Conservation presupposes a desire to attain environmentally to the ideal of a steady-state physics – or as close as possible to it. The Art & Language approach is to indicate the insuperable range of problems involved in ever getting to the stage of taking readings of a kind that would form the basis of thermostatic regulation.

On what basis might a reading be taken? If the object whose temperature is to be measured is in an unstable condition,

and if the observer engaged in taking the measure is in an unstable condition, then what is the status of the mensuration? *Temperature Print* 1 identifies as a philosophical problem the assumption that a series of readings of the same object can be said with any certainty to refer throughout to the same subject and object of perception: 'One is constantly having to decide whether to construe two particular encounters as repeated encounters with an identical physical object or as encounters with two distinct physical objects.' This is to evoke a Bergsonian continuum of experience in which both subject and object undergo ceaseless molecular change, rendering the language of description liable to permanent obsolescence. Physical transformation requires a proportional degree of linguistic transformation. The text of *Temperature Print* 1 accordingly brackets many of its own terms of analysis, inserts them within inverted commas, to signal their provisional status, underlining the extent to which we make sense of the world most of the time on the basis of habit, of received ideas and shared assumptions, using a language that is always already out of date; that is unprepared for, and inadequate to, the reality of our experience.

The series of readings appended to the text, all taken on 25 July 1967, illustrates the variability of heat loss in a single room. The measurements are to all appearances scientifically precise but they are periodic and therefore not a complete record. Even so, they illustrate almost continual fluctuation. The systematic method employed simulates the authoritativeness of scientific procedure, but also exposes this as merely conventional, just as patchy and imprecise in its coverage of the available data as adjacent disciplines that are routinely accorded less power and prestige in their responses to the same environment.

Without even specifying the putative subject matter of any given artwork, Art & Language in these early works are pointing to the manner in which every artwork is imbricated

in a network of connections between science, technology, education, commerce, and the so-called leisure industry, even or especially when these connections are not being addressed, or sometimes when they are being disavowed. 'Geology 1967-8' is ostensibly concerned with the physical geology of the Dee Estuary area, but the generalising title indicates its bearing on geology as a discipline or as an idea in relation to the art project in which it has been conscripted. In fact, the subheading 'Feasibility Study for a Large Object across the Dee Estuary – on Geographical Bases' makes it sound exactly like the concept trial version of a landscape art commission, although the text that follows the subheading is clearly intended as a rebuff to the landscape art movement, seen as pandering to a commercialised reinvention of the picturesque: a 'messing about' with natural features that fails to operate 'outside a merely aesthetic conventionality'.

But this text, which is only half a page long, is followed by several pages composed in a strikingly different register. These read like extracts from a found text taken from the survey report of a professional geologist, referring once to a 'barrage scheme' suggesting that the 'Large Object across the Dee Estuary' is likely to have had its origin in a civil engineering scheme, even if Art & Language have used it as the decoy for an imagined art installation. The introductory text has insisted on the importance of cohesion between the 'projected – expected i.e. possible situation and what you ended up with on the phenomenological dimension', laying down the conditions for the reader's response to the found text. To establish cohesion between this and the 'phenomenological dimension' would require an overwhelming insistence on the profitability of physically intervening in the geology of the Dee Estuary area, since the itemising of the various rocks, gravels, sands, silts, peats and clays does not fail to gauge their commercial uses and values. The mutual interference of

scientific and commercial discourses and interests is allowed to leak into the terms of description of an imagined art project, turning the printed text of 'Geology 1967-8' into a proposition about the historical formation of contemporary art. 'Geology 1967-8' is a conceptual project with a specific focus, but it also serves metaphorically to exemplify a general strategy of Art & Language, whereby every artwork is returned to its geology, by a form of theoretical and critical activity which uncovers a substrate of material connections joining art to a range of different interests which have been laid down at different stages of its formation. The superimposition of 'art' as categorical label over these stratified and embedded layers is what turns it into a resource, a material that is usable in various ways to a range of degrees and kinds of profit.

In some ways a reversal of the general strategy can be seen in 22 *Predicates: The French Army*, where a contentious subject matter is presented in almost absurdly neutral terms echoing the dispassionate use in logical propositions of predicates that would be loaded with affect in social discourse. The date of this work, 1967, comes one year after de Gaulle's announcement of France's withdrawal from integration into NATO's military structure. This makes the French Army an independent structure. The text plays with syllogistic variants on the attempt to define the morphology of the French Army, but it neither says nor implies anything about the Army's history: as an army of liberation, of imperial expansion, of colonial oppression, of civil law enforcement. Nor does it address the role of the Army as focal point of de Gaulle's reassertion of French national sovereignty, which realigns its command structure. In fact, it gives no indication that it has a command structure. It is deliberately offhand in forestalling objections to the idea that 'it's all one whether the elements are specified as the battalions, the companies or single soldiers', despite the fact that French military thinking after the Franco-Prussian

war placed an absolute premium on the morale of the single soldier. Its excision of all these factors is a calculated challenge to the reader to engage in a different form of argument, to historicise what has been included, and repair what has been omitted; and it issues this challenge in an appropriately combative manner. It does not bother to negotiate with the reader, but forces them to object to the register, to its use of specific lexical items ('decimate', for example), and to the claim that its chosen set of units constitutes any kind of 'whole'. Its use of a certain kind of logical decorum is in fact a masquerade for a full-frontal attack. It is as clear a demonstration as one could wish of the way Art & Language's art of language involves a series of tactical manoeuvres designed to activate critical thinking in its viewers and readers, of a kind the commercialised brands of contemporary art leave dormant.

IMPLICATED IN HISTORY

Picasso's *Guernica* (1937) is an exceptional icon of modernist engagement in the public sphere. More than any other artwork of its period it represents the validation of formal experiment in response to an historical event. Picasso's expressive distortion of the human figure, seen in the moment of crisis, secures once and for all political credentials for art's autonomous innovations during the pre-war period. Jackson Pollock's signature method of drip-painting the definitive masterpieces of abstract expressionism has acquired an art-historical and commercial status equivalent to that of Picasso's formal inventions; but in general historical terms its enormous success as a publicity vehicle for American leadership in the visual arts only serves to emphasise its disengagement from politics, or from any role of social or cultural responsibility. At first blush, it seems totally severed from the representation of public concerns. It is therefore reasonable to advance the view that Clement Greenberg's energetic recruitment of abstract expressionist art practice in the service of an ideological project – one that resists the threat of communist standardisation with the culture of expressive individualism – was not entirely wilful; not simply a one-sided construction. There was enough of a predisposition in Pollock's typical procedures towards the enactment of such a stance, which brings with it ideological implications, like it or not.

Art & Language have conjoined the *Guernica* template with an adaptation of Pollock's style, not in the manner of postmodernist pastiche, nor as a piece of late-modernist

grumbling, but in order to reactivate the circuit that links politics with art. By jump-starting the art-historical connections they draw attention to their own work as a form of address to, and intervention in, a field where art production has largely moved away from the task of critique. Their reworking of Picasso via Pollock swerves away from the original materials – paint on canvas – in an entirely characteristic manoeuvre. Although the dimensions of the work match those of Picasso's original, and although the mark-making gestures appear to emulate the scale of Pollock's action-painting gymnastics, the synthesised pattern that results is carefully distributed across a grid of printed pages, bringing together a range of texts of varying critical or theoretical bearing. These texts are partly disclosed and partly displaced by the superimposed design that is itself the outcome of a critical intervention in the art-historical manoeuvring of reputation, value and influence. The replacement of Pollock's typical chromatic range with the severity of black on white is both a reduction of the work's expressive range – putting it at some distance from the reflection of mood, temperament, impulse – while making a direct connection with the printed textual matter on which it is superimposed, and which it recruits as an integral element in its own programme.

The texts in question are disclosed in partial form, in disconnected fragments, but they implicate a continuous and coherent engagement with the politics of art production over a period of forty years. They are all collaborative texts issued by Art & Language in a range of different venues: exhibitions, exhibition catalogues, art magazines, philosophical journals, edited essay collections. The generating of texts, both for incorporation in visual artworks and alongside the traditional genres and formats of historical art practice, is not simply an integral element of the Art & Language programme but

a constitutive principle of the thinking behind it and the thinking through that it performs.

The challenge that Art & Language have become synonymous with, is the refusal to disengage the visual codes of contemporary art from the discursive matrices that have formed them. In the major work *A Bad Place*, the visual codes are all but dispensed with in a monumental triage giving text priority over image. But the texts have been disarticulated; which is to say that each identical-sized page is cut off from those surrounding it. Each attempt to read from one page to another, whether the direction of travel is from left to right, right to left, upwards or downwards, arrives at ellipsis; disjunction; aporia. Technically, these pages are all orphans. The superimposed motto 'A Bad Place' identifies the generic exhibition venue as the location in which the relations of art to social formation are rendered incoherent or deliberately camouflaged.

In their text *qui pourra*, Art & Language propose that 'it is a condition of the aesthetic, political and social morale of our own work that it be project-like or essay-like, that it be a response to a problem or puzzle, and not just be hitched onto one of the versions of "inner necessity" by which media-led generic art tends to be rendered consumable'. This is helpful as a description of what their work opposes and supersedes, but it does not do enough to rehearse the mode of engagement their readers / viewers can expect to be drawn into. It opens up the question of what being 'essay-like' really involves, since the essay is a capacious genre with a choice of different modes of organisation and procedure.

The form sprang into being in the sixteenth century as a vehicle for the train of thought of Michel de Montaigne – in close association with a version of 'inner necessity', but combining an illustration of spontaneity with the application of intellectual discipline. A more prescriptive and

epigrammatic model was imported into the English language by Francis Bacon. These ruminative and nucleated varieties were not seriously superseded until the twentieth century with the development of the constellative, dialectical model exemplified in the practice of Walter Benjamin; and it is this more provocative model that is paralleled in the structural relations of the Art & Language projects.

The imagery that accompanies the *qui pourra* text consists of a number of representations of the studio where the work of Art & Language is developed. Each of these representations is given a number in a series under the collective title *Studies and Conversations*. The term 'conversation' recalls the vocabulary of the *qui pourra* text where it is linked to the 'essay-like' basis on which any given work is constructed. The term 'studies' applies to the range of different approaches taken to the same subject matter, which in this case is the technical, discursive and social platform of the studio itself. This series is not an autotelic work, but a work that insists on a periodic return to the basis of its own enquiries; to the basis of its own conditions of knowledge. The immediate impression created by this series is of a crowded space filled with an accumulation of instruments, containers and materials all bearing the signs of repeated use. One view shows the space filled with nine figures either absorbed in some task, or looking for something, or performing gestures of frustration. Art & Language are now a duo, and some of the figures are clearly duplicates of the same person, but others suggest a third person, or more; another possibility is that the scene includes younger or older versions of two or more persons. Either way, this study of a crowded studio brings to mind the method of representation employed in time-lapse photography. The choice of drawing to replace photography allows for the time lapse to extend over several years, and perhaps even decades. The studio itself is the constant focus while the individual artist-figures

are the fluctuating elements in the composition. A closely similar drawing of the same space removes the human element altogether in order to concentrate on what remains. Paradoxically, the resulting survey of inanimate contents is stylistically more animated, with much more shading and expressive mark-making than in the populated version. Although the variation is granular, the depopulated version is the more cluttered, the more blemished of the two. The working surfaces appear to show more evidence of use than when the space is occupied. The human figures themselves now seem flattened and wraithlike, as if they have been cut out of old photographs where the contrast between black and white has been reduced to different shades of grey.

A third view of the same scene, this time a colour photograph, is populated by thirty-seven small yellow discs. These individually numbered labels resemble evidence markers of the type used by forensic scientists in the analysis of a crime scene. There is a parodic element in this reminder of the methods of criminal investigation, although there is also an invitation to consider whether in fact the work of Art & Language does not amount to an offence committed against the rules binding much of contemporary art practice to the interests of capital accumulation and private ownership. If such an offence has been committed, then Art & Language are implicated: the offence has not been motivated by individual desire or disposition, or framed in terms of a socio- or psycho-pathology. Rather it stems from the application of a method of resistance to the conventions of use and aspiration that govern the reception of artworks under late capitalism. The pattern of markers reveals nothing about motivation or meaning in conventional terms; if it clarifies anything, it is that any pattern will do, since everything that is perpetrated at this location has the common purpose of resistance; and every sequence of actions forms part of the same story.

One might expect Art & Language to sympathise with the exercise of scientific method, but only insofar as its procedures remain hooked up to, and answerable to, the claims of a shared moral code, whether active or in waiting. In a fourth representation of the studio, the same photograph is partly covered up with cut-out fragments of the prose text *qui pourra*. There is no mistaking this as both a bridging and a short-circuiting of the relations between the illusion of depth of field in classical realism and the presence of the art object in the physical vicinity of the viewer. The cut-out fragments of text are arranged in a rough imitation of perspectival depth, precisely in order to break the illusion that this is anything other than a summons to read the visual information discursively and to locate the artwork within a process that is under way in a specific time and place; a process that is being activated and reactivated by agents whose condition is local and specific but whose work uncovers the basis on which art is made to perform the trick of ventriloquising the universal.

If history's persuaders have convinced us that great art speaks to all times and places, then critical realism has shown this to be a form of currency conversion, whereby a medium of exchange whose values circulate within a limited geographical and historical scope will only cross temporal and spatial borders by leaving something behind. An art that does not address directly the processes of production, exchange and evaluation, is liable to be co-opted into a general economy of symbolic values, with the status of its products being determined by fluctuations in the market – not by its achievement of 'lasting' or 'universal' meaning.

Another way of saying this is that bad art is a form of mistranslation, that speaks out of one time and place with a vocabulary too limited to do justice to the complexity of relations that has given rise to it. The result has the effect of a chain of solecisms, a collection of gestures whose desire

to impress is proportional to its failure to express anything of real use. This is the current situation, where art may be either complicit with or resistant to the political currency of 'fake news', where the status of 'authentic' or 'fake' is entirely dependent on competition between vying technologies of persuasion.

Art & Language's own approach to this juncture in the history of conditions of knowledge is to expose the workings of an epistemic 'malapropism'. Their assemblage *Made Active By One Lie* consists of stacks of painted palettes and portraits of politicians. Each stack is presented in a condition of disorder, with partly obscured portraits of Donald Trump and Vladimir Putin included near the top of each pile. The portraits are conventional in style while the palettes are vividly arresting. The stacks resemble archaeological layers, with each layer bearing the marks of a complex process of experimentation and elaboration. Each palette is like a palimpsestic text that records a series of thoughts and actions, changes of direction or changes of mood; the results being various and dramatic. The portraits, however, are generic representations of the overfamiliar, the essence of the banal. And yet it is precisely these universally recognisable faces that are less compelling, less satisfying, than mere palettes supposed to be no more than means to an end. The faces are signifiers of deception, misinformation, and not worth reading; while each palette speaks eloquently and uniquely of the realities of work in process. If the commercialised language of art is now 'malapropped' – disordered and obfuscatory of its true role in the general economy of the times – the ever-varying tactics of analysis and articulation pursued in the compositions of Art & Language are loud and clear in their call to order.

MARC ATKINS: FLEEING THE LIGHT

At the conceptual centre of Marc Atkins's series of photographs, *Equivalents*, is an image of the Roman Forum: physical remnants whose ruined state underlines the permanence, or at least the endurance, of the idea they represent, which is that of permanence itself. Yet in Atkins's hands, the image starts to dissolve, colours begin to leach away, and the monuments become perishable. The stone achieves zero gravity, weighs less than photographic paper, is outlasted not only by the snapshot in which it is contained, but also by the discarded portrait whose bright colours dominate the foreground. The tourist shot includes an extraneous element, which is the Trojan Horse of art in an era of mechanical reproduction. Rome itself was founded on the success of the original Trojan Horse. In Atkins's work, the strategic distraction is that of point of view. We might expect to look at the Forum, but instead we look at a portrait we cannot properly see. The correct angle of approach to the object of contemplation is inaccessible, located somewhere in the space that lies behind the surface of the photograph. Every photograph in the new series involves this dynamic, whereby the frame does not mark out what we look at but opens onto a scene in which looking is already taking place.

The object of contemplation is less the photograph in the show than the photograph it depicts, the object that has been placed or abandoned in an unavailable narrative. These discards are often slight in appearance, yet the aesthetic

strategy of the work gives them an extraordinary power over the environments in which they appear. They flout the architectural logic of receding vistas; the discipline embodied in the perspectival view of a bridge is deflected, offset by a casual and stylish display of female physical power, in an impromptu celebration of indifference to male control. The allocation of relative degrees of power to gendered points of view is systematically troubled in this work. One shot features a male figure, head apparently swathed in bandages, but actually caught in a rapid movement blur; the effect proposes a scenario of medical interference which places at the dead centre of attention a tattoo resembling a raised welt; this carefully inflicted injury rhymes disturbingly with lips brightly outlined in the discarded female portrait lying under the bed. The allusion to a vampiric archetype allows some play with the idea of the photograph as afraid of the light, and as a reflecting surface in which the face of the observer cannot be seen, as well as conjuring up the vulnerability of the subject detached from an original setting. Just as the vampire needs to leave deposits of Transylvanian earth in various safe houses, so Atkins deposits the traces of his work in a variety of locales: Italy, Poland, France, USA, London – to name only those which are immediately obvious.

Many of the discards appear to have been put down momentarily before being caught up again – gaining their place in the landscape for no longer than it takes to make a telephone call – suggesting that photographs and settings are potentially interchangeable, subject to a process of endless translation. A significant number of the environments that Atkins is drawn to record the after-effects of this process: tables, floors and walls have the appearance of a palimpsest of innumerable impositions; they have been tattooed, literally, by a history of domestic rhythms, largely of ingestion and regulation. The Atkins landscape is anchored in scenarios of

neglect, of clutter, dilapidation, and stratified impressibility: an ancient drain; the Thames foreshore; the locked doors of a burial vault. The photograph by the drain is about to be disposed of in a setting which disposes of everything; the foreshore is a place which remembers everything that has ever happened to it, but which is both ignored and despised; the burial vault is a place that has been set aside for commemoration but which has every appearance of being forgotten.

The ratios of remembering and forgetting, of permanence and impermanence, of control and vulnerability, are rendered most exactingly in a pair of images that feature the same woman: once as the subject of a discard, once as an apparent intermediary, poised in the moment of translation from subject into object and back again. The first of these images is introduced into a London tube carriage – a place of intense and constant scrutiny of faces and representations – yet it is placed in a position that is invisible to the ordinary passenger, and can only be seen by contrivance, by using the point of view of committed voyeurism, a point of view that is both cherished and disowned. In the other image, the same woman is seen holding up for inspection the photograph of a female nude, yet her own gaze is averted, away from both the photograph itself and from the viewer, who can only inspect the representation of female nudity by ignoring the 'real' woman. One's glance travels backwards and forwards, uncertain of the true focus of the work, of the social and artistic decorum it bears witness to, of the attitudes and self-consciousness of the two women implicated in the scene, of the nature of the privacy it may or may not violate, of the degree of exploitation, or refusal to exploit, it requires from the viewer. This constant passing from one point to another occurs within the individual composition, but also between compositions, and across the whole series. Atkins's work is composed of passages that each successive instance of construction translates into equivalent, but

different, terms; it always brings with it the trace of its origins, the ground from which it has emerged and to which it will return, and it is locked into a cycle of addiction, succumbing constantly to a light from which it must always retreat.

TRUE LONGITUDE: ATKINS'S *INTERSTICES*

It is five o'clock in the afternoon, about twenty degrees east of the Greenwich meridian. The artist has used a nine-inch nail to secure a photograph to the wall. Underneath this arrangement is a small metal plaque, defaced by rust. It bears an inscription ending in '–niak': almost certainly Slavonic. The sun is high in the sky, it casts a long shadow, which is paradoxically the most incised and definite element in the composition. This tendentious sundial is the archetypal photograph – a writing with light. Not *by* light, but by the artist, although the photograph replaces what the artist saw. His vision is always a fraction of a second out of date, does not coincide with the descent of the shutter and is never actually recorded. The shadow has moved around the nail infinitesimally. The artist has chosen the setting, has placed the elements around one photograph and within another. And the setting forms a commentary, acts as a caption to the idea behind the shot. But just as the inscription is about to name something, to capture what is always on the move, its physical obsolescence suggests the degree to which it is always a misreading. Or rather, this and every photograph is a misinterpretation, since its relationship to the artist's vision is anachronistic. The eye cannot see the difference, cannot measure the sundial's tread, cannot keep pace with the growth of rust. Photography often seems to be an interrogation of space, when it is really asking questions about time.

The individual photograph I am describing works with several different temporal scales at once. It also refers to an

installation of images at the Poznański Factory inŁódź, Poland, in 2001, which required the viewer to walk across a semi-derelict site, following a trail, experiencing the artworks as a sequence of events in a given period of time. The viewer was to pause wherever a nail had been driven home, in a secular version of the Stations of the Cross. The repetition of the artist's itinerary was both a convergence and a divergence, spatially and temporally, tracing the walk of a forgotten textile worker, recalling a route followed thousands of times. The artist's intervention in this scenario was a redemption of the mechanical repetitiveness embodied by the factory and its routines; and yet the gesture of redemption was incomplete, fragmentary, subject to interpretation, requiring a supplementary gesture from the viewer. This act of completion, always provisional, always superseded, would take the measure of time elapsing between the different kinds of enactment, worker's, artist's, viewer's, none of which would take priority.

Atkins's current projects are centred on the experience of re-enactment. Finished photographs are taken up and inserted into a new composition, but not in a way that restricts their effects to those of spatial arrangements. A completed artistic gesture is rendered incomplete, its meanings given a new fluidity not simply by being staged, located in new surroundings, but also by being included in a process of rereading, instigated by the artist and modified indefinitely by a succession of viewers coming to the artwork at different moments of time. The fundamental temporal dislocation that this involves is accentuated in frame after frame. The downward glance of a nude model in a photograph whose vertical axis is made horizontal suggests a missed encounter with the initial gaze of the artist. The portrait sits in the corner of a rectangle of sunlight that has already shifted by the time it is incorporated in the new design. At the centre of the composition is an electric cable and a series of power

points to be used as darkness falls, the cable leading off to a source of energy and epitomising the act of syncopation that is at the heart of this work. Its energy derives from a moment that predates the photograph, thought of as an incident in the gallery, and which post-dates its meanings, the author putting his signature to a transaction whose value will be realised arbitrarily at any given moment, depending on current rates of exchange.

Atkins is drawn especially to arteries of communication, rivers, railways, roads, paths, which vary the pace of our engagement with our surroundings. He juxtaposes the accelerations of urban life with the decelerations of its changing fabric, unavoidably subject to processes of decay and deterioration, and to a changing ratio of mutual antagonism between the inorganic and the organic: the flaking of paint and rotting of wood interacting with the spread of mould and the sprouting of weeds. Atkins pushes hard at the limits of the photograph, bringing out the enormous paradox that is represented by the notion of the cinematic 'still'. His photographs are 'stills' in the sense that they are excerpts from a larger project that is always under construction, always being remounted. They do not relate to one tempo of participation, but to several; interstitial in their reconfiguring of the place of art in the urban environment, but also, and most importantly, in the way they occupy the intervals between moments of recognition and reimagining. It is on that temporal horizon, where imagining overtakes understanding, that art discovers its true longitude, that measure of difference in which place corresponds to time.

CUL-DE-SAC CINEMA

Marc Atkins's *Impasse* is the purest of meta-filmic statements. Its title is not a perversity, or an act of sheer contrariness. To give a sequence of images ostensibly all about journeying a title equivalent to 'no through road' is to follow through a logic of film-making. Film is always aspiring to capture what must always elude the attempt – movement itself – since movement is strictly unrepeatable and film can offer only pale copies of sights and sounds lost on the air. But film copies movement better than anything else, and it is therefore the best container for desire, our desire to cherish and give value to what is lost. Like the touch of Midas, it kills off what is most precious.

Every time we watch a film, we rehearse this scenario: by trying to get back in touch with movement, we push it further away; and the more attempts we make, the more it recedes. We can only experience a film by watching and listening to it, but at its heart this experience is one of repetition, of diminishing echoes moving away from source. Atkins saturates his film with as many movements as it will take. But these movements are often already doubled, trebled, quadrupled. The rhythm of the work combines the illusion of steady onward travel with several small acts of recursion. A pair of girls marches forwards, backwards, forwards, backwards, several times; a dog leaps over its owner's stick repeatedly, out of an eagerness that becomes mechanicalness; the flux and reflux of the waves draw forth exactly the same human gesture on each successive occasion. Celluloid films used to be reeled from one spool to another, exposing their audience to a series of sights and sounds no

sooner registered than left behind. Atkins's film does not reproduce this one-directional flow, but hesitates it, with subtle oscillations of backwards and forwards movements, like the 'scratch' movements of a DJ generating loops of sound from a vinyl recording. There is a complementary pulse-like aspect to Atkins's own soundtrack, which seems to reproduce sounds emitted from two different sources, according to an alternating rhythm that fosters the illusion of sound waves travelling backwards and forwards between the same two points. The quality of sound suggests a vibrating membrane, organic in origin, but detected and broadcast by mechanical means. Less than a minute into the running time, Atkins introduces a passenger into the journey going nowhere, a passenger with the unmistakeable profile of his muse, Françoise Lacroix. But human presences are not identified in Atkins's films, and are usually credited as 'figures' – their function is to pass through, to travel between an unknown point of departure and an unconceived destination.

Wherever films are watched, whether in the cinema or on the computer screen, they take us to another place, make us pass imaginatively through other rooms and landscapes. But in temporal terms, they bind us strictly to their own duration, and their passage through time is always in the here and now. There may be an allusion in *Impasse* to Antonioni's *The Passenger*, where a journey through a landscape crosses paths with a journey through time, when one of the film's characters changes lives with another, following a different passage through history, making history come alive in unforeseeable ways. For the duration of every film, it is as if we are taking a ride on someone else's way of seeing, hearing, moving and being in the world – while temporarily abandoning our own.

But there is another passenger – one more important than any human presence – introduced at the start of *Impasse*, and that is the sun. The sun puts the human passenger literally

and conceptually in the shade. The camera accompanies it; the camera pursues it, as it gets closer and closer to the horizon and gives a literal and conceptual aura to everything caught in its light. The ultimate focus of the film's attention is in fact the sun itself, which displaces every other spectacle, when the camera is turned directly towards the path of light it throws on the sea. The light visually obliterates the sea in its path, while the sea renders fluid the edges of this path. The Midas touch of the camera seems to turn water into liquid fire. The imagery is the same as that of Edvard Munch's many representations of sunset at sea, where the northern setting sharpens the poignancy of the sun's imminent disappearance; never more valued than during the moment before darkness, which can last for months in Arctic latitudes. Atkins's setting is Mediterranean, but the animism of his representation of the sunset, with its desire to prolong or suspend the vitality of human and animal movements, to somehow prevent their cessation – a project as futile as preventing the disappearance of the sun – is ultimately more haunting; the celebration of an everyday loss whose beauty is never the same.

STEPHEN CHAMBERS:
SPINNING THE COMPASS

In Borges's short fiction 'On Exactitude in Science', a time and a place are imagined in which maps become as large as the territories they represent. This cartographic ambition is approached, realised and then abandoned by imperial map-makers in a centralised state. Their enormous charts, unsurpassed in accuracy and easily surpassed in utility, are dumped and allowed to fall to pieces in the remotest spots: deserts, wildernesses; places at the furthest remove from science and civic life, from the culture that requires the making of maps in the first place. Borges's fiction is itself a microscopic fable, barely a paragraph long, and its text takes the form of a footnote, quoting an abstruse, probably forgotten, scholarly work in multiple volumes, the print equivalent of 1:1 cartography.

Stephen Chambers's enormous tableau *The Big Country* is a kind of visual topography recording multiple, successive, perhaps simultaneous, encounters between science and the unknown, culture and the uncultivated; its place is on the edges of the map, and its time is mythical. Chambers does not equal the ambitions of imperial cartography, but his work has grown to its present dimensions partly out of a concern to evoke the scale of effort involved in coming to terms with unknown environments, unmeasured distances, unpredictable behaviours. Its remarkable cohesiveness owes something to the intensity of his own response to the American Midwest, experienced without technology, off-road, riding on horseback, floating down rivers. In his first encounter with this trackless

wilderness, Chambers was accompanied by the journals of Lewis and Clark, the original pioneers who mapped the river junctions leading west from Louisiana as far as the Pacific coast. Their journey of 1804–1806 took much longer than expected, reaching higher altitudes, uncovering more species, and stumbling across far more evidence of continuous human presence in the landscape, than their planning could ever have bargained for. The space-time of the American continent was revealed as unimaginable to the Enlightenment culture of the Eastern Seaboard.

The unwieldy size of the wilderness experience has since been reduced in various ways, but never abolished. The land's ultimate resistance to a human scale of operations has been rehearsed time and time again in the last 200 years. Some way from the centre of Chambers's pictorial scheme is a fist fight inspired by a scene in William Wyler's film *The Big Country*, the two characters played by Charlton Heston and Gregory Peck slug it out in an empty landscape extending as far as the eye can see without any visible sign of human management or interference. The almost complete insignificance of the tiny human figures actually works against the film's ethical scheme which revolves around the Gregory Peck character's ability to navigate and orientate himself – physically and morally – in a seemingly boundless expanse beyond the reach of conventional law and order. A ship's captain, he has both a literal compass to take his bearings with, and a moral compass to guide his conduct. Like Crusoe on his island, he is ever-ready to rebuild the world in the image of what he has left behind. He makes sense of the untravelled world, brings it within range of his imagination and unifies it with the exactitude of a science he carries around with him as easily as a compass in a kitbag.

Chambers's letterbox panorama invites comparison with the sweep of Hollywood cinematography in the big-screen era, but it neither contains nor unifies its various fragments

of implied narrative derived ultimately from frontier history. These belong in the same conceptual space while appearing to occupy separate picture planes. Although bound together stylistically, they suggest a process of serial composition, recording a chain of events subsequently seen as turning points in the movement from historical circumstance to the afterlife of myth, an aggregation of details making sense to the viewer only in the repetition or inversion of rhythms and gestures. Pressing against the frontier – an ever-yielding margin for several decades in the nineteenth century – is what unified the territory now known as the United States; but Chambers positions the viewer within the experience that predates that moment of consolidation, maintaining a constant tension between knowing and not knowing what connects up different tracts of country and different episodes of historical time.

The most common gesture in this visual chronicle is the pointing finger. It performs an action, worn smooth by time, which we take to be confident, decisive and assertive. But from one end of the drawing to the other, there are fingers pointing in every direction. The sum effect is of a counterbalancing, an offsetting of the drive towards the frontier and the opening up of territory with an implicit need to return to origins – to the source of frontiersmanship – and review the reasons for setting out in the first place. Of necessity, most of the words towards which fingers point are the names of departure points, since all those places that lie ahead in the path of various expeditions are not named in advance. The myth of the frontier has settled on all these itineraries, absorbing them impartially into its own substance. But for Chambers, the story is one of indeterminate episodes, unrelated and unresolved, each one glimpsed in the process of construction, each one a return to inexperience, to innocence even, to the realm of possibilities that predates the narrative of citizenship, the building of the nation. There are many stories, not one; stories that do not yet know their place;

stories where the compass is spinning in every direction. Their images are magic-lantern images without sequence; where the drum of the magic lantern has been unrolled and laid out flat, divided up, and spliced incongruously with images from other sequences. If Chambers's subject matter glances at a cinema of origins, his silhouetting technique is also a reminder of the origins of cinema.

The systematic variation in size of the images reflects a standard medieval and Renaissance method of separating different narrative strands; most often used when the same space is portrayed as encompassing different incidents separated by time. In fact, both the scale of Chambers's composition and its pictorial scheme bring to mind a specific genre of Renaissance painting, that of the *spalliera*, a large panel painting in landscape format, set at shoulder height in a public room and often linked in series with other *spalliere*. A well-known example is Piero di Cosimo's *The Forest Fire*, in the Ashmolean Museum, Oxford, which may be part of a series with other panels now in the Metropolitan Museum, New York. Piero's letterbox-shaped paintings all feature several groups of figures engaged in separate activities. According to Vasari, Piero's common practice with such works was to provide scenes of 'different stories with little figures'. In *The Forest Fire*, the majority of figures in the foreground are animals, while in the background there are small groups of silhouetted human figures, some of whom are seen gesticulating and pointing towards the distance. The subject matter of these panels is suggestive in relation to the overall themes of Chambers's drawing: coming to terms with nature, understanding the landscape, and harnessing its resources. The popularity of late fifteenth-century artistic renderings of the transition from savagery to civilisation, from a state of conflict with nature to one of cooperation with it, has been linked to growing interest in Lucretius's philosophical poem

De Rerum Natura. Various aspects of this tradition seem to be borne out in Chambers's work: Lucretius's thinking about the evolution of human societies, about the translation of history and natural history into myth, and about the development of language from gesture.

But while Piero di Cosimo and other Quattrocento artists (such as Uccello in his *Battle of San Romano* panels) reserve the use of silhouetting for the depiction of figures in the background, Chambers's dramatic innovation is to use silhouettes of all sizes throughout the entire picture plane. The universality of the black figure in Chambers's drawing is irresistibly reminiscent of Athenian black-figure vase painting, and in fact there are many stylistic parallels with fifth-century-BC depictions of costume, hairstyling, poses and gestures. The conical female hairdos and travelling caps and outerwear of several male figures suggest classical Athens rather than nineteenth-century America, and yet there is a clear rationale behind the parallel, as improbable as this may seem. Unlike the later red-figure painting, which introduced the means of portraying anatomy with greater accuracy, the older tradition of black-figure painting emphasised figures in relation to landscape, preferring outdoor to indoor scenes. It was also less likely than red-figure painting to refer to contemporary historical events, more likely to engage with political ideas through representations of myth. Most importantly, the ideological focus of black-figure painting, evident in its repertoire of myths, rituals and customs, can be summed up as the artistic exploration of what it meant to be an Athenian. Chambers's rendition of twenty-first-century black-figure painting lacks the mythic potential of vase painting, where the inevitability of the continuous frieze generates a series of narrative loops cut off from the stream of history, but it still alludes constantly to myths of the frontier regarded as ineradicable from the experience and understanding of what

it means to be American. It is an updating not just of the techniques but of the cultural agenda of black-figure painting.

The stencil-like simplicity of Chambers's outlines suggest a home-made art practice, a homestead aesthetic, and an improvisational skill reflecting the make-do-and-mend technology of the pioneering phase in American cultural history. It engages with the myth of self-reliance, resourcefulness and self-definition that is still dominant in the American conception of identity and value. It invites us to question the radical innocence attributed to the American encounter with wilderness. This version of the primal encounter continues to surface in American cultural productions such as the recent Wes Anderson film *Moonrise Kingdom*. Here, the exploits of Lewis and Clark are gently parodied in the compass-using skills of an adolescent pioneer scout and his girlfriend, who separate themselves from the disillusioned and over-sophisticated adults in their lives, make their way around a small island off the coast of New England, and settle (for one night only) as an Edenic couple on the shores of a bay which they name, eponymously, Moonrise Kingdom. The audience is updated on their progress from time to time by means of a full-screen map that tracks their movements. The film-text is larded with references to Noah's flood and its aftermath, and offers a counterpoint to Chambers's own rehearsal of the American foundation myth, although it lacks the depth and breadth of his allusiveness, as well as his studious avoidance of sentimentalism and the powerfully estranging effects of his technique. Chambers revives the innocence of early discovery in full awareness of the opportunism and cynicism that replaced it, grasping the nature of its adaptation and perpetuation in the form of myth.

Chambers provides an array of narrative fragments that refuse to be tidied up or tidied away. The ragged edges of these stories-in-the-making are not conducive to interpretation;

they refuse to take on proper shape or conventional form. The work as a whole struggles with the onus of interpretation, hesitating between the temptations of neat packaging and the desire to let its mark-making progress on impulse and under its own momentum. All over the surface of the paper, the same black substance spreads in the changing guises of smoke, speech bubbles and shadows on the ground. The speech bubbles without words resist our desire to insert meaning into their empty containers. This shapeless, metamorphic, fluid substance dissolves meaning as it goes along, and dominates those areas of the paper not colonised by the exact opposite: packages, parcels, suitcases, satchels, all beautifully secured and arranged, stacked and balanced. Packages contain the culture of the point of departure; they are a temporary form of organisation that is not finally dispensed with until conditions have been created in which their contents can feel at home. Somewhere between these representations of a primitive viscosity and cultural containment, Chambers develops a third category of images that mediates their antagonism. He has grown an entire forest of trees with spreading boughs, but has also supplied his human figures with seemingly inexhaustible reserves of timber, to coppice, prune and whittle. Lopped branches are strewn all over this composite scenario, put to various uses or simply left lying around. They have been worked on, but not shaped and finished, representing an intermediate stage between unmanaged growth and systematic control of the natural environment. Chambers's *Big Country* divides the attention between movement and arrest, excess and curtailment, just like the Perspex boxes in which it is presented, endlessly repeating an illusion of packaging the very images spreading beyond their borders: framed and gridded but ultimately incorrigible.

AN ISLAND ROMANCE:
THE COURT OF REDONDA

A realist, in Venice, would become a romantic by mere faithfulness
to what he saw before him. — Arthur Symons

The isle of Redonda is a lump of volcanic rock, one mile long
and a third of a mile wide, rising to a height of nearly 1,000
feet. Nothing grows on it except grass – not very much grass.
The inhabitants are seabirds and black rats. It was named
and claimed by Cristoforo Colombo in 1493, but the island
itself failed to notice this distinction. For a period of some
fifty years, between the 1860s and the First World War, it was
occupied by guano miners, but has never really been home to
any human beings, except in the imagination.

It first took proper shape as a fantasy in the mind of
Matthew Dowdy Shiel, a trader who reclaimed it from the
Spanish (who had shown no interest in it) naming himself
king of the island in 1865 and effectively building castles in
the air that others would add to and populate; none more so
than his son, the writer M. P. Shiel, crowned king in 1880. The
younger Shiel was oversupplied with imagination; his adult
works provide the evidence for a reckless, almost hysterically
over-productive and paranormally inclined inventiveness.
But the most lasting of his Redondan inventions was the
establishment of an Intellectual Aristocracy, membership
of which has been bestowed by successive monarchs. There
have been several rival claimants to the throne, and rival
aristocracies, but this has not undermined the very concept
or the credibility of the Court of Redonda, which Stephen

Chambers has now reinvented all over again. You have to be a writer, an inventor of stories, to become king of Redonda – to become its court painter, you must have a strong weakness for narrative, but also the skill of equivocal narration, where you camouflage your meanings; where you conceal as much as you reveal. Because reality does not reside in a geographical location, or on a geological foundation, or in the experience of historical time; but in a state of mind that transforms material existence into a pattern of meaning. The art of Stephen Chambers makes visible the patterns of meaning that activate the individual imagination from within and without; his patterns refer us to the stories uniting us as a group, even when they are stories of division and rivalry: stories about islands, and their relationship to bigger land masses; stories about the State of the Union.

'My mind to me a kingdom is' wrote Sir Edward Dyer in 1607, in a poem that translates all the material benefits of high office into gifts of the imagination; or, into the shadows of pretence. Of all pretenders to the throne who have claimed the title of King of Redonda, it is the Spanish writer Javier Marías who has most attracted the imagination of Stephen Chambers. And Marías is nothing if not a connoisseur of shadows and a specialist in the art of pretence. His qualifications for ascending the throne of Redonda rest on his expertise in island-diagnosis. And the island at the very centre of his own mind map is the most successful realisation of an impossible idea ever to break surface: Venice.

Venice is the place where Marco Polo set out from: Polo the traveller who is given the task of narrating Italo Calvino's architectural fantasy *Invisible Cities* (1972), an account of fifty-five imaginary cities, none of which could ever be built, but each of which is founded on a reminiscence of Venice. As Polo says, 'Every time I describe a city I am saying something about Venice.' The city is nothing less than a dream constructed

in brick and stone, a chimera that has discovered gravity, a shimmer on the surface of the waves that has migrated onto a marble pavement. It is the very enactment of Henry David Thoreau's injunction to the idealist: 'If you have built castles in the air, your work need not be lost; that is where they should be. Now put the foundations under them.' And Venice now provides the foundations (still settling) for the first display of Stephen Chambers's great collective portrait of the Court of Redonda – for the bodying forth of its invisible citizens.

The saying 'See Naples, and die' is often misapplied to Venice, and with good reason – seeing Venice at least once during a lifetime is an idea harboured by many, perhaps most, people – much more than the idea of visiting Naples. But in Redonda there is nothing to see, and little to choose between its surfaces of barren rock and the featureless monotony of a mudbank in the Venice lagoon. And yet the latter is the platform on which Venice stands, improbably. At base, it is a congeries of mudbanks, while the superstructure we think of as Venice is the aftermath of an irrational excess of willpower, or, better yet, desire. The city is as much, and perhaps more, a product of the imagination as it is a construct of wood, brick and stone. You don't even have to go there to know precisely what to expect, and any photograph of the place is enough to form a vivid picture of what it is like; just as only one Canaletto or Carpaccio is enough to build your Venetian castle in the air. There is no other location that claims our attention, or rather our unfocused yearnings, in quite the same degree.

According to Marías, in his book *Venice, an Interior* (1988), the Venetians themselves contribute to this process of fabrication. He insists that 'they don't go out very much', are reserved and incurious about the outside world, exclusive, hidden away. See Venice, and retire. As a consequence, they too have to be conjured up by the imagination. And even when they do go out, they are as inconspicuous as possible,

shying away from the crowds of tourists and frequenting only the unfrequented parts of the city; choosing those passages and defiles where there is little or nothing to see, apart from 'the essential elements, stone and water'. Marías makes them sound as though they might as well be in Redonda, where existence is planed down to the foundations on which everything remains to be built. And Chambers takes him at his word; taking the erasure of the historical Venetians as his starting point.

The withdrawal of the Venetians from their own city takes more than one form. In the tradition of portraiture, from Bellini to Titian, the Venetian expression is austere and inscrutable. While the streams of foreigners that flow continuously along the streets and canals and bridges are ever-changing in their clothes and general appearance, the Venetians are uncompromisingly static, both in place and time. Marías claims they feel no need to travel elsewhere, or change their daily, weekly, seasonal habits, or make the merest alterations in their ancient apartments. Just as the look of the buildings has scarcely altered in the last 500 years, so the Venetians themselves seem to have stopped time, more easily within their over-furnished interiors than on their unwearying façades. And there seems little prospect of this ever changing: 'Just as it is the only inhabited place in the world with a visible past, so it is also the only one with its future already on display.'

In the absence, or scarcity, of hard evidence, the Venetians take on imaginary form. And should we ever be able to penetrate their mysterious lairs, all our surmises would take on even greater proportions. Or so argues Joseph Brodsky in his book *Watermark: An Essay on Venice* (1992). Like Marías, Brodsky is almost obsessed by the obscurity in which the Venetians manage their affairs. He gives an account of the only occasion on which he is invited into one of their aristocratic *palazzi*. He is prepared for the architecture to be labyrinthine

and deceptive, but the suite of rooms through which he is conducted gives back the impression of a three-dimensional *mise en abyme*. This effect is created above all by the contents of the picture frames, which are not filled with portraits, but with portraits waiting to happen – mirrors: 'Having grown unaccustomed over the centuries to reflecting anything but the wall opposite, the mirrors were quite reluctant to return one's visage, out of either greed or impotence, and when they tried, one's features would come back incomplete.' The failure of the mirror is, of course, the failure of readability; or rather, of one particular kind of readability, the sort we expect to prevail when scrutinizing a portrait: it should be realistic, it should give a likeness, it should deliver the unvarnished truth. But what does it mean for a portrait to be invisible?

> From room to room, as we proceeded through the enfilade, I saw myself in those frames less and less, getting back more and more darkness. Gradual subtraction, I thought to myself; how is this going to end? And it ended in the tenth or eleventh room. I stood by the door leading into the next chamber, staring at a largish, three-by-four-foot gilded rectangle, and instead of myself I saw pitch-black nothing. Deep and inviting, it seemed to contain a perspective of its own—perhaps another enfilade. For a moment I felt dizzy; but as I was no novelist, I skipped the option and took a doorway.

Brodsky is a poet, not a novelist. Chambers is neither, but as a painter he produces un-portraits in much the same way that Marías produces un-novels. They keep the frames that go with conventional narratives but subtract all predictable content. Chambers gives himself the freedom of the black mirror. His portraits do not reflect the surface of things, not even the wall opposite, which the mirrors do when their Venetian owners avoid them. His portraits contain ideas of

the self which have nowhere else to live, no *terra firma*, apart from a remote Atlantic island which has more meaning in the minds of believers than in its actual physical mass. The *Court* portraits present a host of individuals who ought to exist even if they do not. Together they project an idea of community that ought to exist even if it does not. And they crowd the rooms in which they hang, setting up a clamour for attention that merges into one clear message: 'We are not going away anytime soon...' This is the antithesis of Venetian society as Marías and Brodsky construe it. Instead of receding into the background and diminishing into darkness, Chambers's islanders turn out for carnival in their brightest colours. It cannot be said that they are self-evidently aristocratic. Their style of clothing is a touch countercultural, perhaps even louche, with the creases and wrinkles in their garments given the definition of lines on a map. Some of them show hints of an allegiance to street culture. They are multi-ethnic, of all ages and genders (ambiguous and unambiguous), mixing the costumes of different eras, and of different registers – wearing suit jackets over undershirts or with loosened ties. This is the kind of sartorial bricolage one associates with a colonial culture, where the symbolic language of the incomer is adapted and repurposed; where the subtleties and distinctions of the dress code are overlaid with the bold patterns and colour combinations of a less discriminatory society. If the Venetians haunt their own houses, shunning what lies outside their walls – as much as they shun outsiders – Chambers's courtiers wear the complexion of those who live out of doors in a Caribbean climate. This is what Redondans would look like if anyone lived on Redonda.

And they do not know what it means to 'sit' for a portrait, since many of them are incapable of sitting still. They bestir themselves, doff their hats, adjust a headscarf, wave their hands or press them together, are caught in the act of speaking, or

of listening, hand raised to ear. Above all they are extroverts, not like the introverted Venetians at all. And they point and gesticulate, more like Neapolitans, as if the space they occupy is not that of a portrait, but part of a *sacra conversazione*; or rather, the iconographic convention that makes an upward-pointing finger indicate spiritual elevation, or a sideways-pointing finger indicate progress on life's journey, is displaced to latitudes in which every *conversazione* is *profana* and every hand gesture is communicative. Each portrait shows a single figure on the same scale as all the others, but the massing of so many individual portraits alongside one another has the effect of showing the full membership of an unholy chat room all speaking at once. Several of them carry sticks, roughly pruned, like staffs of office that have turned feral. And these reminders of a state of nature, almost entirely excluded from the artificial island of Venice, behave like a conducting medium for shocking ideas of first principles and returning to basics. More immediately, they link the portraits to the large and mysteriously dramatic landscape paintings that go under the collective title 'State of the Nation'.

What these depict is in fact a state of crisis, showing three versions of a pony express rider in the process of being pitched from his saddle, hat and mailbag flying. His path is strewn with sticks, obviously cut to length but not finished off, and so halfway between a state of natural growth and something fit for purpose, although what purpose is not clear. In two of the paintings, sticks are also seen in the messenger's grasp, like olive branches divested of their leaves, while the stick in the third painting has slipped from his hand and is flying through the air. In all three paintings, the urgency of the message is proportionate to the risk of its not being delivered. And a message of sorts is also expressed by the speech bubble that issues from the rider's lips. This speech is wordless, taking the form of a rainbow of different colours, and this suggests that

the state of the nation should relate to its being diverse in meaning, identity and purpose: a 'rainbow nation'.

The spectacle of the unhorsed rider brings irresistibly to mind the tradition of equestrian sculpture – horse and rider – which in the mind of Henry James, no less, culminated in the 'finest of all mounted figures', the statue of the *condottiere* Bartolomeo Colleoni, in the Campo Santi Giovanni e Paolo, in Venice. Verrocchio's masterpiece epitomises the symbolic function of the equestrian pairing, in which the rider exerts control over a creature many times more powerful than himself. It is a public, highly visible representation of the dynamic of power, and a somewhat intimidating claim for its necessity – an ideological argument that discipline, leadership and strength of will are vital for the state to survive and prosper. But James filters his description of this artwork through the point of view of the narrator of *The Aspern Papers*, which is a novella all about insulation – about the withdrawal from 'sociability' in its most generous and inclusive sense. Colleoni, the ruthless mercenary, and the narrator who feels such a magnetic attraction to his image, are identified with an egocentric island mentality. James contrasts them with the seething ordinariness, 'the splendid common domicile, familiar, domestic and resonant', the collective 'cousinship and family life, which makes up half the expression of Venice'. In other words, his version of Venice is almost the reverse of the picture painted by Marías and Brodsky, but very like the great collective picture that is Chambers's Court of Redonda, with its celebration of diversity, its openness to a mixing of influences, and its cautionary tale about trouble on the road for the riders bearing that message. There is more than one way to imagine an island.

JAKE AND DINOS CHAPMAN:
THE SURPLUS VALUE OF HELL

≈ PARENTAL ADVISORY

For the Chapman brothers, the imagining of horrors returns
time and again to the example of Goya, whose etchings
Los Desastres de la Guerra they have obsessed over, attacked,
reworked, supplanted in several separate projects. Goya's work
does not represent simply a turning point in the representation
of history, it coincides with a re-conceptualising of history.
The long-memoried Catholic nation of Spain is seen colliding
with the forces of modernity, with the revolutionary, atheistic
culture of the new France. It was György Lukács who argued
that the French Revolution and the rise of Napoleon changed
the historical imagination, by revealing that history was not
forever in the keeping of an aristocratic elite, but could be
seized by ordinary people and channelled in new directions.
However, what Goya and the Chapmans after him propose
is that the individual imagination is never content to be
subsumed in a collective identity – ordinary people acting
only as a group – but must express its participation in acts of
control through direct, immediate, local expressions of power,
all too often in appalling acts of brutality.

The opposition of traditional and innovative societies, of
anciens régimes and revolutionary states, also remodels the
symbolic meaning of youth, a key *topos* in the oeuvre of the
Chapmans. Starting history again from the year zero, the
revolutionaries projected the new social formation as youthful,

independent of the past, genuinely experimental, exploratory. Goethe invented the Bildungsroman, a literary form that focused on the protagonist's development from youth to maturity, giving a special value to adolescence for the first time. Counter-revolutionary societies abominated adolescence and asserted the superior moral value of early childhood, a cultural elision of unreliable youth encapsulated in Wordsworth's phrase 'the child is father to the man'. English culture was mobilised in a monstrous rearguard action; G. H. Lewes, husband of George Eliot, wrote the first English biography of Goethe, consigning his subject's adolescence to three pages entitled 'The Child is Father to the Man'.

The Chapman brothers pivot around the European, revolutionary conception of adolescence as the period of dreaming, the imagining of possible lives, impossible desires, immense ambitions; the ability to change direction dramatically and comprehensibly. Their 1999 project, *Dinos and Jake Chapman GCSE Art Exam* revisits their own adolescence at precisely the juncture where individual creativity encounters formal constraint through social conventions and institutional criteria. Both artists were given a B by the examiner, clearly an heir of G. H. Lewes (an A would have been problematic). Their subsequent assemblage, *Hell Sixty-Five Million Years BC* (2004–2005), revels in the use of schoolroom materials and pigments in the construction of cardboard and papier mâché dinosaurs, both subject matter and technical performance evocative of the youthful imagination surpassing the limits of verisimilitude. Part of the appeal of the dinosaur is its simultaneous ability to conjure a world of unbridled predation and to push this back into an almost inconceivably remote past. Hell does not have this kind of geological distance. 'Why this is Hell', says Dr Faustus in his study, 'nor am I out of it.'

The *GCSE Art Exam* exhibition included two drawings of nuclear explosions. In *Little Cloud on the Prairie*, a mushroom cloud appeared as a picturesque detail in a sentimental landscape, while in *Kid with Mushroom Cloud*, the eponymous cloud was a tabletop affair, a fantasy projection in a child's game. This miniaturisation of catastrophe has a clear bearing on the scale adopted for *Hell* and *Fucking Hell*. The late eighteenth century inaugurated a change in the meanings of history and youth but was also responsible for the manufacture and marketing of toy soldiers, which began to be mass-produced by the Paris-based firm Mignon, established in 1785. The French royal family had amassed quite a collection before it was destroyed by the Jacquerie.[6] Enthusiasm for the marshalling and manipulation of vast armies in miniature grew inexorably throughout the nineteenth century and the first half of the twentieth. These experiments with power were not always illusory, however. Wellington thought he had won Waterloo, until 1838, when Captain William Siborne created his diorama of the battle with no fewer than 90,000 lead soldiers, demonstrating that victory had only been secured with the aid of the Prussians. The Duke was furious, and Siborne's career was stalled permanently, but perceptions of Waterloo were revised accordingly. (Prussian victory in the Franco-Prussian War of the early 1870s was attributed directly to *Kriegsspiel*, the habit of wargaming with figurines on maps.)

Among the British, the scale of volunteering for the First World War (two and a half million in 1914–1915) was related to the ubiquity of toy soldiers, eleven million being sold by

6 'That furious insurrection of the common people in France called the Jacquerie', Edmund Burke, *An Appeal from the New to the Old Whigs* (1791)

British manufacturers alone in 1914. In Nazi Germany, it was common practice to give boys sets of tin soldiers as Christmas presents.[7] The hygienising of war through miniaturisation is a cultural phenomenon that reflects an important aspect of the Chapman brothers' decision to create a version of Hell with thousands of mass-produced figurines. The size of the installation is daunting, and the excessive crowding of the figures is disorientating, and yet the implicit invitation to inspect closely the details of individual scenes confers a feeling of dominance on the viewer. The generic figures discourage identification, encourage fantasies of torture and mutilation without feelings of guilt, since the scenario is plainly the product of make-believe; and yet the glibness with which the individual imagination invents varieties of suffering prompts reflection on the facility with which the Nazis ceased to regard their victims as human.

≈ JAWS

From the end of the eighteenth century, Hell was to lose much of its power in an increasingly agnostic era. But if a metaphysical underworld started to disappear from the conditions of knowledge, Goya showed that it had only one place to go: here and now. At the same time, there is an extremely medieval element in the Chapmans' iconography of Hell that has to do with an emphasis on incorporation and expulsion. The most familiar image of Hell in pre-Reformation Europe was of an enormous and all-encompassing mouth from which there was no escape. For the less prosperous members of the congregations in churches where such images

7 Ralph Thurlow, 'Under the Nazi Christmas Tree', *The New Republic* (25 December 1935)

were on show, there was a paradoxical gratification in the spectacle of Hell as egalitarian, indifferent to rank or privilege. In this respect, the idea that punishment in the afterlife centred on the maintenance of a system of ingestion and excretion – in the conversion of material into different forms of energy – bracketed the infernal with the carnivalesque, with the subversive imagining of a world in which the existing hierarchies were turned upside down. This was a possibility that could only be empowered by the activity of the carnivalesque body, which Mikhail Bakhtin characterised memorably as the 'devouring and devoured body', the body caught up in an appetitive cycle of flows and discharges, the body as a system that 'swallows the world and is itself swallowed by the world'.[8]

The plan of the Chapmans' installation makes it clear that the nine tableaux that comprise the shape of a swastika are also squints that allow a series of partial views of a closed system of energy conversion. The infernal ecology requires victims as fuel for the continued operation of the system; the rounding up and driving forward of the miniature Nazis is reminiscent of the activity of traditional devils with pitchforks, stoking the damned like solid fuel into a boiler. Once the bodies have been composted and decanted into silos, they can feed the greenhouse cultivation of skull-plants in a process of regeneration. The main departure from the tradition of the carnivalesque is indicated by the presence of a toxic waste pit. It is characteristic of the Chapmans's acerbic wit to observe that even Hell is post-industrial these days, that in a world where the endless engrossing and exhausting of materials has become toxic in both a moral and a chemical sense, that there are certain by-products too poisonous even for Hell itself.

But the main form of adherence to the traditional functions

8 Mikhail Bakhtin, *The Bakhtin Reader* (London: Edward Arnold, 1996) p.233

of the carnivalesque body is in terms of the tendency to de-individualise, in the concentration on bodily rhythms and processes that are held in common – not only with all classes of humanity, but also with other forms of animal existence. The Chapmans are at their most philosophically consistent when they are most mischievous, as they demonstrate with the inclusion of a landing craft powered by a cargo of farting pigs, truffling busily on human heads. And there is throughout the artists' career an extraordinary consistency in their representations of the human body. Their most celebrated and notorious hybridisations of the human figure, the 'zygotic' multiples with their profusion and confusion of gender characteristics, are grossly magnified versions of the traditionally conceived grotesque and carnivalesque figure; intensifying the desires, compulsions and physical exigencies of bodily existence, at the expense of any indication of how the body might be related to individual history, identity, personality.

≈ TOO MUCH IS NOWHERE NEAR ENOUGH

Fucking Hell is excessive: in its grand scale, its microscopic exactitude, its grisly ingenuity, its outrageous mixture of tones. But its most rampant form of excess is semantic; in its provision of an uncontrollable range of references and allusions to the visual languages of both high and popular culture, it resists any attempt to establish a hierarchy of meanings among its superfluous data. The most exquisite torments of Hell are reserved for the critics; whatever they say can be reversed, engulfed and eliminated. From the mountainous outcrops of Quattrocento painting, specifically the background to Andrea Mantegna's *Agony in the Garden*, to the McDonald's icon superimposed on the masonry

of a classical temple, the Chapmans run the gamut of available styles and contexts. There are the horror insignia of Hollywood's versions of evil: the ubiquitous skulls on poles from *Apocalypse Now*; the obscene tailoring with human skin from *The Silence of the Lambs*. There are the memory shards of definitive news footage: of the column of burned-out and abandoned vehicles on the road to Basra; of the cargo spillages of cumulative ecological disaster, the ever-growing numbers of oil drums drifting around the world's coastlines. There are the commercialised visions of endlessness and unstoppability: of the labyrinthine arrangements of stairs and platforms in the architectural trickery of M. C. Escher; of the always renewable threat of the skeletal warriors in *Jason and the Argonauts*.

There are also the repositories of mourning, sentiment and pathos: the sculptural friezes of the generic war memorial; the isolated figure of Anne Frank in her attic. And there are the classic scenographies of genocide: the mass graves; cattle trucks; Polish factory buildings. The inscription over the gate at Auschwitz, *'Arbeit Macht Frei'* ('Work Shall Set You Free') – a cruel misprising of Dante's inscription over the Hell-mouth, 'Abandon Hope All You Who Enter Here' – is here given an especially parodic twist in the postmodern lifestyle slogan 'Work Hard / Play Hard'. This vertiginous recessing of implications, colliding of portentous and playful tonalities, confusing of historical and mythical narratives, reproduces the ethical challenge of individual response to the corruption of the languages of value and judgement in postmodernity; in a global system whose governing vocabularies are those of economic consumption and of the consequent reduction of the vast array of differently coded versions of experience to interchangeable units. One size of interpretation fits all: Mantegna; Escher; Harryhausen. It is in the wide margin of difference between the carnivalesque and the postmodern body that the Chapmans screw around with our received methods

of viewing and reading the topographies of consumption, forcing us to experiment with our buried juvenile selves in imagining the world before we were forced to inherit it.

LESSNESS

The title of this exhibition *In the Realm of the Senseless*, alludes to Ōshima's film *Ai No Corrida* (translated as 'In the Realm of the Senses'), an erotic masterpiece that ends with a graphic portrayal of dismemberment. This act of violence is the curious outcome of complete mutual devotion on the part of two lovers. Their steadily increasing attachment during the period of time covered by the film converts their emotional and affective engrossment in one another into literal forms of physical engrossment. They feed off one another, in a way that binds them ever more closely together, not in the dreadfully isolating manner of those in the lowest circle of Dante's Hell. Ōshima's lovers are not in Hell, because their hunger for one another is redeemed by trust and self-sacrifice. The Chapman brothers' negation of this, and of the paroxysmic joy with which one lover is strangled and mutilated by the other, changes surprisingly little in Ōshima's visual world, but almost everything in his conceptual world. A narrative in which everything extraneous to desire gradually falls away, in which association with anyone other than the two lovers themselves becomes more and more irrelevant, in which the world is narrowed down to the interactions of two bodies, is paradoxically the ground of an enlargement, an expansion, an excess, of sensuality and of the value of existence. The Chapman brothers' revision of a small particle of language introduces in an abstract fashion the realisation of a lack, of a loss, of everything that has given meaning to that existence. Their Hell is quite precisely that of a surplus of bodies robbed

of all value, where all the interactions are alienating. Theirs is a Hell of less-ness.

Samuel Beckett's *Lessness* (translated from the French *Sans*) is a text that discloses a world of radically reduced agency, and of very few predicates. It is a language system that combines a limited number of elements in a set of minimal variations, suppressing the evidence of individual style, and stirring in to affect only with the use of cliché. Its abolition of conventional markers of place and time and of distinctions between the real and the imaginary, between sleeping and waking, proposes a condition that is trapped in an unknown dimension. The body is a 'block' with almost no vital signs, inhabited only by a desire for 'refuge'. The absence of rest or refuge, and the inefficacy of both cursing and blessing, suggest a state of exile from the afterlives of the Christian world view that is nonetheless dependent on them for its terms of reference. Beckett's state of less-ness offers a counterpoint to the senseless-ness of the Chapmans in its single-minded repetitiveness, but its overwhelming emphasis on solitude is the most salient aspect of its Hell for the 1970s, in dramatic contrast to the sheer tumult of the Chapman brothers' twenty-first century vision.

The Hell vitrines included in this exhibition comprise a diorama of overcrowding generically familiar from spectacles of combat, natural disaster and humanitarian crisis. These are all experiences that give an appalling focus, a traumatic unity of purpose to those caught up in them, but the decentred, disseminated, disarticulated character of the miscellaneous events trapped by chance within the frame of each vitrine correlates them more easily with the diffuse experience of the urban crowd, with its arbitrary assemblage of individual arrays of fixation and aimlessness. The progressive agglomeration of modern populations since the early nineteenth century reaches a point of uncontrollable excess, a surplus of individual trajectories that goes beyond the critical mass at which a civil

society gives way to blind competition: the Chapmans' Hell is nothing more nor less than an allegory of capitalism. Hell both predates capitalism and prepares for it, in its massive concentration of labour, its unbroken rhythm of production, and in its confining the operative to a single function. But it also shows, in a flash, the variety of routes taken to that single function. The medieval Hell caters to a wide spectrum of offenders, to a diversification of sin so energetic that it requires a bureaucratic genius to classify all the appropriate forms of discipline required in response. It is only with modernity that Hell ceases to individualise its punishments. It is only with capitalism that the individual becomes instrumental to a general system of production.

The figurines used in such vast numbers in all the Chapman brothers' Hell installations are of course themselves mass-produced, before being given individual details in the studio. The artists clearly relish the paradox involved in creating a spectacle of industrial slaughter with components produced by industrial means. The assembly line of horror owes its peculiar menace perhaps more to the routine character of the butchery portrayed than to its depravity. The limited repertoire of gestures employed in this butchery matches the limited repertoire of gestures required in its manufacture. But clearly the most alienating aspect of the installation has to do with its manipulation of scale. Miniature soldiers have been manufactured since the late eighteenth century, and were used during the nineteenth century not only to represent the troop dispositions on famous battlefields, but also to cater to a growing enthusiasm – especially in Prussia – for *Kriegsspiel*, the habit of wargaming with figurines on maps.

In the Chapman brothers' *Hell* installations, the size of the assemblage as a whole, and the sheer number of figurines involved, is intimidating, but the physical posture required to focus on the microscopic details of the individual

tableaux places the viewer in a situation of dominance. The achievement of close-up allows one to identify the targets of cruelty as Nazis; this satisfies a crude vengefulness but also allows an imaginative complicity with the situation of one who has victims at his disposal. The use of children's toys allows the viewer to indulge in fantasies of dismemberment and mutilation that are not going to lead anywhere, while at the same time forcing recognition of the facility with which such ghastly scenarios could be entered into, shared and perhaps even enacted, by almost anyone. The slippages are multiple, between childhood and adulthood, between fantasy and reality, between dominance and subjection, between art history and the history of brutality; most crucially, between tonalities, between the tones of play and pathos. The viewers who linger around the vitrines are fascinated by the sheer intricacies of torture, by the appalling craftsmanship of murder; by the same ingenuity of persecution that holds in its grip the connoisseur of horror film aesthetics; but we are all of us that kind of viewer. Our fascination with the endlessly slight variations on a basic model of subjection is undoubtedly libidinal; and yet it is that aspect of our fixation on atrocity that we dismiss as infantile. Perhaps the only adequate response to atrocity adjusts to precisely this mix of categories, this confusion of scales.

For the Chapman brothers, less means more. In place of the dying echoes of relations with others, of the mere residues of affect that are typical of Beckett's sterile afterlives, the Chapman brothers' hellscapes are overcharged with human presence, narrative incident and cultural memory. In their aesthetics of the intolerable, it is less the perversity of their nonconformism, than its totality, that gives most offence. The key to their devastating effectiveness is not obscenity, but information overload; not semantic exhaustion, but semantic proliferation. None of the actions performed in this scenario is

singular or isolated; each one concatenates with all the others; is constitutive of the whole; is caught up in a transfer of energy, in a self-regulating system that incorporates everything in its path. The Hell of the vitrines is a machine; a machine that is always in production, that is never switched off.

It comes as no surprise to learn that the so-called *Death Machines* were first thought up and assembled hastily as substitutes for the first version of *Hell* after this was destroyed in the Saatchi warehouse fire. The meticulous, insanely laborious craftsmanship of the vitrines was erased in their replacements by the signs of rapid improvisation, reckless patching, cobbling, and making-do, slapdash gestures towards a systematicity that is knowingly elided. The complete attention to every detail in the vitrines was exchanged for a defiant negligence, a deliberately careless resort to the sketchy, the provisional, the unfinished. What both installations had in common was an illogical faith in the mechanical: *Hell* represented an absurd and satirical extension of the modernist investment in technological progress; the *Death Machines* advertised their open revelling in the postmodern acceptance of failure in that endeavour, recognising the intrinsic obsolescence of every product of industrial development. Both works were made to pivot around couplings, linkages, conjunctions, that could also be thought of simultaneously as fractures, interruptions, disjunctions. These junction points were most disturbing when they amalgamated the organic and the inorganic, turning the human into a prosthesis of the inhuman, and vice versa. Body parts and machine parts were incorporated into the same mode of operation – both the organic and the inorganic apparatus had been dismantled and reassembled in the form of a hybrid.

The earliest version of this hybrid is found in the work of Goya, in the butchered tree whose mutilated limbs are supplemented by an assortment of human body parts. The Chapmans's altering and supplementing of Goya's etchings

The Disasters of War offers a sarcastic parallel to this grafting of alien matter onto a host organism. The art-machine both acknowledges and destroys its own makers, raiding and cannibalising the works of the past in a constant series of appropriations and deletions. The Chapmans transplant certain elements of Goya's art into the body of their own work, both extending and adapting it to new uses. Goya proposes such a contract in his fascination with the modern war machine, with its prosthetic relationship to modern forms of industry and economy. In the Chapman brothers' *Disasters of War*, the grotesquely altered physiologies of their sometimes realistic, sometimes cartoon-like figures do not refer directly to an identifiable historical episode, as Goya's do, but they do refer to the history of representing atrocity that has followed in the wake of Goya's example. They might remind us of the drawings and etchings of George Grosz, whose maimed and disabled veterans of the First World War are depicted with an horrific verve that anticipates the Chapmans' appetite for morbid inventiveness. Goya, Grosz and the Chapmans are part of the same art-machine, partly because all are responding to the same war machine.

The Chapmans' own version of this art-machine is run entirely on extraneous energy. Their work until now has existed only in collaboration. Each brother must respond to, adapt to, bargain with, endorse or undermine, supplement or subtract from, accept or reject, the contributions of the other. As creative partners, they are intimate aliens. Their work depends on a simultaneous convergence and divergence of individual fears and desires, fantasies and obsessions, that involves a constant bridging of fractures, an endlessly repeated attaching of borrowed tissue. It is a form of dependency always shadowed by lack, organised around the awareness always of being one too many, haunted by the possibility of being less.

THE INSCAPES OF TONY CRAGG

The work of Tony Cragg has made trial of a wide variety of styles and methods, but one of its most constant principles of organisation has been the use of assemblage to give body to a conception of form that derives ultimately from templates in both the natural and man-made worlds. The imagery that has inspired many of his sculptures might be thought of as fissile, pointing in both these directions at one and the same time, while the choice of materials used in their construction has often seemed contrary and even deliberately perverse. In the works of the 1980s, industrial debris provided a rich resource for piecing together the composite works that would manipulate the viewer's perception of the size and context appropriate to the iconography of everyday life. The map of Britain would be recreated on a scale that exceeded that of any normal map while drawing attention to its miniaturisation of the land mass it represented, as well as the arbitrariness of its orientation (Cragg would turn the island on its side). The subsequent career of the artist has ramified, time and again, the paradoxical relationship between form and substance, motif and material. An apparent taste for contradiction is rooted in a systematic determination to hold all the elements of object-making in a dialectical relationship.

The potential scope of this configuration is demonstrated in the key work *Secretions* (2001). As the title confirms, there is a suggestion of organic process in its composition, of growth by extrusion, of form emerging from the realisation of successive stages of development, each segment a distinctive variant

on the challenge to equilibrium mounted by the continuing energy of its movement into empty space.

It is difficult to take the measure of this work, which reads like a magnification of botanical or zoological growth whose form usually requires a microscope to be made legible. Its size does not belong in the visual world familiar to humanity, a world in which its precise response to the simultaneous pressures of weight, gravity and expansion reaches only as far as the edge of what we see. If you get right up close to certain kinds of lichen, this is the kind of intricacy of overlapping plates, funnels, lobes and ridges that comes into focus.

Cragg has monumentalised the miniature, making us realise the limitations of our vision, especially in a culture where the range of our inbuilt viewfinder is recalibrating to the distance between eye and screen, and where the eye is being trained to flatten its perceptions, rather than reach through the space around the perceptible with a curiosity that is now archaic.

The translation of organic form into sculptural form involves a change of scale in our perceptions, and also a metamorphosis in our understanding of the purpose of structure. The enlargement of a microcosm imprints a trace of its origin on our awareness, a subliminal recognition of its structural inevitability, but also moves it into a relationship with objects in the man-made world that are scaled up and down to fit into the scope of our requirements. In this context, the baffling ensemble of rings, cusps and lozenges that seems to have been prised away from an original context seems equally to have come adrift while en route to a new function, as a vessel or conduit, a mimic hydrant, or an eccentric form of cladding for some mysterious equipment whose precise usefulness has been defused and diverted into an alternative sphere, an experimental realm of systematic lopsidedness and parodic excess.

This outgrowth of the organic, caught in the process of mutation into a sign of the technological environment, has been fabricated with a granular appearance, articulated through the massing of hundreds of identically shaped components which on close inspection are revealed as dice. Dice are identical in shape but subject to a controlled variation in meaning, which depends entirely on a combinatory system associated with chance and with rhythmic action. Dice are meant to be put into motion; they involve a clustering together of elements precisely intended to fall apart. The array of numbers displayed by each throw of a set of dice proposes conformity to the laws of mathematics but also resistance to the idea of repetition.

Cragg has fixed his dice in place. What does it mean to arrest the motion for which these objects were created? It stabilises the numerical relations of adjacent dice, but does so on a giddying scale, surrounding each cube with dozens of others, rendering unmanageable and impossibly protracted the calculations that are usually accomplished so rapidly with a set of six. A game of dice is a game of chance, producing the merest illusion of control for those who gamble and win, and inducing a corresponding sense of loss of control in those who gamble and lose. In reality, the fall of the dice is random, unpredictable, without pattern, and yet we recruit it into our imaginative schemes. The moment of the wager epitomises the human attitude towards an environment whose dimensions we imagine in terms of our own capacities, although its reach surpasses our grasp in a range of different ways.

Dice is the earliest surviving form of gaming equipment, and its basic design has not altered since antiquity, only the material from which it is made. The synthetic dice in Cragg's sculpture references much of human history, and may echo prehistory, in its combination of bronze-age design and contemporary materials science. In its provision of the skin that forms around and defines the eponymous secretions of

the concept that inhabits the work, it suggests the extent to which human invention is ultimately and unconsciously at the service of principles of design that originate outside of its own conscious purposes and needs. Cragg's sculpture asks us to reconnect with the space in which it stands, by retraining our sensory intelligence and revising our awareness of our own place within a total environment.

It is in his drawings that he takes us further into that environment, into the internal spaces that are only alluded to by the surfaces of his sculptures, into a palimpsestic practice of making that seems to encode a landscape of different temporalities, and into a use of the line that sustains an illusion of continuous motion.

The *Woodscapes* of 2009, with their proliferating dendritic forms, demand to be interpreted simultaneously as both macroscopic and microscopic. From one point of view, they bear sufficient resemblance to an unforested, primeval woodland to be accommodated in our visual world, even though few of us have first-hand experience of such dense, hyperbolical tangle, giving rise to the suspicion that any resemblance to familiar kinds of tree growth is deceptive. If this intensity of competition for light and space is found anywhere on the surface of the planet it must be as part of an exceptional ecosystem that has emerged in extreme conditions. The impenetrability of the forest canopy, and the strange seamlessness with which the forest floor is covered with the same material that composes the vertical system of trunks, proposes the more likely reading of an internal landscape, a bodyscape; a reading made all the more likely by the severely restricted palette. Once our understanding of the drawing is adjusted to this very different scale, the evenly distributed system of ringed segments that permeates the entire composition is transformed into a complex arrangement of cells that are adapted to a variety of uses as trunks, roots,

branches, rhizomes, buttresses, stabilisers. Something that had lent itself to interpretation as an effect of stylisation begins to look like primary matter evolving a template for growth that is only reproduced and varied in the world perceptible to humanity. The carefully constructed ambivalence of Cragg's invitation to the viewer both feeds human presumption and exposes its inadequacy.

A slightly more sketchy equivalent to the system of linked cells that fills all the available space in the *Woodscape* drawings comprises the underwater banks and ridges that enter the imagination prompted by the title of *Seascape* 1, also dating from 2009. The effect of perspective that arises from the carefully graduated diminution in size of these cellular components encourages us further in our interpretation of the drawing as a fairly naturalistic representation of the seabed. But either overlying or underlying the plane on which these structures resembling coral reefs have been formed is another system of marks altogether that recalls the linear arrangement of linguistic or numerical ciphers. The pictorial plane seems to intersect with a textual alternative, or rather it competes with it, or ignores it, or illustrates it, or turns it into an extended caption. The relationship is unresolved and indecipherable. It suggests a dual use of the same sheet of paper, in the tradition of Renaissance drawings whose thrifty use of all the available space allowed for an aesthetic of disarticulation. The textual element remains gestural but implies the provision of information that cannot be conveyed by visual means alone. Perhaps it takes over where sensory perception leaves off, or vice versa. Its potential role as a supplement raises questions about the limits of perception and makes us wonder whether the pictorial plane is representing a landscape within or beyond normal limits – perhaps the simulated text is more like a translation of what the eye cannot detect: another miniature landscape under magnification.

Resonance 1, from the same year, 2009, is a clearly related exploration of the invisible effects of the laws of physics. Its title refers to the condition of bodies in space that vibrate when struck or impelled and which can have the effect of amplifying relatively small forces so that they become much larger. Cragg's drawing is not a diagram of an oscillating body but an expression of the idea of resonance in its depiction of the stress patterns that are generated in an object when it resounds. It resembles a translation into visual form of an audible phenomenon. What is compelling and vivid in the resulting artwork is its capture of the instantaneous transformation of the object through the communication of every part with the whole. Cragg achieves this effect through the tracing of a continuous line that appears to jump and crackle across its surface and volume with immediate effect.

The continuous line is a defining feature of Cragg's practice in the drawings of the last ten years. It can be used to imply both the acceleration and the retardation of movement and leaves the viewer with the illusion that drawing can approximate the effects of a time-based medium. The tracking of a movement in space that flows from one holding pattern to another, recording a series of slight deviations from each pattern to render the effect of tipping it backwards and forwards, echoes the complex eccentricities recorded on a photographic plate that has been subject to an especially long exposure. It also brings to mind the rigmarole of lines that inhabits a still taken from a film in which movements recorded in real time are played back at greatly increased speed. Just as Cragg is concerned to locate human perception in relation to the microscopic and macroscopic sublime, so also is he interested in measuring the rate at which the human mind processes the information relayed by its senses in relation to much quicker and much slower transfers of data. The reeling energy of a drawing such as *Untitled* (2009) seems partly to sum up the proportions of

two sculptural forms hovering between figurative and abstract, and partly to arrest the eccentric orbits of a constellation of particles held very unsteadily within the same magnetic field.

These charmed particles could be in the process of imploding inwards or exploding outwards, at a rate that only a drawing could hint at, while also inviting us to remember that the same principles of integration and disintegration can be found in the parallel worlds of both the microscopic and the macroscopic, and of both the unthinkably gradual and the unthinkably immediate. Cragg has always been fascinated by the seemingly infinite permutations on the same basic principles of organisation shared by a staggering variety of materials and tissues in an immense array of settings and habitats.

Some of the most recent sculptures seem to enact the imaginative movement between these separate but related conditions by hypothesising an embodiment of the inherent principles divorced from their familiar envelopes. These works, while they continue to share the motivation of earlier projects, are more elusive in form, less easy to assimilate, gravitating neither to the designs of known organisms, nor to their prosthetic equivalents in the man-made world. They are best understood in terms of the metamorphoses of the dream world, as the title of the large work in this exhibition, *Caught Dreaming* (2007), makes clear. The sculpture is dreaming an existence which revolves the conceptual frameworks we might use to stabilise its meanings while never coming to rest in any of them. Its striated appearance suggests that it must have behaved like rock to accumulate the folds and layers that give its overall form such a dynamic tension, while it simultaneously recalls the growth patterns of mycelium in an organism like bracket fungus, as well as the flexure and torsion of musculature, the contours of erosion effected by changing levels of running water, and the coagulation of heavier molecules in a chemical

solution. In profile it evokes the bristling alertness of a primeval beast. Its polyvalency grows out of its concentration in a form that suggests an original impulse in primary matter convulsed by a type of vital energy whose direction and outcome might be infinitely variable. It convinces us of the inevitability of its design and structure in response to this unignorable power surge. In many ways it encapsulates the evolution of Cragg's work into a sculptural condition that meets the requirements of Gerard Manley Hopkins's prescriptions for an authentic poetry corresponding to the design of all things that are given form by creative energy:

> There is one notable dead tree… the inscape markedly holding its most simple and beautiful oneness up from the ground through a graceful swerve below (I think) the spring of the branches up to the tops of the timber. I saw the inscape freshly, as if my mind were still growing, though with a companion the eye and the ear are for the most part shut and instress cannot come.

'Inscape' is a good term to describe the lines of force we see in the surfaces and shapes of Cragg's sculptures; and 'instress' offers us a good way to think about our renewed perception of the spaces that they inhabit, and that inhabit them; and us with them.

FEELING FOR TREMORS:
THE DRAWINGS OF JOHN GIBBONS

The Mayo drawings of John Gibbons were produced during a concentrated period of time and all in the same place. They carry no obvious markers of geographical or historical origin, but there is no doubt of their interrelatedness, of their breathing the same atmosphere. They are all under the pressure of a common creative principle; their abstract designs are multifarious, but this does not prevent them from seeming to integrate into a single vision of an overarching phenomenon. And there is something arrestingly compulsive about them, as if they are the graphs of an addiction, representations of drawing as an obsessive activity, driven and almost unwilled. One can just imagine the artist picking up the next sheet of paper in the moment of finishing with the last.

Many of the drawings also resemble windows or portals into a non-human world, of what the human eye cannot see without microscopic or telescopic enhancement, systems and networks that extend beyond what the human mind can grasp. Their multiple, simultaneous formations of shape and pattern seem to capture the stages of birth and growth of intelligent matter, of a process that combines unconscious prompting with intentional response. In their totality they comprise an atlas of the invisible and the unknown, a logbook of soundings for a submerged presence, which the artist responds to like a pilot, sensing the contours of an ever-changing environment.

The viewer, faced with an array of these drawings, has to tackle a sense of vertigo. There is typically no starting point

for the eye, and no resting place for it either, no vertical or horizontal hold, only a world of proliferating events that cannot be brought visually under control. And in many cases, there is more than one plane for the artist's mark-making, more than one layer of material, more than one event horizon. The resulting palimpsest is a history of different attempts to track the course of a persistent disturbance in the artist's field of awareness, the quiver or tremor that makes visible the inherent structure of what holds his attention. This exhibition of thirty drawings reads like a succession of waves that bring up to the surface a hidden intricacy; it functions like a seismic array whose object is not the detection of inimical force but of creative delirium: its improvised geometry is endlessly reformed and unlimited in range. And its feeling for tremors transfers into an art of exhilaration.

LIKE A HINGE
John Gibbons interviewed by Rod Mengham

RM: Although all your sculptures are very palpably worked, even wrestled and forced into a certain physical condition, they seem to be intended as containers or vehicles for something that cannot be seen, but which the viewer is given a sense of. Energy does not merely skid across their surfaces but seems to have been recruited in a tremendous effort of containment. Do you think of these works as somehow enclosing a source of power or energy?

JG: All living matter has energy and for me art engages with that energy in life – it is about that experience and where it takes you.

RM: The sculpture you are showing is one from the *Presence* series that has been emerging over the last couple of years. It seems very indicative to me that a sculpture very like this one was shown first in a religious context – in Winchester Cathedral in 2007 – since these brooding forms seem to carry associations with totemic objects giving a visual form to an unseen presence.

JG: Religions deal with the 'unknown' in our world – there is a sense of presence in particular places, people and objects that defy explanation – or perhaps we have problems engaging with this presence because it is not an everyday event or it makes demands on us that generate discomfort. I think making

sculpture for me is about rooting me in the physical world while acknowledging otherness. Buddhists talk of young and old souls – it makes a certain sense.

RM: There's a very paradoxical arrangement then, whereby strong physical presences, objects that are very emphatically taking up space, with their weight bearing down on the world, are the ones that can speak to us most eloquently about something that is disembodied. The sculptures in your *Angels* series are very similar in this respect – they defy gravity yet they are lumpy and seem to carry ballast; are both freighted and delicate, with armour plating round an imagined tincture of spirit

JG: Spirit has character, and is defined by its individuality – I do not understand why certain places have this power – you can spot them in the landscape whether at home or abroad – religious buildings deal with this aspect but you still need people to engage with it to bring it to life. I like the sense that sculpture is just about holding on to the ground – irrespective of how big or heavy they are.

RM: This is reminiscent of the way some of the early modernists spoke about their work. Is there any connection back to that way of thinking and working in your practice? Both the composition and the reception of the work involve being caught up in a set of dynamic relations that the surface of the steel preserves a record of, or perhaps a kind of musical score rather than a record, an encoding of the energy that the viewer can reactivate in some degree?

JG: All art has energy and life in it – that's how we connect with it irrespective of time or material – it is no different to a great piece of writing or music score – you have an experience through that engagement.

RM: Although you have used a variety of materials in the past, for many years now the majority of your sculptures have been made in steel. What is it about steel that has compelled you to use it so often? Why is it the best medium for the themes and preoccupations of your work?

JG: Steel is a very forgiving material, readily available, incredibly versatile and used throughout our living and working lives. I have been using stainless steel over the past ten years or so because I have a fascination for the light it generates – it has an extraordinary range, which I am still discovering. I like the way it is there and not there at the same time – changing with the light and as you move about it – like a cloud shadow moving across a landscape or a word on a mindscape.

RM: It also requires a great deal of effort and coordination of physical and cognitive and imaginative energies. You know when you've been using it! It engrosses your whole being in the process of creation in a way few materials can, I would imagine.

JG: I am still fascinated by the nature of the material in terms of where it takes me – discovering new ways of using it exposes other more buried places – observing how the material responds to being cut by a disc – falling away like a hinge – opens up another way of seeing – the sculpture will then demand a very different way of engaging with light which takes you somewhere else. There is work that is incubating – unknown to you – triggered by such observations. Experiences of life, opportunities, other art, be it sculpture, painting or music will equally expose and help to focus. When working you are completely connected, there are no boundaries – you are in a place where everything is connected – all part of a greater whole.

RM: That resonates with the evident connections that exist between your drawings – they all seem to integrate into a single vision of an overarching phenomenon. And there is something very compulsive about them, as if they are the graphs of an addiction, they represent drawing as an obsessive activity, unwilled and driven – they give one the impression that as soon as you have finished with one sheet of paper, you have to pick up the next.

JG: The drawings in this show were worked on as a whole by and large – they covered the studio walls and I was moving about working on whichever one gained my attention. Mostly, my drawing can be worked on over many years in very different locations.

RM: Many of the drawings were produced during residencies; continuous but limited periods of time in specific places. In what way or to what degree do they relate to the specific times and places of their composition?

JG: These particular drawings were made in Ballycastle, County Mayo on a fellowship at the Ballinglen Arts Foundation. This was the first time I had gone to make drawing in a studio – I usually draw when travelling, in hotel rooms, apartments, rented houses. This was very different – it was making new demands on me. One of the great advantages was the place itself and the landscapes and seascapes – as well as a cupboard filled with leftover inks, acrylic and oil paint, which was great fun to discover and play with. I brought a lot of different kinds of paper – some of which I had wanted to explore for some time. Occasionally, I can see references to the locations I have stayed in – it is not important for me to know this – no one place is isolated from all the other places you have been to.

RM: Many of the drawings also resemble maps of the non-human world, of what the human eye cannot sea without microscopic or telescopic enhancement, systems and networks that extend beyond what the human mind can grasp.

JG: I think the human mind sees a lot more than the eye – you need to listen through your eyes. The drawings filter into my sculptures over time – I become aware of this process but do not seek it out – it is better left to its own devices!

RM: There is typically no starting point for the eye, and no resting place for it either, no vertical or horizontal hold, only a world of multiple simultaneous events that cannot be brought visually under control.

JG: I am curious about the many levels we exist and are placed in – a short flight and you could be in the desert of North Africa or the Atlantic shore – how does that affect your perception?

RM: Has your work simply acquired more conceptual layers as you have built it up?

JG: Nothing exists without concept – I prefer to let things grown in their own way and listen for instructions.

MAINTAINING TRANSMISSION

The sculptures of John Gibbons amalgamate pieces of engineered steel but show the marks – innumerable marks – of sustained, intensive, purposeful work on the part of a single maker intent on steering all his resources towards the continuous refinement of a single, overriding project. This project is a shared endeavour and an inherited responsibility that Gibbons's work adumbrates both in its characteristic forms and dimensions and in the clues it offers in a series of elusive but suggestive titles. The titles act as confirmation that these ostensibly very contemporary works are also echoing and remodelling a set of ancient preoccupations, that they are extending the repertoire of ancient sculpture found not just in the Western tradition but in other traditions less easy to assimilate to our Western readings of sculptural form and function.

Two of the works exhibited in the show *The Messengers* (Hillsboro Fine Art, Dublin: 2018) bear the prefix 'temple' as part of their typically enigmatic descriptors. Gibbons's titles, even when very brief, tend to point in different directions, often including slashes and dashes to qualify or complicate the initial term. But 'temple' would not be out of place in relation to many of his works, since their forms often resemble architectural structures, even though their dimensions are adapted to those of the human form. During an installation of the sculpture *Untold* at Jesus College, Cambridge, in 2017, Gibbons selected a location within sight of a chapel tower to the north-east and a church spire to the south-east. Their combinations of horizontal nave and vertical tower structures

rhymed with the sculpture's own cage-like form that looked as if it could accommodate a single human body either lying down or, in the centre of the work, standing up. These correspondences enforced a recognition that Gibbons's work is more often than not concerned with the accommodation of the spiritual in a material world. The church, the chapel, the temple, are all structures built to contain our encoded transactions with the spiritual; the body is where the individual struggle to accommodate the spiritual begins and where it would end without the fabricated structures that result only from collaboration, from a sense of community built up only through time.

Gibbons's works are not about religion or creed, but about a broader and more fundamental apprehension of the spiritual that often affects us in ways that cannot be defined in any language. One of the sculptures in the show *The Messsengers* invokes the columns that form part of the 'temple' archetype in many cultures but disrupts the architectural scale that would involve by providing the columns with a base in the shape of a bell. Bells are used ritually across the world, they harness our thoughts of the spiritual to our daily routines, and they create a sense of community by drawing together those within earshot. They speak in no language except that of a wordless sense of belonging. And they speak to successive generations in the same place. After the French Revolution, many church bells were buried to save them from being melted down to make cannons. A generation later they were resurrected, as a very symbolic part of the general return to tradition. But the physical scale of Gibbons's work is that of a much more easily transportable artefact; it invites us to think of the handbells used in the itinerant days of the early church. The overall emphasis here is on the transfer, the transmission of messages; the tradition of message-bearing is the focus rather than the content of specific messages.

Both *Temple/Beginning* and *Messenger/Revelation* are vessels through which messages might pass, containing tube-like passages that suggest a connection with crossing from one state to another. The titles suggest this might form part of a spiritual progress, moving from ignorance to a state of enlightenment. But the passages are just lengths of steel tubing, that might have been used for any number of purposes. And this very foregrounded act of repurposing is a vivid reminder of the wholly material basis of many of the most revered artefacts entrusted with spiritual meaning by generations of believers. Gibbons's work implies a fascination with relics, physical objects touched by an association with the holy, but it is much more precisely focused on the power of art, on art's ability to conjure a belief in the sacred using purely physical resources. The most important tradition that his work taps into is belief in the power of art. The title of the show, *The Messengers,* brings associations with the transmission of the Word, the holy book, scripture. But in many faiths it is the spoken word of prophets, often speaking in obscure or riddling language, that is the basis of tradition. Or it might be the prophets themselves. The message takes many forms, and many of its most distinctive and memorable embodiments take the form of art and architecture. Many constructed objects have been endowed with a sacred power in their own right. The two works *Messenger/Announce* and *Messenger/Revelation* are given properties that are simultaneously architectural and corporeal – with dome-like features conceivably resembling breasts – while they also assume the dimensions and cryptic purposefulness of a portable shrine. The sculpture *She Moved /Her Hair* chosen to accompany these works is closely related in size and appearance although its title might suggest a secular alternative to the tendentious sacrality of the others. In relation to the human body and its forms and measures, this work suggests an incomplete upper torso, emphasising the

musculature of one shoulder in the act of turning. This is the part of the body that would be swept by a female head of hair. It provides an extraordinary counterpoint to the composure and meditative inwardness of the other works. The hair has been celebrated by countless poets and artists as a distinctive marker of beauty, especially in women, and yet it is the part of the body that is already dead. Gibbons's sculpture juxtaposes the evanescence of temporal beauty, whose distinctiveness has a lasting quality only in memory, with the enduring power of the spiritual. And yet the collective memory of the art-historical tradition contributes to and sustains what is individually the experience of a moment, proposing that the two traditions of sacred and profane art are in fact mutually confirming. The art-historical tradition is even more clearly invoked in the two panel works, where the rectangular shape that has distinguished the Western tradition of painting is both deployed and disrupted. *Panel / All Out* is positioned in a way that refuses a conventional presentation of the landscape or portrait format, being set on its edge in a way that is reminiscent of Malevich's radical gestures aimed at disturbing conventional settings in the Russian icon tradition. But the most radical gesture of all in Gibbons's work is signalled by the injunction *All Out* and its physical corollary. The phrase might remind readers of Beckett's novel *Murphy* of the cry of the park-keeper at closing time, a cry which is given metaphysical overtones, although in the present place, it refers in the first instance to the handle-like structure that sticks out from the surface of the work. It offers itself to the viewer not as a pictorial event but as an implicit invitation to grab hold of the metal bar that runs vertically above the surface of the work, as if it were a handle put there to tempt the viewer whose imagination is prone to turn the work round to suit a more conventional format. The second panel work, *Panel / Dancer*, seems to have been caught in the act of dancing with

the laws of magnetism, where the opposing forces of attraction and repulsion have been caught on the turn, at the point when the distribution of its parts is subject to either a centripetal or a centrifugal force. Both panel works share the insistence of the sculpture *She Moved / Her Hair* on the close observation of the laws of the physical universe as a basis for grasping the order underlying the apparent unruliness of the experience of the moment. The outer edges of *Panel /Dancer* are established by shards of metal arranged around the perimeter of the work to resemble a sunburst, at once an unpredictable phenomenon and an enduring symbol of the sacred. The messages of these works, like their titles, are hinged, or hyphenated; they point in two directions at once, and their power derives from maintaining that tension.

ANTONY GORMLEY: BODY COUNT

Yet though the choice of what is to be done
Remains with the alive, the rigid nation
Is supple still within the breathing one;
Its sentinels yet keep their sleepless station,
And every man in every generation,
Tossing in his dilemma on his bed,
Cries to the shadows of the noble dead.
— W. H. Auden, 'Letter to Lord Byron'

The story of modern archaeology is the story of impermanence. For every object buried with care, there are many others trapped by chance, around which shapes form; so that momentary events give rise to structure, fleetingness is frozen, and the accidental takes on the guise of the general, becoming a cultural symptom. As soon as treasure-seeking is overtaken by a desire for knowledge, the single-minded pursuit of grave goods is exchanged for a general impressibility, the evenly distributed, impartial attention of the map-maker and surveyor. At which point, what is most cherishable in the archaeological record is what nearly escaped it: the ephemeral, the ignorable, even the negligible. We feel closer to the past when we see what no one else saw, the acts of omission, displacement, or of failed recovery; and we feel closest of all when these acts have a bodily immediacy: in the mark of the maker's thumb on a still-drying tile, in a child's footprint on cement, in the body trying to catch its breath while it is buried in ash.

The early work of Antony Gormley, created during the decade after his graduation in Archaeology and Anthropology

from the University of Cambridge, is attuned to the paradox of the instantiated body. In sculptural installations such as *Mother's Pride* (1982) and *Bed* (1981), the body is absent as a solid object, and yet the work is wrapped around that absence. *Bed* refers in its title to an article of furniture in daily use, and yet its impression of two body shapes side by side suggests an artificial posture, a formal arrangement that recalls the composure of death, of two corpses that have been laid out. The bed-like shape becomes public, a plinth for display, rather than a place for intimacy and repose. The layers of sliced bread that comprise the sculpture echo the stratigraphy of an archaeological site, reminding us that the word 'bed' has a geological connotation, while the human-sized cavities resemble the outlines uncovered in the soil at archaeological excavations where human remains have decayed and disappeared. Gormley's sculpture makes humanity seem more fragile, its existence more evanescent, than a common foodstuff that is easily more biodegradable, and yet the spots of mould that begin to fleck the sculpture after a while are a reminder that different rates of decay are still reflections of the same organic process. The sculpture reverses expectations in several ways, being composed of bread that appears to eat humanity, rather than the other way round. As organic material, humanity never really disappears, but is simply converted into a different form, while as individual consciousness it seems to disappear in sleep and death. As collective consciousness, it survives in the encoding of rituals, customs and traditions, in a repertoire of activities that span the *rites de passage* of daily life and human longevity, from going to bed to going to our graves. Art intensifies that encoding, which Gormley highlights, magnifies and interrogates.

Another bread work, *Mother's Pride*, continues the dialogue with archaeology as the study of human traces. The outline of a single prone body is recorded in a single layer of tessellated

bread slices. On this occasion, the posture does not suggest deliberation, does not confirm our expectation of inherited and repeated gestures (what John Grierson, the pioneer of the British documentary film movement, referred to as 'actions worn smooth by time'), but seems to be the outcome of a chance event, capturing the experience of an isolated moment. Nevertheless, the body is hunched up, implying an awareness of fragility, of vulnerability through exposure; it seems to have obeyed an instinct for turning in on itself, in the search for warmth, protection, invisibility. The bare outline, the stencilling of the human form, recalls the iconography of a crime scene. The title refers not only to the brand name of one of Britain's major bread suppliers, but also to the familial status of the missing body, as somebody's son, the focus of all their hopes and cares. The forensic investigation that aims to reconstruct the sequence of events leading up to the crime employs many of the same techniques as archaeology, composing a narrative from circumstantial evidence. The mystery that is solved by detective work is structurally related to the puzzle that must be pieced together by the excavator. Gormley's interest in scientific procedures begins with their investment in story-telling, their emulation of artistic methods of interpreting the world.

The absent bodies of the early bread works are not exchanged for, or upgraded to, presences in the anthropomorphic forms of the early 1990s, since these are more often than not derived from body casts, which are solidified versions of absence. The main difference lies in the abandonment of the fictional body, which is paradoxically more individualised than its substitute, the replica of the authorial body, whose expressiveness is severely curtailed. The sarcophagus-like shape of *Instrument II* (1991), the hieratic pose of *Sovereign State* (1989–1990), and the *kouros*-like rigidity of the works in the *Learning to See* series (1993–1996) all invite comparison with the stylised restraint of ancient Egyptian and archaic Greek statues.

Both cultures are nominated by Wilhelm Worringer in his *Abstraction and Empathy* for the retraction of subjective experience in their art, for their avoidance of individualising characteristics. They represent a tendency towards abstraction in those traditions of thought which reject the attraction towards empathy, towards a romanticising identification with the primacy of the individual. In ancient art, this is part of the subordination of the human to the divine, while in Gormley's art, the de-emphasising of the realm of the subjective is not driven primarily by an acknowledgement of the sacred, despite his interest in meditation, breathing techniques, and heightened states of consciousness. The disciplined formality that marks much of his figurative work is part of its orientation towards the anthropological dimension of human experience; paradoxically, his extensive use of casts of his own body does not concentrate attention on features that are unique but on those that are typical. Any suggestion of portraiture is eradicated in the process of making generic statements about shared conditions. The unrepeatable nature of individual experience is displaced by the proliferation of casts of the same body, and by replications of the same pose in serial works like *Learning to See*. *Sovereign State* and *Instrument II* represent a further stage in the movement from figurative to abstract, although they are rooted in some of the oldest traditions of funerary art. The equivalent of the sarcophagus lid that once provided a canvas for the painter to reveal the identity of the deceased is left bare or wiped clean in these works, which focus on the means of achieving a seminal or umbilical connection with the bodies of others. The forms of joining that motivate and animate these works seem to conceive of cultural identity in both spatial and temporal terms, imagining a community in which the memory of traditions binds together the living and the dead, and in which sculpture provides a material basis and a generic template for the act of commemoration.

Although they stand alone, these single figures are grouped with others in the mind, as well as with the viewer, who brings to them a reciprocity of scale. This is one important effect of Gormley's structural allusions to the first known yardstick for monumental sculpture, the Egyptian cubit, which was derived from the proportions of the human body, referring specifically to the length of the forearm between the elbow and the tip of the middle finger. With the move away from the standard figure to the assembling of crowds of related figures in the *Field* works of the 1990s, Gormley cuts the link with the perception of the body as point of origin for the scale of significance we respond to most naturally. The various versions of *Field* all combine a contraction and expansion of scale: the individual components represent a dramatic miniaturisation of anthropomorphic elements, while the ramification of slight variants seems unmanageably extensive, and potentially endless. With the turn towards the figurine, Gormley is experimenting with the earliest known scale adopted for plastic art during the Palaeolithic, when carving and modelling related most closely to the range of activities of everyday life, to the practicalities of survival as well as to ritual observances, and was less specialised than it ever would be again. Taken individually, the small terracotta figures of the *Field* installations are clearly the products of artisanal practice, of the non-professional activities of a team of helpers whose lives are centred elsewhere. Their participation in these large-scale projects does not provide them with a medium for the expression of individual preoccupations, but binds them together, through a collaboration whose purpose is to assign an aesthetic value to their labour with its attention to material and design. Their production of a crowd is what transforms them into a community, for however short a period. It offers a secular parallel to the mobilisation of labour in the erection of the great religious earthworks of the Bronze Age, when the

creation of a monument like Silbury Hill, it is now supposed, did not have as its objective the use of a completed structure, but achieved its purpose in the consecration of labour to the process of building. All that remains of that experience and its duration has been homogenised in a single, massive barrow shape, unlike Gormley's assemblages which preserve the granularity of individual contributions. For the spectator, whose gaze is returned in a thousand pairs of eyes, there is a sense of being on the wrong side of that collaboration, excluded from its conditions of belonging and transplanted to a different experience of duration. At the same time, it is possible to grasp the economy of effort involved by focusing on single figurines. But which ones? To encounter these installations for the first time is to be overpowered by a sense of infinite regression, by the feeling that the relationship between the details of the work can never be grasped. There is no way of taking the measure of art that observes the principle of cellular multiplication when each cell of meaning is peculiar and incommensurable. It is not unreasonable to react to Gormley's *Field* projects in terms of a constant oscillation of scales: an initial focus on detail gives way to a perception of volume, and the viewer is soon caught up in the alternation of choice between small and large, between individual and crowd; always missing, and therefore always trying to locate, the intermediate term of community.

Perhaps the most unnerving aspect of the viewer's experience is that sense of being on the receiving end of something very remote from modern sensibilities: the concentrated pathos of a supplication, a mute appeal for intercession, that is usually directed towards an object of faith. The choreography of these installations touches the neutrality of individual figurines with a contagious sense of shared expectations: they are congregants, worshippers, cultic adherents, inhabitants of a world in which labour is equivalent to prayer in a system of obligations like that of the gift economies described by Marcel Mauss. Their

petitioning of the Western art-lover takes place within the institutional space of a gallery whose conception of value is influenced by the stress patterns of commerce and fashion, whether yielding or resistant to them. The confrontation is unsettling in its divination of the relations of power, and no less in the way its spatial arrangements articulate a present-day geography of answerability.

In the more recent *Event Horizon*, the field that is occupied by both viewer and sculptures is extended beyond the gallery into the surrounding urban environment. The relative equilibrium in the mutual regard of viewer and work (it is the visitor to the gallery who chooses when to break off) is exchanged for the protean uncertainties of immersion in the city, with its patterns and rhythms of circulation. Sustained contemplation within the gallery increases the viewer's confidence in being able to take the measure of the work, while the unpredictable disclosures of separate elements in *Event Horizon* – the viewer is repeatedly taken by surprise over the timing of these 'events' – has the reverse effect: the living relationship with the sculpture seems to consolidate its advantage over spectators, and not vice versa. Recourse to eidetic memory in order to build up a picture of the total installation can foster the suspicion that the key to the work lies beyond perceptual reach. The viewer's first awareness of each element is haunted by the way it approaches a model of pre-emptive surveillance, although the gathering host of onlookers has much in common with the company of angels in Wim Wenders's film *Wings of Desire*, transforming the conditions of oppressive surveillance into those of benign watchfulness: a utopian alternative to the everyday lines of force around which the city is organised when the sculpture is not there.

With the *Allotment* installations of the mid-1990s, Gormley adhered to the scale of his lifecasts, but introduced greater variation of size while simultaneously enhancing the tendency

towards abstraction – or at least towards a geometrical reduction of the proportional relations of the body. The resulting box-like shapes are swivelled in different directions, their straight-sided alignments emphasising the passivity and regimentation only hinted at in the orientation of the *Field* ensembles. There was something more organic about the dispositions of the terracotta figures, inclined towards the viewer as towards a source of light and heat, lumps of clay awaiting a breath of life, although there was a greater self-possessiveness about their rectangular successors. The title *Allotment* refers to the leasing of a small plot of ground within a patchwork of smallholdings, an area restricted to private use within a public scheme. The tension between private and public recaptures the mutual offsetting of individual and collective in the earlier work, and gives it a deliberately commonplace bearing, a context of mundanity. At the same time, the most obvious visual, as opposed to semantic, correlate for these works is supplied by the even greater density of individual plots in a graveyard. The verticality of the separate elements, the rigidity of the concrete with which they are constructed, and the simulation of family groupings, recalls an arrangement of headstones. And yet each component is more coffin-shaped than tablet-shaped, suggesting the imagined state of graveyards at the Last Judgement, with the dead standing rather than lying in their allotted places.

Within the context of Gormley's work as a whole, these modernist sarcophagi recall most strongly the singular *Room for the Great Australian Desert* (1989), which anticipates the two-tier structure used throughout the different versions of *Allotment*, although it is based, unlike the standing forms of the larger work, on the crouching body of the artist. The Australian room seems only just large enough to contain humanity, qualifying the status of habitation in relation to domestic space, and more generally to the idea of settlement.

In its true condition, humanity does not inhabit rooms, but an uncircumscribed environment, in which Western conceptions of property are irrelevant. Australian aboriginals do not think of their relationship to the land in terms of ownership, but in terms of guardianship. The individual body as habitation has no more value than any other container for a cultural legacy that is continually renewed in art and in song and that incorporates the living within the community of the dead. The containers of *Allotment* have alternative functions, like the replicated structures of Neolithic societies in which the houses of the living are identical in form to houses built for the dead.

In a certain sense, the exploration of these concerns in *Allotment* runs parallel to Heidegger's understanding of 'dwelling' as the most significant way in which humanity partakes of Being (a category of being larger than that of human existence). 'Dwelling' is the most fundamental way in which humanity takes the measure of its relationship to Being, and the most fundamental mode of 'dwelling' is in art. Heidegger specifies poetry as the 'measure-taking of all measure-taking' in his essay 'Poetically, Man Dwells', but the rigour and consistency with which Gormley's work has questioned the scope of measure-taking, habitation, and anthropocentric thought, while animating the relationship between them, proposes no less of a role for sculpture.

Perhaps the most compelling way in which these questions have been framed is in the different versions of the installation *Another Place* (1997). It is difficult to grasp the extent of these installations at any given time, since their visibility is subject to the diurnal rhythms of the tides. Temporal measures, of a kind over which humanity has no control, are of equal importance with the spatial intervals that dictate the viewer's sense of relation both to the life-size figures planted on the shore and to the vanishing point on the horizon that they are all turned towards. On a clear day, this makes the projected

measure of the installation identical to the threshold of the traditional sublime, where the capacities of the intellect and the senses reach a limit that only the imagination can cross. That threshold marks the limit of the anthropocentric world, whose representatives are not drowned by the sea but are made to collaborate with it, their immersion corresponding to the absorption of humanity within a larger category of being, whose temporal and spatial measures they periodically converge with and diverge from. The morphogenetic parallels offered by the diverse locations in which *Another Place* is situated (the title itself proposes other levels of displacement, tries to look beyond the horizon) evokes an awareness of shared or reciprocal conditions that cannot be apprehended directly. Gormley's work has expanded outwards, from the hollow vacated by the body, to the geographies and histories in which it is implicated, emptying out the meanings of individual experience and excavating layers that reveal the evidence of what E. P. Thompson used to call 'customs in common'. His archaeologies of perception have changed the sculptural landscape.

Antony Gormley's works in the exhibition *Ataxia II* (Galerie Thaddaeus Ropac, Salzburg, 2009) are clustered around the implications of the Greek word, which refers to an absence of order. It is a term used most frequently to identify a medical condition in which a loss of coordination is progressive and attributed to a dysfunction of the nervous system. Of all the major bodily systems, the nervous system is the most modern, the most recent to come to light, and the most difficult to control; in many respects it remains mysterious, beyond even imaginative reach.

From the beginning of his practice as a sculptor Gormley has maintained a curiosity about the power and limitations of scientific knowledge and a determination to synchronise and fuse innovation in the field of sculpture with cutting-edge research in several scientific fields, such as molecular biology, quantum mechanics and computer imaging. But the distinction of his work resides in the imaginative excess of its configuration of elements, its response to installation contexts, its juxtaposition of sculpture and the environment. It is partly his dependence on the advances of the scientific imagination that enables him to project his work beyond it.

Gormley's earliest deployments of the human figure preserved the barrier of the skin as the basis of its integrity, concentrating the attention on muscle and bone structure and diverting the viewer from consideration of other subcutaneous forms of organisation that are less precisely symmetrical and even somewhat rhizomatic in their relationship to formal

development. But even in those works that go literally under the skin, that seem to run the gamut of biological and chemical networks within the body, the resulting complex structures have mostly been contained within postures that allude unmistakeably to the architecture of the classical body.

Vitruvius is cited as the origin of conceptions of the body that relate its structure to geometrical forms and the classical orders of architecture. His treatise is the only surviving work of architectural theory from antiquity and is therefore the earliest possible source for correlative statements about the body and stereotypical form:

> Therefore, since nature has designed the human body so that its members are duly proportioned to the frame as a whole, it appears that the ancients had good reason for their rule, that in perfect buildings the different members must be in exact symmetrical relations to the whole general scheme. However, while transmitting to us the proper arrangements for buildings of all kinds, they were particularly careful to do so in the case of temples of the gods, buildings in which merits and faults usually last forever.[9]

Vitruvius not only attributes his principles of design to 'nature', he also gives them a temporal scope reaching into the distant past of the 'ancients' and the distant future of temples that must last forever. Sacred buildings must transcend human history (even if, in the Rome of Vitruvius, they are badly in need of repairs). The tradition that descends from Vitruvius through Alberti and Leonardo da Vinci – whose sketch of the human body contained within the forms of square and circle is perhaps the most widely disseminated of all images of humanity – has established the power over our imaginations

9 Vitruvius, *The Ten Books of Architecture*, translated by Morris Hicky Morgan (Oxford Univeristy Press, 1914) p.74

of representations of the body that emphasise the desirability of conforming to standard. The geometrical aspirations of the classical tradition in sculpture have been secured by depictions of the body that illustrate the mathematical ratios governing its equilibrium, its assimilation to the fundamental imperatives of balance and symmetry. And yet this fixing of an ideal form as the basis of the way the body is imagined has erected principles of uniformity that do not exist outside of the classical tradition. There is no uniformity of body type even within the species of *Homo sapiens*, let alone among related species whose extinction was guaranteed by the relationship between the proportions of the human body and questions of power and efficiency, not of aesthetics. Gormley's ongoing research into our constantly mutating understanding of the body has reached the point of both tactical and strategic resistance to the fetishising of order that has universalised a body type produced by the chances of history.

Even the Vitruvian moment that generated what became known ultimately as the universal body type was not the summation of a long tradition of thought but the immediate response to specific historical pressures. Recent scholarship has explored the extent of its debt to the requirements of power and efficiency in eliciting ideological conformity to the goals of Roman imperialism. Vitruvian theory did not crystallise the relationship between architecture and the body in general, but between architecture and the specific body of the Emperor Augustus himself. In this reading, architecture becomes the medium for rendering coherent the Roman presence throughout the known world; a policy of building everywhere according to the same principles is what persuades a variety of peoples with different cultures of the orderliness and rationality of the changes wrought in their lives; the fact that the uniformity imposed on their lives from without matches a uniformity found or imagined within, in the proportions of

the human body, reinforces the seeming inevitability of their assimilation to the empire; the knowledge that every building is intended to relate to the proportions of the emperor's body not only confirms the emperor's strength and dignity but encloses his subjects within the security of imperial space.[10]

This insertion of the Vitruvian body in its historical moment offers a prime example of the body's intimate relationship with macrostructural forms of power, and of the ways in which the body has always been used as a medium for ideological seduction. As Foucault has observed, power succeeds less by brute force than by smoothing the path of acceptance, by the 'simple fact that it doesn't only weigh on us as a force that says no, but that it traverses and produces things, it induces pleasure, forms of knowledge.'[11] It is precisely because art and architectonic form have converted the systematic demands of power into pleasurable forms of knowledge that they have acquired their own power to subvert those demands and produce irregularities in the system. Gormley's installations of groups of human figures, both within and beyond the gallery space, have comprised a spectrum of such irregularities.

They have disturbed the proportions of architectural space, often through supplementation, through the displacement of individual figures onto the roofs and walls of the building nominally the site of the installation. In the *Event Horizon* installations, the movement of the viewer through the built environment becomes a passage through irregularity, as sculptural figures emerge into view or disappear, creating an infinite variety of forms of imbalance. Within these contexts,

10 See Indra Kagis McEwen, *Vitruvius: Writing the Body of Architecture* (Cambridge, MA: MIT Press, 2003)

11 Michel Foucault, 'Truth and Power', in *Power/Knowledge. Selected Interviews and Other Writings*, 1972–1977, ed. Colin Gordon (New York: 1980) p.119

the repetition of the human form is not experienced as the duplication of stereotypes but as a phantasmal doubling, as individual figures advance and recede; uncanny presences and absences, embodied shadows, hesitations between identity and difference.

Within the rooms of the Villa Kast in Salzburg, Gormley's new sculptures represent a subtle but far-reaching interference in the force field of neoclassical space, in a building that both renews the relationship between classical design and imperial ambition and that contradicts it, since by an historical accident it is also the site of a failed assassination attempt on the Emperor Franz Joseph I. Both imperial and anti-imperial at once, this is a space that admits the historical nature of its relationship to time, and which renders its relationship to classical proportions uniquely vulnerable and circumscribed. With this building as their conceptual plinth, Gormley's sculptures are disproportioning presences, not merely in the way they reorganise its spatial relations, but also in relation to themselves and each other, since each figure captures a moment in the life of the body, a gesture or displacement activity that is precisely an expression of the human variable; the reverse of an ideal, the undoing of a stereotype. Gestures and symptomatic movements are minutely expressive of non-standard practice in the symbolic language of the body. Any given posture means different things at different times in different places, despite the powerful contraindication manufactured by the classical tradition.

The first ethnographical study of gesture was in fact an attempt to relate the bodily postures of ancient statuary, vase painting, mosaics and frescoes to the language of gesture employed in the Neapolitan streets of the early nineteenth century. But the real value of Andrea de Jorio's *La Mimica degli antichi investigata nel gestire napoletano* (1832) was its comprehensive inventory of the meanings of a repertoire

of gestures employed by a single community in a specific place and time.[12] It provided compelling evidence not of the stability and continuity of meaning through history, but of its transformation; of the constant change in conventions of meaning that affect the symbolic behaviour of the body as much as the forms of spoken and written language.

Gormley's figures are sculptural equivalents of this capture of meaning in flight. Disengaging from the classical endorsement of art that functions as a medium for permanence in a mutable world, he is now focusing on the creation of static figures that represent the fluid and unstable condition of all matter. The relationship between self-consciousness and body-consciousness can no longer be projected in terms of memory, coherence and regulation, but is forced to acknowledge a lack of coordination, an ataxia, between inherited ideas of the self as dependent on composure and consolidation and scientific observation of the perpetual transformation of the tissue to which the self is attached.

In one respect, these anomalous abstractions of organic process resemble individual case studies, reminding us perhaps of the freeze-frame moments of instability recorded by Eadweard Muybridge, or the taxonomy of expressions derived from the clinical records of Charcot. Muybridge has been shown to have engineered the fluidity of movement disclosed in his sequences of stills by editing individual images, while Charcot appears to have elicited the postures required to render more persuasive his theory of hysteria.[13] Both recruited an artistic medium in the name of scientific research,

12 Andrea de Jorio, *Gesture in Naples and Gesture in Classical Antiquity*, translated by Adam Kendon (Bloomington: Indiana University Press, 1991)
13 Georges Didi-Huberman, *The Invention of Hysteria: Charcot and the Photographic Iconography of the Salpêtrière*, translated by Alisa Hartz (Cambridge, MA: MIT Press, 2004)

subordinating the interests of both to personal obsession with a conceptual scheme. But Gormley's practice offers neither diagnosis nor illustration of a pet theory, but a series of propositions about the unknown, about possible ways of feeling in an environment where the communication between the body and the world is no longer based on the classical premise that art and science are commensurable in terms of mathematical proportions.

Among Gormley's latest works there are corporeal figures assembled from blocks of varying shapes and sizes that recall architectural elements, and block-works of an architectural character that correspond to the scale of the human body. They relate to one another unevenly and approximately in a way that might have been intended as a response to Robert Smithson's call for an architecture that aligns planning with chance: 'Architects tend to be idealists, and not dialecticians. I propose a dialectics of entropic change.'[14]

The idealising classical project based around forms of order that transcend history could only be maintained in a world of limitless territorial expansion. We are now inhabiting a world of territorial contraction, with more than half the global population living within an urban grid. The body-consciousness of the classical world cannot survive the abandonment of Vitruvian space, even though its twilit afterlife has shadowed our passage through the towns and cities of twentieth-century and early twenty-first-century Europe. The massive disequilibrium of urban growth in the Second and Third Worlds is incommensurable with our civic imaginings and with the individualising scope of most First

14 Robert Smithson, 'Entropy Made Visible', in *The Collected Writings*, ed. Jack Flam (Berkeley and Los Angeles: University of California Press, 1996)

World art. Sculpture presents a unique opportunity to place the viewer within zones of contact as well as within spaces for reflection, to move around representations of the body animated by entropic processes and contagious energies that affect, however inaccessibly, our own body-consciousness. Gormley's series of figures, encountered in sequence in separate rooms, creates a narrative of variables that requires its viewers to engage dialectically with their shifting sense patterns, tackling in the form of a constant improvisation, and in the space of a kind of architectural laboratory, a model of that entropic process in which our bodies, if not our minds, are already caught up.

Bodies are of course ensembles of different materials with more or less conductivity and subject to fluctuations of temperature. Sculpture cannot provide a match for the body's range of processes without turning itself into illustration, advancing anatomical knowledge at the expense of aesthetic experience. But in its use of material, a sculpture such as *Dublin Pose* can magnify on its surface the principles of transformation that pervade the body, the chemical reactions that produce rust functioning like bandages around the Invisible Man, converting into visibility a truth about corporeal existence that we could not otherwise access without translating it into the wrong terms, exchanging knowledge that we sense for knowledge that we merely hear or read about.

And the visual gymnastics of a work like *Feeling Material*, although controlled by its erratic circuiting around an absent body, is more eloquent about the thermally induced pressure that sent the lines of this three-dimensional drawing hurtling through space, than it is about the contours of the body that launched it. The turbulence of the casting process does not stop short of our awareness of these works. The process of annealment, which reforms the structure of metal by heating and cooling it in order to give the same material a different

temper, parallels the conceptual work of Gormley's sculpture which reforms the received image of the body in a way that prevents us from ever seeing it, or thinking about it, in quite the same way again.

At time of writing (in summer 2019), Britain was bracing itself for an invasion of millions of painted lady butterflies. This particular species migrates annually from Africa to the Arctic Circle in a journey that may take up to six generations of butterfly to complete. The idea that this migration narrative can be passed from one generation to another is beyond our grasp, even though we have included the life cycle of the butterfly within many of the stories we tell about our own development in many different parts of the world.

The butterfly paintings of Damien Hirst effect a considerable degree of alienation from these familiar stories, at the same time as they bring into focus a fascination that has deep roots in various cultures. In the history of painting in the Western tradition, the butterfly provides the crucial, most vivid example in the natural world of the transitory condition of mortal life, as well as the unique stimulus to the imagination provided by the phenomenon known by its Greek name – metamorphosis. The Greek word for the butterfly itself is actually *psyche*, which means 'soul'. The traditional belief was that butterflies were the souls of the departed. The Greek myth of Psyche and Eros, in which Psyche is the female object of desire for the god of love himself, was not written down before the Roman period – which is to say, if there was an earlier version, it has not survived. The earliest and most detailed account is provided in the central chapters of Apuleius's *The Golden Ass*, a book otherwise known as *Metamorphoses*. The central character, Lucius, is himself transformed into an ass while attempting

to change into a bird. The Psyche and Eros chapters form a story within a story, and describe the misfortunes of Psyche, a mortal whose beauty outshines even that of the goddess Aphrodite. Aphrodite's jealousy prompts her to instruct her son Eros to seduce, and ultimately to destroy, this mortal rival; but all too foreseeably, Eros falls in love with Psyche and tries to maintain a secret relationship with her. The subterfuge fails, prompting even greater anger on Aphrodite's part. Such is the peril in which Psyche stands that only the clemency of Jupiter can save her. Jupiter rewards the fidelity of the two lovers by allowing Psyche to metamorphose into an immortal.

In the classical tradition, then, the butterfly was identified with the soul, its physical beauty an indication of divine potential. Hirst's prolonged engagement with the cultural history of the butterfly has divided its attention between the sheer diversity of forms of beauty the species is capable of and the narrow margin it traces between physical frailty and symbolic power. In the Renaissance humanist tradition that renewed the links with classical culture, it is hardly surprising that the butterfly was taken as a kind of trace element of the spiritual in a fallen world and associated with the hand of the divine in the creation of material existence. The extraordinary inventiveness of evolution, as we would now think of it, visible in the design and chromatic variety of the butterfly's wings, conjures up a sense of the divine creator as primal artist – and specifically, as the world's first painter.

Dosso Dossi's painting *Jupiter, Mercury and Virtue*, usually dated to 1524, shows the father of the gods painting butterflies into existence. As soon as each butterfly is depicted and the artist's brush leaves the surface of the canvas, the painted creature takes flight into the world of three dimensions. There is a vivid recapitulation of this prodigious event in Hirst's 1991 project *In and Out of Time*, in which pupae attached to the canvases allow for butterflies to hatch from the surfaces of the

paintings and fly away. Since the butterfly is the emblem of the soul in classical culture, Dossi's painting – which is a product of the humanist court of Alfonso d'Este, Duke of Ferrara – is an allegory of the act of creation; and the constructive nature of the act is emphasised by contrast with the destructive potential of the thunderbolt that Jupiter has cast aside. But the act of painting is not the only thing that is taking place in this particular painting. Jupiter is so absorbed in the business of creation, he is unaware of the drama unfolding behind his back. Palette and brushes in hand, Jupiter is seated alongside the canvas, swivelling his upper body to the right in order to paint. Seated to his left, Mercury, messenger of the gods, swivels left in order to intercept a petitioner who is the female personification of Virtue. Mercury raises a forefinger to his lips in warning that Jupiter must not be disturbed, a gesture that unlocks the world of sound implicit in the scene: the rustle of Virtue's dress, her quickened breathing, the murmur of leaves in the trees as they bend before the wind, and perhaps the rumble of a storm as the sky darkens towards the left of the painting where a thunderbolt lies on the floor, ready to be used. But Jupiter has ears only for the faint crepitation of butterfly wings, whose delicate action is seen against a background of painted sky whose colour scheme is a perfect match for the real sky beyond it. It is almost as if Dossi's painting is intended as an illustration of the 'butterfly effect' proposed by Edward Lorenz in 1963. Once life is granted to an individual being, its independent actions may have far-reaching consequences whose effects are unforeseeable.

Virtue's petition to Jupiter is for protection against the depredations of Fortune. The claims of 'Virtu' and 'Fortuna' in the conduct of human affairs are debated in a series of works by the humanist Leon Battista Alberti, who received several commissions from the Ferrarese court. Although the individual is never immune to the unpredictable effects of 'Fortuna', the

self-reliance of the virtuous man is the best protection against these unforeseeable contingencies. Damien Hirst's mandala paintings are nothing if not attempts to exclude the fortuitous event, the random gesture, the spontaneous impulse. And yet a major aspect of the history of painting has been concerned precisely with the challenge of the accidental.

Among those artists who have been obsessed by the butterfly, both as aesthetic phenomenon and as object of scientific enquiry, is the novelist Vladimir Nabokov, whose work is drawn continually towards two kinds of exploration of the butterfly's potential for artistic enquiry: the first explores the parallels between the activity of the artist and the behaviour of butterflies themselves; and the second compares the behaviour of the artist with that of the lepidopterist. The first kind of exploration hinges on the concepts of metamorphosis and mimicry. Nabokov's own artistic identity is inseparable from his condition as émigré, as linguistic outcast, obliged to undergo a dramatic cultural transformation at the very outset of his literary career (he had to exchange his native Russian language for the English of his adopted country): 'After a period of panic and groping I managed to settle down rather comfortably but now I know what a caterpillar must feel on the rack of metamorphosis, in the straitjacket of the pupa.' Revealingly, the text in which the process of metamorphosis is most fully implicated is that of the autobiography, *Speak, Memory*, a species of composition that Nabokov himself characterises as 'this re-Englishing of a Russian re-version of what had been an English re-telling of Russian memories in the first place.'

The attention to mimicry is the outcome of similar pressures; Nabokov's obsession with mimetic phenomena in nature is driven by the conviction that animal camouflage is never the product of natural selection, never developed for the 'crude purpose of mere survival'. It is rather 'a form of magic, a game

of intricate enchantment and deception'. Forced to adapt to an alien environment, the exile takes on the colouring of his new surroundings, but seeks to translate this urgent necessity into terms of skill and mastery. This, finally, is what attracts the literary artist to the project of the lepidopterist, whose ultimate ambition is that of primal naming – he will only ever be truly happy 'in that incompletely named world in which at every step he names the nameless', achieving a condition that redeems the predicament of the exile, learning for the first time the foreign names for familiar things. If for Dosso Dossi the butterfly's wings display the artistry of the Creator, for Nabokov the discoveries of the lepidopterist extend the reach of the original Adamic language. Almost in an aside, Nabokov betrays his desire to control his environment, in a parenthetical admission of how drastically uncontrollable the world outside has become: 'I sort out in my mind my entomological discoveries: the exhausting labours; the changes I have introduced into systematics; the revolution – with bloody executions of colleagues – in the bright circle of the microscope'.

It was precisely the deaths and separations of the other kind of revolution, the Bolshevik Revolution, that engendered in this uprooted sensibility the need to transform valediction and isolation into the positive image of the solitary collector, parrying the moments of loss, the sense of bereavement, by voluntarily wandering off alone on his butterfly-hunting expeditions – even moving all the clocks in his house forward to advance the moment of departure, taking by surprise all those who might otherwise depart from him.

From origins to endings, introductions to valedictions, the butterfly has often signalled the most complex and ambiguous responses of art to the brevity of existence, to the march of time – triggering the imperative to gauge the intensity of the experience available to us. No painting deploys the image of the butterfly to more poignant effect than Gainsborough's double

portrait of his daughters, Margaret and Mary, *The Painter's Daughters Chasing a Butterfly* (1756). Here, the butterfly is seen exiting, stage left – it has nearly reached the edge of the canvas – while the younger of the two sisters leaps after it, and perhaps is only prevented from capturing it by her older sister's restraining hand. There is only a year between these two siblings, but the artist has condensed a range of different perceptions and attitudes into their contrasting responses to the same event. The butterfly is a cabbage white, celebrated by the poet Robert Graves for not having 'the art of flying straight'; yet for all its 'lurching' here and there, its journey through life is a proverbially brief one. The younger daughter, Margaret, seems mesmerised by the butterfly's flickering agility and strains after it impulsively, while the older girl Mary is visibly cautious, perhaps because she is afraid her sister might crush the fragile creature in her excitement, but also because she sees beyond it to the precariousness of infant existence during the mid-eighteenth century (her own older sister having died at the age of two). The sun is low down in the sky and shining full into the faces of these two girls before its light is extinguished altogether. Perhaps rather artificially, and therefore tellingly, darkness is already thickening in the surrounding foliage. These girls are still at a stage in life that precedes their metamorphosis into women. The butterfly is the pivot around which all of Gainsborough's hopes and fears for his daughters are made to turn. It symbolises both the bright, leaping appetite for life that is evident in the younger girl's springing into action, as well as the shadow of inexorably passing time that accompanies the older girl's reluctance. In hindsight, the painting has even greater poignancy with the knowledge that Margaret married unhappily while Mary succumbed to premature senility.

Gainsborough's painting is almost a match for Wordsworth's vignette in his 1802 poem 'To a Butterfly':

Oh! pleasant, pleasant were the days,
The time, when, in our childish plays,
My sister Emmeline and I
Together chased the butterfly!
A very hunter did I rush
Upon the prey:– with leaps and springs
I followed on from brake to bush;
But she, God love her, feared to brush
The dust from off its wings.

Wordsworth represents his childhood self as a hunter, in keeping with the gender conditioning of the day. But, in truth, the butterfly was less in danger as a form of prey, than as a prospective specimen. Wordsworth addresses it as 'Historian of my infancy', partly, one suspects, because the butterfly itself offers such a graphic instance of different stages in the growth of the self, but also because it prompts the poet to be his own historian, at a time when the discipline of History was still largely dependent on the art of narrative.

All of these stories from the Western tradition – Psyche and Eros; Jupiter, Mercury and Virtue; The Painter's Daughters Chasing a Butterfly; Wordsworth and his sister chasing a butterfly; Nabokov's metamorphosis from Russian to English writer – read from right to left; have a narrative logic; follow a temporal arc that points in one direction, even when this arc is the subject of recollection. Paradoxically, it is in the classificatory systems of the lepidopterist, and the methods of display developed out of them, that Hirst has found a release mechanism from this diachronic imperative.

Large numbers of Victorian butterfly display cases survive, and in many instances the layout is governed by aesthetic rather than scientific principles. There is a strong tendency towards visual symmetry with results that can only be described as pedagogically disorientating. The most impressive

of these arrangements are characterised by an excess of visual information and often bear a strong resemblance to the kinds of pattern created by the Rorschach inkblot test. Several of the Rorschach test cards look like drawings of elaborate butterflies. The earliest precursors of the Rorschach method, called klecksographs, were in circulation from the 1850s onwards.

If one contemplates the display cabinets of Victorian entomologists and lepidopterists, it is clear that taxonomic clarity is often sacrificed for the sake of visual impact. The scientific and educational imperatives that motivate and justify the acquisition of specimens are often superseded by a level of acquisitiveness bordering on the obsessive. The overcrowded Victorian museum may resemble a cross between the *Wunderkammer* and a country house assemblage of hunter's trophies.

Hirst is himself a connoisseur of Victorian lepidopterology, and many of his butterfly works include specimens taken directly from Victorian displays. But in Hirst's own poetics of display there is a very different aesthetic at work. The medical cabinets that withhold information about their contents display phials whose utility is made symbolic and whose pharmaceutical status is in close proximity to something like a religious aura. Science appears to inhabit the shrine of a tacit belief system whose narrative is no longer available.

In Hirst's intensely crowded entomology and mandala paintings, there is a radial organisation that resists any attempt to impose narrative. The eye may start anywhere and move in any direction; the perception of pattern is soon followed by the realisation that patterns are mirrored and ramified systematically. Although the number of routes it is possible for the eye to take is not inexhaustible, the effect is mentally extremely challenging. Our problem in viewing these works, is that we do not have a compound eye. The butterfly does,

and this gives it an unusually wide angle of vision – it sees everything as if it were a mosaic. One suspects that Hirst has chosen his method of composition and arrangement in order to reflect the visual priorities of the butterfly itself.

There is an extraordinary rigour involved in Hirst's choice of names for the constituent parts of his major projects. In the present instance, the discursive variety reflected in the choice of terms such as *Radial Balance, Dromenon, Noble Path*, which seem to point in very different directions (architecture; epistemology; Buddhism) is ultimately subsumed in a common indexicality – each term is associated with a mandala-like pattern, whether this be articulated pictorially, architecturally or conceptually.

In eastern religious traditions, the mandala has been taken as emblematic of the cosmos, and associated with meditation practices focused on the transformation of the self. However, Hirst's mandala paintings tend to utilise the wings of butterflies once these have been detached from the body of the insect. The evidence of body parts that recall earlier stages of growth in the development of the butterfly have been literally excised. These works are powerfully perverse in their occlusion of the transformation narrative, and in their insistence on the beauty made possible only by death. Hirst's practice is thus a logical extension of Van Gogh's during his period of incarceration in the Saint-Paul de Mausole asylum in Provence, when he was limited in his choice of subject matter to what he could see around him in the hospital grounds. During 1889 and 1890 he painted several studies of butterflies and moths, including the remarkable *Great Peacock Moth*, featuring the largest of European moths. Given that his period of residence at the asylum was intended as a prelude to the transformation of his mental health, it is rather grimly ironic that in order to paint his specimen of the great peacock moth, Van Gogh had first to kill it.

Hirst's prolonged exploration of the life cycle of the butterfly, its spectacular visual appeal, the mythological and cultural formations it has inspired, and the variety of forms of response it has provoked in both artists and scientists, is one of the most thoroughgoing and many-sided conceptual projects sustained by any contemporary artist. And during the course of its working out, his fascination with nature's most artful creation has become our own.

ILYA AND EMILIA KABAKOV:
AGENTS AND PATIENTS

Dostoevsky offers a diagnosis of the Russian dreamer in his early text 'White Nights' (1848). His narrator is a character whose imaginary interactions with other people have long since compensated for a social reality of total isolation:

> The dreamer – if a precise definition is required – is not a person, but a sort of genderless creature. He usually prefers to settle in some inaccessible spot, as if to hide from the very daylight, and once he has taken up residence, he grows attached to it like a snail, or at least like that amusing creature which is both animal and house, and is called a tortoise.[15]
>
> He desires nothing, because he is above desire, he has everything because he has surfeited, because he is the artist of his own life and creates it for himself by the hour as the mood takes him.[16]

The overproductiveness of fantasy in confinement, the underlying desire for withdrawal and secretion, are symptoms of a Dostoevskian malaise, but they are equally rife among the numerous fictional characters devised by Ilya and Emilia Kabakov. A particularly striking parallel can be drawn between the nineteenth-century recluse and the protagonist of the installation *In the Closet*, initially devised for inclusion

15 Fyodor Dostoevsky, *A Gentle Creature and Other Stories*, translated by Alan Myers (Oxford: World's Classics, 1995) p.17
16 Ibid, pp.22–3

in *The Palace of Projects* (1998). The dweller in the closet equips himself with shelves, utensils, books, lighting, and even a bed, despite the tortoiseshell-scale of his bizarre habitat. Kabakov's analysis of the dreamer's motivation assumes a failure of nerve virtually identical to that of his literary antecedent:

> the person who has settled into the closet has hidden precisely from such curious people as the viewer, he has fled from that life in which all of us are submerged from morning until night, he wants to disappear, to hide from the hustle and bustle and noise of the corridor which we are walking along. He would like to attain solitude or peace – but his peace and solitude are doomed, since anyone can peer into his life[17]

What Kabakov makes explicit is the discomfort, the embarrassment, of the viewer or reader, that is implicit in Dostoevsky's text. The anxiety with which the threshold between private and public is negotiated is focused on the narrator in Dostoevsky's text, whereas it is at the centre of the viewer's experience in her or his encounter with Kabakov's installation. Joseph Bakshtein formulates the claim that Kabakov's miniaturisation of domestic space in several of his works provides 'the central metaphor for life in the Soviet Union'.[18] But attention to point of view suggests otherwise. The dreamer's fundamental division of purpose – wanting to eavesdrop on other people's lives but not take part in those lives, needing to feel he is at the hub of everyday affairs while remaining invisible to passers-by – seems to qualify as a constant factor in Russian culture of the last two centuries. Both Dostoevsky's and Kabakov's dreamers inhabit a cultural

17 Ilya and Emilia Kabakov, *Catalogue Raisonné of Installations* (Düsseldorf: Richter Verlag, 2003) Vol. 2, p. 237
18 Ibid, p.239

formation that began to take shape after the failed insurrection of December, 1825. This was a crucial turning point in Russian history that encouraged the authorities in their cultivation of a secret state, enhancing the repressive powers of the police and driving intellectual dissent into hiding. The Soviet Union did not invent the conditions in which artistic culture was forced underground, it merely accentuated and refined them, and in the process lent a special poignancy to the forging of a utopian politics, to the social anthropology of dreams.

The now immense oeuvre of Ilya and Emilia Kabakov revolves around the paradox of a culture whose degradation, both moral and material, often seemed to relate inversely to the grandiose ambitions of its five-year plans and other impossible projects. Early Soviet art was often naively complicit with this disproportion: *Fulfil the First Five-Year Plan in Four Years* is the title of one work by Varvara Stepanova now on display in the Museum of Modern Art in New York. The Kabakovs' extraordinary labour of commemoration and interpretation is fuelled by the now strange candour of those archaic desires, and by their subsequent alienation; by the energising fallacies not just of individual sensibilities, but of an entire political ecosystem. They tap into a reservoir of dreams that were the myths of at least three generations.

Dreaming was literally and conceptually at the centre of the Kabakovs' design for their installation at the Serpentine Gallery in 2005. Beneath a dome-like structure, a radial plan featured several divans inclined on pedestals that encouraged the viewer to imagine a ritualised form of sleep. The circular structure brought to mind an observatory, while the elevated beds also resembled sarcophagi. The top of each pedestal was reached through an underlying chamber in which a magic lantern show was projected above a bed that resembled a hospital cot. Above and facing outwards was a form of sleep in the universal with evocations of the dreams of the dead.

Below and facing inwards were the manifestations of delusion, medicalised, narcotised and maybe pathological. What was remarkable about the design of this project was its close similarity to an earlier conception that seemed antithetical to the desire for repose and sublimation but that also tried to adjudicate between the dreams of the individual and the conformations of a group identity.

In a certain sense, this earlier construction was a foundational work, since it attempted to give spatial expression to the ensemble of artistic and intellectual collaborations developed over a number of years by the group of conceptual artists that Kabakov belonged to in Moscow. In Bakhtinian terms, this installation, *NOMA or the Moscow Conceptual Circle* (1993) gave plasticity to the idea of the 'chronotope'.[19] *NOMA* anticipated the circular arrangements beneath a dome that governed the layout of *The House of Dreams*. And it attributed to this design a religious aura that seems more naturally intrinsic to the later work: the viewer was supposed to receive the impression of 'some sort of secret, ritualistic place, a departure site of some sort of cult'.[20] There was more conceptual agitation in the earlier work, which substituted the buzz of language for the silence of repose; it installed a team of 'chatterers' rather than the company of sleepers and dreamers invited to take their ease. Despite this contrast, both

19 'In the literary artistic chronotope, spatial and temporal indicators are fused into one carefully thought-out, concrete whole. Time, as it were, thickens, takes on flesh, becomes artistically visible; likewise, space becomes charged and responsive to the movements of time, plot and history. This intersection of axes and fusion of indicators characterizes the artistic chronotope.' Mikhail Bakhtin, 'Forms of time and of the chronotope in the novel', in *The Dialogic Imagination*, translated by Caryl Emerson and Michael Holquist (Austin: University of Texas, 1981) p.84

20 *Catalogue Raisonné*, Vol.1, p.487

projects conceived of their dramatis personae as patients of a kind: in the earlier, more volatile work, the participants figured as 'highly flammable material, a certain quantity of neurotics with... the ability to articulate their own neuroses'.[21] Kabakov clearly regarded the interaction of the different members of the group as the key to their being 'cured'. The establishment of a dynamic network of communication prevents knowledge from becoming coagulated, whether as individual idée fixe or as collective ideology.

'Incessant chatter' must be held in tension with 'incessant introversion'. The installation featured a range of texts that provided descriptions not only of 'external' but of 'internal' circumstances; of both communal and subjective realities. Interestingly, Kabakov quite deliberately used Bakhtinian terminology in mapping the lines of force that converge and diverge in the transactions of the group. The radial plan divides up the circular structure into a series of booths, with each booth predicated as an 'entirely closed world of subjectivism'. The risk of this introspection is 'monologism': 'the individual monologic speech act in this scheme is to a great degree doomed to reflect a fiction engendered by "large" collective formations'; whereas, a 'small local circle built on the basis of the individuation of its participants [is] capable of undermining and repudiating the integrity of communal speech... through a system of dialogic' interventions.[22] The politics of the nucleated group, the activity of the avant-garde, is judged to be the most effective subversion of the monomania of the individual dreamer on the one hand, and of the monolithic ideology of the state on the other.

Revealingly, Kabakov names the Decembrists as precursors to the Moscow conceptualists, evoking the legacy of 1825 as

21 Ibid
22 Ibid, p.489

a pretext for actively contesting the circulation of stereotypes. In a number of other installations that hinge on their allusion to official definitions of mental health, in a culture where psychiatry was employed as an agent of social discipline, the 'patients' are often absent, often projected, imaginary receptors for different kinds of treatment. Hospital beds abound in the Kabakovian output; most conspicuously in *Treatment with Memories* (1997), where the 'treatment procedure' bears comparison with that of the *House of Dreams*. The treatment involves the display of slides containing biographical material. Each slide show divulges an individual history, its details unrepeatable. However, the soothing rhythm of the eleven-second intervals between slide changes tends to narcotise the mood of the patient, who is also aware of the synchronisation of his or her reception of the visual information with that of relatives who have come to visit. Their joint attention is both assimilated and disturbed by the point of view of the visitor to the installation, who becomes progressively absorbed by the individual narratives. As with many of these thematically grouped installations, a very fine line is drawn between evidence of communication and of self-communing. There are further vivid parallels between the new work and *Children's Hospital* (1998), where the slide-show element is supplied by a series of customised miniature music theatres, where each theatre is so angled as to be visible and audible equally to patient and visitor.

But perhaps the most resonant correlation is with the *Universal System for Depicting Everything*, shown at the Göppingen Kunsthalle in 2002.[23] There, the place of the magic lantern show was taken by the separated pages of various albums displayed on the four walls of a large hall, in

23 Ilya Kabakov, *A Universal System for Depicting Everything* (Düsseldorf: Richter Verlag, 2002)

the centre of which sat two objects: a glass pyramid and a hospital bed. These objects and their forms recall many similar constructions in the history of Kabakov's oeuvre. The pyramid evokes the towers, monuments and architectural blueprints of the early Soviet era, and especially the Tower of Babel-like structure of the *Palace of Projects* seen in London at the Roundhouse in 1998. This great upward spiral, like the dome in *The House of Dreams*, epitomises the ultimate ambition of sharing in the universal, perhaps in the totally comprehensive scope of a divine point of view, while its failure announces the descent into a history of incomprehension, the loss of a universal language, the language of a dream. Kabakov holds its flawed grandeur in a permanent tension with the implications of the hospital bed, suggesting that the obsessive attention to detail in the pursuit of his projects is a form of insanity, nothing more nor less than the paranoid delusions of a mental patient.

The albums comprise an attempt to represent in two dimensions the idea of a system for depicting objects in four-dimensional space. Theoretically, this would involve representing spatial relations from all sides at once, and temporal relations from all points in time simultaneously.[24] In practical terms, what the viewer gets is a series of beguiling images subject to the systematic distortions of elongation and compression, of amplification and shrinkage, resembling the condensations and displacements of the dream-work. The images are decipherable, just. They are unmistakeably drawn from the same image bank as Kabakov's other evocations of a relatively early period in Soviet history, mixing innocence and idealism with the first inklings of a future that should never

24 Compare Bakhtin: 'What counts for us is that [the chronotope] expresses the inseparability of space and time (time as the fourth dimension of space).' *The Dialogic Imagination*, p.84

have happened.

According to the commentary to *Album no. IX*, the most comprehensible form taken by the fourth dimension is evident in the deformations of real space that are occasioned by our desires. In this respect, perhaps the entirety of Kabakov's oeuvre should be thought of as four-dimensional, given the intensity of its focus on the living spaces of Soviet culture, spaces that are obsessively reimagined, reworked, reconfigured. The irony embodied in the *Universal System* is that its constant demand for the abandonment of a unified point of view, of monologism, its insistence on the dialogic migration of points of view and objects, both in time and space, is precisely what is achieved in the experience of installation art. Kabakov's installations are the logical outcome of a social and political history in which the citizen as viewer is turned into patient rather than agent, is overpowered by a lack of choice, by a perspective that leaves hidden or invisible the real space of desire, a space that can only be visited in dreams.

FROSTWORKS

Ilya Kabakov's series of paintings entitled *Under the Snow* has also attracted the alternative titles of *The Thaw* and *Through the Clouds*. All three versions speak both to important aspects of the works themselves and to the cultural history they spring from. The symbolic properties of snow, the thaw, and clouds, have been intertwined in Russian art and literature of the last two centuries. Kabakov's early twenty-first century summation of these themes is distilling a mixture drawn from various sources.

≈ SNOW

Perhaps the most well-known Russian painting on the subject of thawing out is Fyodor Vasilyev's 1871 canvas, now in the State Russian Museum in St Petersburg. This famous image captures the ambivalence of the moment when the snow starts to melt in Russia. Vasilyev's canvas shows two diminutive travellers on foot, pausing to contemplate a stream of meltwater crossing the road they are following. Humanity is dwarfed in this image by the huge cloud-laden sky, and by a sense of the seemingly infinite extension of the Russian landscape: a vast emptiness to which people make little difference. The indomitable scale of the landscape conveys the very idea of Russia as resistant to management and change, while the loosening of ice and snow with warmer temperatures, while it promises spring, also turns everything to mud and makes

journeying even harder than before.

In cultural-political terms, the most significant historical episode associated with the concept of the thaw was the brief period after the death of Stalin, when a liberalisation of the conditions affecting publication and discussion allowed for a greater freedom of expression in all the arts between 1954 and 1957. The most obvious single catalyst for this shift was the novel entitled *The Thaw*, by the controversial Ilya Ehrenburg. The novel consists almost entirely of interior monologues by a variety of characters demonstrating the pervasiveness of totalitarian control even of the imaginations of ordinary Russians, inhibited from following their own desires or from resisting their fears. As the narrative draws towards a close, there are signs of a change of attitude among several of the characters, a growing sense of individual purpose, timed to coincide with the turn of the season from winter to spring, and the beginning of a universal thaw.

It is in the nature of Russian history that such thaws are brief; certainly, the relaxation of controls in the mid-1950s was not sufficient to allow for the publication of Pasternak's *Dr Zhivago*. This novel incorporates a collection of poems by Pasternak's character Zhivago, many of which indicate a time and place of composition in the snowbound location Varykino. As A. K. Zholkovsky has shown, Pasternak's own verse is dominated by images of windows, literal thresholds through which the observer contemplates the outside world, and metaphorical thresholds through which he views the inner world of memory.[25] Zhivago's poems accentuate this tendency – as snow accumulates on the windowsills, writing becomes a means of constructing windows into the past and future, as the

25 A. K. Zholkovsky, 'The Window in the Poetic World of Boris Pasternak', *New Literary History*, Vol. 9, No. 2, Soviet Semiotics and Criticism (Winter, 1978) pp.279–314

protagonist agonises over his personal and political choices. The parallels of situation and mood with Kabakov's paintings are highly suggestive.

≈ CLOUDS

As one of Kabakov's three titles for the series suggests, the paintings can be viewed as curious aerial arrangements of images glimpsed through cloud cover. They offer fragments of scenes, some of which can be grasped readily, while others are baffling in their incompleteness. These apertures in the sky suggest the link between picture-making and the construction of windows that is as old as the tradition of icon painting, habitually referred to in Russian culture as the creation of 'windows into heaven'. Movement upwards is a desirable goal in many of Kabakov's works, and in fact the vertical axis is an organising tension in much of the oeuvre, especially in those projects that imply the capacity for angelic flight, or that imagine a paradisal realm in the upper atmosphere of even the most confined spaces. The architectural designs of the *Palace of Projects* and of *The Utopian City* prioritise tapering and spiralling shapes with a strong emphasis on elevation. However, the launching upwards of the imagination quite precisely reflects those aspects of the work concerned with social and spiritual dreams and desires, a secular equivalent to the religious icon's invitation to awareness of a higher state, while Kabakov's images in the paintings under review suggest rather a bird's-eye view of terrestrial scenes glimpsed from time to time through mountain ranges of vapour.

In this, they are quite uncannily reminiscent of certain key scenes in Tarkovsky's film *Solaris*, where the alien planet is seen through an enveloping blanket of swirling clouds. The clouds part from time to time to disclose an image that projects the

desires and fears of the exiled cosmonauts. Kabakov's work has shown a fascination with the unique perspective of the cosmonaut from an early stage. Perhaps the most widely exhibited installation from his Moscow years was *The Man Who Flew Into Space From His Apartment* (1985), a work whose playful, humorous title suggests a whimsical attitude towards this particular version of the journey to Heaven. However, there is nothing more serious than his recognition of the deep psychological need for such fantasies and of the damage effected by their curtailment. In *Solaris*, the materialisation of the cosmonauts' most deep-seated anxieties and longings produces a violent reaction; but each attempt to destroy or repress these manifestations increases the stubbornness with which they resurface. The plastic, material form they assume gives them a purchase on reality outside the mind, just as Kabakov's images seem to be projected from more than one imagination. If they are the products of illusion, this is a shared illusion.

Remarkably, the one reproduction of a canonical painting in the library of the space station orbiting Solaris depicts a landscape under snow, Pieter Bruegel the Elder's *Hunters in the Snow*. The painting actually turns its back on the wilderness, following the hunters as they return to their community, back to warmth, food, recreation. Although the snow-covered background reaches into the far distance, it does not diminish the activities of the tiny human figures seen from high above, but gives their bustling interaction a greater vitality by contrast. The poignancy of its presence on the spacecraft and in the film is in its insistence on homecoming, its celebration of the familiar, its desire for the rituals of togetherness. In Kabakov's sequence there is a similar counterpointing between myths of solidarity, half-remembered, half-manufactured, and an agonising sense of exclusion that is the cost of nonconformism, resistance, exile.

In his essay for the catalogue *7 Ausstellungen Eines Bildes* (Kasseler Kunstverein, 1990), Boris Groys attributes the nature of Kabakov's investment in whiteness to the influence of Kazimir Malevich. Malevich's output includes a number of signature works largely or wholly devoted to the exploration of whiteness; the most well-known of these is *White on White* (1918), now in the Museum of Modern Art, New York. Although this painting shows a superficial allegiance to a modernist emphasis on abstraction, impersonality, rational form, the geometry is fallible and the brushwork hints at the personal preferences of an individual artist. Malevich's theory of Suprematism makes clear his intention to represent states of feeling with an unprecedented intensity, rejecting the available forms of nature as incapable of bearing the impress of pure subjectivity. His interest in aerial photography stems from its ability to present the familiar from a defamiliarising viewpoint. In *Non-Objective Art and Suprematism* (1919), he speaks in terms that immediately evoke the trajectory of Kabakov's experimentation: 'I have ripped through the blue lampshade of the constraints of colour. I have come out into the white. Follow me, comrade aviators. Swim into the abyss.' Still more, in a letter of 1916, he insists on the necessity for the artistic imagination to become airborne: 'My new painting does not pertain to the earth alone. The earth has been abandoned like a termite-ridden house. And man really does consciously seek space, he longs to break loose from the earth.' There is no doubt that Malevich's ultimate goal was to facilitate through art a new form of spirituality. He established the link between his own painting and the icon tradition during the first showing of his most radical canvas, *Black Square*, in the 0,10 exhibition in Petrograd in 1915. It was noticed immediately, and regarded by some

as blasphemous, that he had chosen that part of the room traditionally associated with the placement of icons.

For Malevich, white is associated with transcendence; for his contemporary Kandinsky, it represents an almost infinite potential. During the hot, stormy summer of 1911, Kandinsky experienced a revelation of the meaning of whiteness:

Suddenly all nature seemed to me white; white (great silence – full of possibilities) displayed itself everywhere and expanded visibly. Later, I remembered this feeling when I observed that white played a special role and had been treated with particular attention in my pictures. Since that time, I know what undreamed-of possibilities this primordial colour conceals within itself.[26]

For Kandinsky, this realisation has a 'spiritual-logical' consequence, which finds a greater spiritual scope in the latency of pure whiteness than in the actual performance of 'linear elements' for which whiteness is merely background. Echoing Malevich's rejection of adulterated natural forms, Kandinsky focuses his imagination on the infinite possibilities of expression that exist before the painter makes his first delimiting mark on the canvas. The idea that the 'indifferent' white is potentially more expressive than the most fully expressive combination of colours helps to contextualise Kabakov's division of the picture space into white and polychrome areas.

In Kabakov's own oeuvre, the most important predecessor to the current work is the series of *White Paintings* executed in 1977–1978. These large white canvases marked with a variety of barely discernible outlines in white paint often feature sets of figures that anticipate some of the groupings of *Under the*

26 Wassily Kandinsky, 'The Cologne Lecture', in *Art in Theory: 1900-1990*, edited by Charles Harrison and Paul Wood (Oxford: Blackwell, 1992) p. 94.

Snow. Perhaps the most significant aspect of this 'realised utopia' is the installation design that specifies an arrangement reminiscent of the interior of a church, with paintings placed together to form triptychs, especially the group of three large works opposite the entrance wall simulating the backdrop to a high altar. Kabakov's original description of the concept includes many revealing details:

> If there really were nothing on the canvas, then for our perception this canvas would simply be an object purchased in a store, a canvas covered with a white prime coat (as we see often in the works of Robert Ryman). But, thanks to the fact that we can discern various depictions on the canvases, a special optimal effect emerges for the viewer that is connected with his visual and historical memory. What might arise during the reconstruction of such a memory are recollections about window displays, where a blinding white light shines towards us, almost dissolving, making invisible the sections between the glass. The large surface of the white canvas covered with fine contours (of course, given a special 'attuning' of the eyes) to a certain degree stimulates such 'blinding' quality. The circle of such 'windows' surrounding the viewer on all sides creates the sensation of a shining space beyond the walls of the hall where pseudo-paintings hang. But in essence, the 'light' we are talking about is only what might appear to exist to us, it is the result of our imagination. It is not light that is present on the surrounding canvases, but white colour which carries with it the sensation of quiet, calm and tranquillity, a unique kind of psychic relaxation.[27]

Kabakov's reaction to his own project holds together in the mind the ecclesiastical aura of the installation with the experience of window shopping; it provides a mental

27 Ilya/Emilia Kabakov, *Die Utopische Stadt und andere Projekte* (Bielefeld: Kerber Verlag, 2004) p.97

space where the spiritual and the material intersect without conflict, not because the religious and the commercial have become interchangeable, but because they make their claim on us through the medium of a 'white light' whose volume is insupportable. It is precisely through the failure of perception that the power of memory exerts itself, and for Kabakov, it is the vagaries of the historical memory that animate the whiteness, and that punctuate the arrangements of clouds and snow.

≈ MEMORY

The memories that provide the anecdotal content for these pictures are both familiar and unsettling; they resemble images seen before but given an individual tonality in the artist's handling of paint, in the startling juxtapositions of colour and in the combined freedom and delicacy of touch. They conceive of memory neither as personal possession nor as public myth, but as a constant interfusion of the two; and their sense of history is of an unresolved process, a system of uncertainties, subject to revision through official censorship (the sort that 'whites out' telltale details) and through the fears and desires of individual psychology. Although there is clearly a narrative ambition behind the series, it is buried deep below the surface, with too many elisions and interruptions to sanction an authoritative reading. Nonetheless, despite the suppression of narrative logic, there are distinct changes of mood, different reactions to changes in the social and political atmosphere that can be identified and described, and what follows is an attempt at one such description.

The first picture in the series includes pastoral scenes in an idyllic mood, imagining the possibility of a Soviet impressionism that uses pastel tones, with the blue of the sky

nuanced by the blue and lilac of clothes and meadow flowers. The scene in the lower left-hand corner might represent a moment of respite during the working day, or it might be the epitome of leisured inactivity: a Soviet version of *dejeuner sur l'herbe*. From the start, the apertures through which the viewer peers are eyelet-shaped, and across the middle of the second canvas a pair of these – resembling the shape of a pair of spectacles – reveals two different kinds of parades, one a military inspection, the other a rally of Young Pioneers with standards and a banner portrait of Stalin. In the top left corner, we are afforded a glimpse of a discussion group or Party cadre meeting, animated and apparently uplifting; it is revealed in a way that suggests the corner has been torn away from a dust sheet covering something that has fallen into disuse. It is as if a built-in obsolescence forms part of the organised solidarity of these scenes, as opposed to the casual gregariousness implied by the imagery of the first picture.

The third picture depicts two scenes of technological progress and nation-building: in the first, a passenger boat sails under what resembles a triumphal arch rather than a functional bridge, while in the second, three identically clothed engineers or architects discuss blueprints on site while a surveyor takes observations. This highlighting of achievements only serves to increase awareness of what remains submerged from view, of what cannot be presented in the same positive light. The fourth picture is even more idealising, showing a well-lit station in the Metro, rational and orderly, with pairs of well-dressed passengers who are composed and patient. Given the setting, this is a surprisingly restful scene, paradoxically more limpid and aerated even than its counterpart in the same canvas; this features a military launch or pleasure boat – the difference seems merely academic – venturing forth onto a lake that reflects the pastel blues, pinks, greens and mauves of an early evening sky. The boat is watched by a family group in

light clothing and sun bonnets, with one holding an umbrella in pale green that is almost Parisian in spirit.

The elegiac tone of these cherished images begins to harden into something much more willed and programmatic with the fifth painting. Until now, the apertures have been largely horizontal or gently diagonal, but they are now more like vertical slashes; it is as if the past is slipping into a crevasse. Despite this, the scenes are emblems of heroic cheerfulness, where every face is infused with satisfaction and purposefulness. The upper scene might be a resumption of the study-group theme – whatever else it does, it records a mutual admiration session – while the lower image is of a Stakhanovite metalworker, clearly inspired by his task, face lifted to catch the light of socialist energy: politics as blessing.

But the sixth canvas is the pivot around which the whole series turns. It is clear that the temperature has plummeted, and the openings have frozen over. There are now the merest chinks in what has become a stifling whiteness, making the retreat of warmth and colour – the reversal of the thaw – seem dramatic. Already in the seventh picture, the scenes betray a distinctly different character. The insect in the top left-hand corner has an assertive brilliance, making it more solidly present, paradoxically more permanent, than the ghostly, vulnerable figure in the bottom right-hand corner, its humanity melting away with more facility than the disappearance of snow. In the eighth canvas, the images start to become more obscure, sketchy, fugitive, with a sense of haste and urgency that matches the iconography of groups of people on the move, in an atmosphere of anxiety and foreboding. The orchestrated unity of the earlier groups, with their converging moods of recreation and labour, has disintegrated into bewilderment, loss of direction, discouragement, panic. With the ninth and tenth paintings, this initial disorientation has turned into a hunt for refuge, for hiding places, underground or high in

the mountains, as remote as possible from the modernised environment of the planned economy. This hurried exodus is an attempt to get beyond the scope of a totalising ideology, perhaps to one of the very few places ideology is not interested in. Whereas the attitudes and glances of the figures in the first few canvases had been oblique to the viewer and often conversational in purpose, they now need to look straight out of the painting in a direct address that begins to feel like a petition. In the tenth picture the outward gaze is particularly searching, while the shadows in the snow begin to absorb more of the colours used previously to denote the absence of snow: pinks, blues, greens, mauves.

By the time we reach the eleventh canvas, the progressive huddling of the figures has become crowding. The highly concentrated tableau at the centre of the picture suggests two readings equally powerfully: one is of the composition of the eye, almond-shaped, with circular pupil and iris, framed by the brow; the other is of a tondo-like composition of the sort pioneered by Venetian painting, with a deeply recessed paradisal space seen from below, towards which ranks of human and angelic creatures aspire and beckon. This unattainable utopia seems to be reflected on the retina, the true place of its formation. If the eleventh painting depicts a version of heavenly aspiration, the twelfth pushes the aspirants as far as possible back into their bolt-holes and subjects them to an ordeal of waiting, their exile or expulsion a desperate period of suspended animation, their only resort a combining of temporal and spatial impasses.

The thirteenth, fourteenth and fifteenth canvases still reflect the obsessions of a hunted sensibility, but it is now prepared to take the risk of open spaces. The thirteenth looks relatively unfinished; the modelling of the figures in particular is rudimentary, while the relationship between figures and landscape is provisional and unresolved. In the fourteenth

painting, there is a sudden dramatic focus on the faces of two figures; they are in close proximity to one another but might as well be miles apart, since in both cases the gaze is unseeing – they are completely absorbed in introspection. The glimpse beyond of an extended panorama of rolling hills is effectively redundant, given the figures' total lack of attention to anything except their own gnawing uncertainty. In the fifteenth painting, three of the four images concern the representation of a mountain, with one figure climbing to the summit, separated from a group that remains in conference lower down, suggesting the kind of scenario in which guidance is sought from above. But the fourth image shows a figure who has been given no answers to his questions, who has found nothing but confirmation of his own abandonment and isolation.

The sixteenth picture moves into a different space altogether, a remote wilderness that nonetheless carries the risk of acute exposure. Despite the emptiness of the setting, the painting is imbued with a sense of harassment. Like Tarkovsky's film *Stalker*, it suggests that even the most despised terrain does not lie beyond the vindictive thoroughness of a paranoid state. The assembled figures seen hazily through the random openings of the seventeenth painting are beginning to resemble group portraits of the disappeared, and their bleached outlines suggest that once this record of their former existence fades away, they will simply be lost to history. The evidence for this seems hard to deny in the eighteenth, nineteenth and twentieth pictures, with their *trompe l'oeil* effects that turn the landscape inside out in a vain search for human presence. In the eighteenth canvas, the vacancy through which a distant terrain is picked out solidifies into a blue and green mountain ridge that would block out such a view. In the twentieth canvas, a remote circular aperture which provides a rare glimpse of fertility in a sterile universe metamorphoses into a solitary planet almost lost in the void. In the devastating coda of the

twenty-first painting, the eyelets appear to be multiplying, but if anything this means an augmentation of despair; the pink edging around each aperture turns it into a wound, or recalls the flame-like souls of the damned in medieval iconography.

Kabakov's sequence is a dismaying reversal of the future projected by the early avant-gardes of Soviet Russia; in place of Malevich's formula which regards the material culture of the Revolution as the basis for spiritual renewal, Kabakov's psychomachia reflects on a history that erodes the soul, leading from the specific promise of a culture forged from unique circumstances to the kind of unravelling of the social contract that accompanies every failed utopia. It abandons history for myth, geography for atopic privation, and in the process of monitoring the gradual victory of self-deception – individual and collective – takes the full measure both of our complicity with the programmatic imaginings of the state, and our failure to trust in the extemporised imaginings of art.

THE FLIGHT OF THE ARTIST: WINGS OF DESIRE

Flying has been an ambition of several of the fictional characters who have populated the Kabakovs' oeuvre. The desire to be borne aloft, whether on wings of one's own, or with the aid of mechanical contraptions, is a recurrent motif in both paintings and installations. Ilya Kabakov's first installation, *The Man Who Flew Into Space From His Apartment* (1985) linked this aspiration to a corresponding need to escape the confinements of the standardised housing units of Soviet Russia. And the principle of following a vertical path in the imagining of utopian forms of life has taken shape both in the architectural blueprints and maquettes of projects such as *The Utopian City*, and in the organisation of sculptural space in major installations such as the *Palace of Projects*. Several of the component projects included in the overall scheme of the *Palace* focused on the desire to transform the scope of everyday life through the wearing of angel's wings. The tension between the claustrophobic cells of the built environment and the literally unbounded dimensions of aerial flight is the pivot around which several of the Kabakovian projects have turned. *The Red Wagon*, for instance, combines the restriction of movement (the viewer has to climb inside the close quarters of a small wagon) with painted panoramas of futuristic cities featuring small flying machines effecting communications between upper and lower levels of habitation. The major series of paintings *Under the Snow* (2004–2006) shares certain formal elements with the *Flying* series, not least in its occlusion of

certain areas of the canvas. The ostensible reason for the partial concealment of anecdotal subject matter in *Under the Snow* is that the imagery has been obscured either by drifts of snow, or that each scenario in question is being glimpsed though gaps in the clouds, inferring that the point of view is that of someone in flight above the earth.

≈ WHOSE PAINTINGS ARE THESE?

The emblematic style of painting foregrounded in the *Flying* series is deliberately stereotypical – its mimicry of the approved manner used everywhere in Russia before the artists' flight to the West may be responding in some measure to a satirical impulse on their part, but its tonality, its sober accuracy, avoidance of parody, and even of obvious irony, would seem to argue otherwise. One consequence of the artists' voluntary adoption of this restricted vocabulary and the self-discipline it incurs is the corresponding diminution of opportunities for self-expression, for the creation of a point of view outside the scope of ideology, for the psychological freedom that is the dividend of alienation. In this respect, the *Flying* series adopts the general stance found in the work of the Kabakovs in its emphasis on shared culture, typical experience, generic attitudes. The fact that their entire output is presented as a collaboration indicates the strategic importance of obscuring the agency of the individual artist as the source of the vision embodied in any given painting or installation. And the deflecting of the almost automatic tendency on the part of the viewer to fix the attribution of the work of art implies the necessity to look elsewhere. This rerouting of the hunt for origins is further complicated by the frequent adoption of pseudonyms, as in the monumental project that proposed an 'alternative history' of Russian painting in the twentieth century. Here,

three distinct bodies of work were attributed to the separate personae of Charles Rosenthal, Ilya Kabakov, and Igor Spivak. Rosenthal's fictional biography identified him as a student of both Chagall and Malevich, as an enthusiastic exponent of socialist realism, and as having died before the worst excesses of totalitarianism had been exposed. 'Kabakov', most confusingly, was not to be identified with the Kabakov who had in fact created him, but with an imaginary figure whose work, mainly from the 1970s, represented a continuation of Rosenthal's legacy. The multiplication of Kabakov-figures epitomises the extent to which the 'signatures' of style, normally employed to circumscribe the individual artistic identity, are used to the opposite effect in the Kabakovs' work, confusing the boundaries supposed to separate one body of work from another. A great deal of the Kabakovs' ingenuity is deployed in laying false trails, scattering clues that lead away from provenance, rather than towards it. The final figure in the trio of invented artists, Igor Spivak, was given a birthdate of 1970 and a predilection for postmodernist assemblage of found materials, most often of photographic materials torn from Russian newspapers. The triangulation of media, methods and conventions appears to be mocking traditional belief in the value of style as the crucible of authenticity, but at the same time it demonstrates the value of a diversity of different modes of representation. This simultaneous presentation of three mutually qualifying responses to the same cultural context proposes the necessity for critical debate in the practice of painting itself. It is not surprising, therefore, to discover that the Kabakovs have used, sparingly but decisively, the terminology of Russian theorist Mikhail Bakhtin in certain of their installation texts. Bakhtin's insistence on the special value of works of art that embody dialogue, mobilising the viewer's or reader's awareness of a competition of meanings, of a rivalry of points of view, in the articulation of the social sphere, is what will facilitate

resistance to the 'monologic' power of state ideology and its incitements to conformity. In the *Flying* series, the potential for nonconformism, together with an acknowledgement of the conditions in which it has been suppressed, is implied in the calculated provision of gaps in the evidence, in the evacuation of meaning from significant areas of the canvas.

≈ ELLIPSIS

The areas of whiteness that interfere with the visual information in *Under the Snow* are given a naturalistic motivation in the imagined screen of clouds or snow; but there is no such motivation in the *Flying* series, where the patches of imagery very clearly take the form of pictures in an exhibition. It is the naturalistic context of an exhibition space that is missing, and not only that, the inset pictures themselves are not disposed on the same plane – where there is more than one inset picture in a painting, and this is the case in at least half of the *Flying* series, the separate picture planes are often angled away from one another, as if they are outside the earth's atmosphere, oblivious of gravity, lost in space.

The spatial priority given to whiteness means that the viewer is being offered a conflict between abstract and naturalistic traditions, a conflict that the history of Soviet culture has turned into much more than a question of style. The aesthetics of Soviet socialist realism has accumulated a deposit of propagandistic imagery that is instantly recognisable, no less from its style than from its content. Even when the content seems innocuous, the style predisposes the viewer to interpret the imagery in a political context. The ideological choice of socialist realism over alternative methods, indeed, its displacement of all other methods, involved the suspension of experimental forms of abstraction such as those developed

by Malevich, whose arrangement of geometric shapes on the canvas bore a resemblance to the overall design of the *Flying* paintings, where the angling of the inset picture planes transforms them into a variety of geometric shapes. Malevich was both fascinated with whiteness and with the idea of flying. In *Non-Objective Art and Suprematism* (1919), he includes a proposition that intersects very strikingly with Kabakov's concept and design: 'I have ripped through the blue lampshade of the constraints of colour. I have come out into the white. Follow me, comrade aviators. Swim in to the abyss.' Malevich's intention of rejecting naturalism, since the forms of nature are no longer sufficient to reflect the concerns of modernity and the precise inflexions of a unique subjectivity, is projected into the idea of leaving the earth's surface, of flying away from the world and from the imagery and colours used to represent it in the past. Whiteness represents an abandonment of habitual forms of perception, just as the view of earth from space has the effect of defamiliarising an environment we take for granted. Kabakov's *Flying* paintings can be seen from different angles simultaneously, as displays of ultra-conventional Soviet imagery, and as a conceptual version of satellite imagery that estranges us from these formal reminders of Soviet reality.

The fragmented views of cultural topography in these works have been composed in the robust manner sanctioned by officialdom; they echo the confidence of anonymous artists whose work is endorsed by its sheer reproducibility. But their fragmentariness, their condition of being hemmed in by significant areas of blankness, renders them curiously fragile, even lends them a certain degree of pathos. From one point of view, the treatment of Soviet life in these partial tableaux is cynical – it is highly selective – but from another point of view, it appears naive, is reminiscent of the faith and optimism of ordinary people to whom the facts of Soviet history have not yet been revealed. It is this variability of viewpoint that the

Kabakovs have made technically unavoidable, in the subtle but unmistakable use of *anamorphosis*.

≈ ANAMORPHOSIS

If only small areas of the surface of the canvas depict scenes from the history of Soviet culture, then the greater areas of canvas that remain unused imply the omission of significant aspects of that culture; they imply that what has not been revealed might be more revealing. If the erasing of inconvenient truths was a common practice during the Soviet era, and if censorship became the merest reflex of official disapproval, then Kabakov's foregrounding of mark-making under erasure can be partly understood as a representation of censorship itself, and of its formative role in the construction of Soviet historical identity.

The handling of those areas of the canvas that are not under erasure suggests that each painting is concerned with the representation of a series of tableaux floating in space. It is as if they have become detached from the time and space of terrestrial reality and are now drifting in another dimension. That they are subject to movement is implied in single paintings that show more than one tableau, and in the comparison between paintings that confirms the variety of angles at which they have been caught in mid-flight. The gradually evolving movement of tableaux, whatever its cause, has the result of discomposing the relations between them, condemning them to a state of perpetual misalignment. The reality they represent can never again be rendered coherent from the angle of vision it was possible to take for granted in the past. Certain of the tableaux need to be seen from quite a sharp angle in order to make sense of the visual information they provide. Paintings 19 and 20 offer particularly striking examples of this. However

gently, however moderately, the Kabakovs' insistence is that the illusory well-being, the utopian projections, enshrined in this imagery could only ever be sustained by a greater or lesser degree of psychological contortion.

Obliging the viewer to adopt a variety of positions, mentally or physically, in relation to the canvas, instead of contemplating each painting from roughly the same position, converts the experience of the viewer into that of participant in an installation, where movement through time and space transforms the visitor from passive consumer to active collaborator in the production of meaning. The distortion of imagery created by angling the plane of the inset tableau creates a degree of encoding that resembles the effect of *anamorphosis*, deployed with a certain degree of regularity by Renaissance artists. The most celebrated use of this technique was in Han Holbein's canvas *The Ambassadors*, which includes the depiction of a skull that would remain unrecognisable if the viewer did not contrive a point of view that secured a drastic foreshortening of the image. In twentieth-century culture a comparable effect was achieved by axial cutting in early Soviet cinema, especially in the films of Eisenstein. In the work of the Kabakovs, a closely similar technique was explored comprehensively in the installation *A Universal System for Depicting Everything*, where a routine distortion of imagery combining both the stretching and foreshortening of visual elements was intended to convey the side effects of representing objects in four-dimensional space. According to the textual component of this installation, the underlying motivation for this deformation of objects in space was to measure the scope of human desire. The use of *anamorphosis* has less to do with mounting a challenge to the viewer to restore to its familiar condition what has been defamiliarised, than with inviting reflection on the desire to transform reality that has a political scope no less than the ambition to create an optical phenomenon.

The imagery of the *Flying* series is both poignant and deceitful, nostalgic and amnesiac, at one and the same time. It evokes above all an atmosphere of relaxation and harmony, of a citizenry at ease with itself and with its diet of work and leisure. There is an assumption of mutual dependability in the representation of groups, a conviction that trust in others is well placed. Bodies are well-built and faces are either happy or purposeful. Shops are well-regulated, their shelves well-stocked. Architecture is rational and orderly, the cities balance aesthetic idealism with functionality, the domestic environment is modern and well-equipped. Transport is efficient and available to all. Meanwhile, nature provides a suitable frame for the dignity of human labour or for suitable kinds of leisure pursuits that promote cooperation and mutual respect. Spare time is never wasted, and is used for the cultivation of the mind or for developing athletic skills. The soil is fertile, cultivation is systematic, forests are abundant, parkland is well-managed. The livestock industry is operating on a scale that can provide for all, but without losing the human touch. People listen to what others say, draw their own conclusions, respond constructively. Political meetings represent a pinnacle in the steady building of a culture that all can be proud of, whatever their occupation or ethnicity. And surrounding all of this, embodying the furthest reaches of technological achievement and of ideological unity, is the protective cloak of the military, conducting itself with a perfect discipline that allows the civilian to relax even while civilian life is performed in unconscious emulation of this very discipline.

In some of the paintings, this imagery has begun to fade, in others, one tableau partly obscures another. In all of them, the iconographical commandments are no longer addressed to the audience originally intended for them. They are like radio

signals still travelling through space long after the station of origin has ceased transmission. Above all, they are detached from one another – the ideological glue that held them together has dried out and crumbled. Seeing all twenty of the paintings together compounds the effect that pervades each one, of the dismantling of an entire structure of feeling, of the dispersal of a whole gamut of responses to the collectivisation of a culture. This is in a sense disposable imagery, mass-produced and without intrinsic value, and yet its very status as the available language of public life entailed a degree of adaptation, of accommodation, of compromise, on the part of all those who were exposed to it. Our memories of the past are always a negotiation between private and public versions of the same event, of the same experience. Many of our memories of what happened in history are in fact memories of photographic images or of verbal and written accounts. The *Flying* series seems to propose that the centrifugal fallout that has followed the collapse of the Soviet Union might entail a settling of accounts that dispenses with certain points of view, that does not record the moment of utopian anticipation, but that finds inside it the very pretext to consign it to oblivion. The Kabakovs' work is unique in its suspension of different historical vantage points in an artistic medium that enables the viewer to enter imaginatively very different angles of approach to a conflict of interpretations that is not only unresolved, but should properly remain so.

ANGELOLOGY: HOLDING PATTERNS

Angels have a more prominent position in Russian religious art than in the iconography of the Western European tradition. The medieval polyptychs collected in the State Tretyakov Museum in Moscow feature as many angels as saints and not infrequently more angels than saints. Andrei Rublyov's famous *Deesis Tier* of 1408 includes five figures, of whom two are angels (Michael, the Virgin, Christ, the Baptist, Gabriel). The same artist's *Trinity* of 1420 is a trinity of angels. Figures portrayed as saints in the West are transformed into angelic equivalents by the Russian icon painters. John the Baptist is frequently given enormous wings and referred to as the Angel of the Wilderness. This fascination with the angelic in Orthodox religion accounts at least partly for the promptness with which nineteenth-century Russian poetry resorts to the same iconography to articulate its own relationship with spirituality. In Pushkin, poetry is identified with prophecy, with a visionary and auditory scope beyond that of the human faculties. This clairvoyance and clairaudience is the gift of a six-winged seraph, who grants the first-person speaker of the poem the power to overhear the distant rustling of angels' wings (Alexander Pushkin, 'The Prophet'). Twentieth-century Russian literature continues to deploy the trope, but for the more tactical purpose of pitting the claims of the mystical and supernatural against those of the rational and scientific. The figure of the angel becomes less securely attached to the Christian moral scheme, and the traditional distribution of virtues and vices between angels and demons becomes

ambiguated. Valery Bryusov's symbolist text *The Fiery Angel*, used by Prokofiev as the basis for his opera of the same name, exemplifies this trend, as does Bulgakov's satire against communist bureaucracy, *The Master and Margarita*.

Bulgakov's masterpiece, with its flying sorceress Margarita, comes close to the Kabakovs' historically precise insertion of the sublime winged figure within the resolutely earthbound realities of Soviet and post-Soviet culture. One of their most cohesive exhibitions, *Flying* (Galerie Ropac, Paris, 2010), announces in its title the importance of flight as both motif and organising concept across their entire output of books, paintings and installations. The figure of the angel is central to this emphasis, but is joined also by the cosmonaut, the aviator, the dreamer and the architect. There is an unmistakeable resistance to the force of gravity in the fantasies of the fictional characters that populate their albums and installation schemes. And the architectural elements of their work, whether actually realised, as in the *Palace of Projects*, or projected, as in *The Utopian City*, emphasise the upward movement of spiral forms and the vertical thrust of narrow towers, spires and pinnacles.

Certain kinds of vertical ascent are practically attainable in the conceptual world of the Kabakovs, but others are pure products of the imagination. There are very few situations envisaged by their work that do not involve an admixture of both. The utopian city is, or rather should be, constructed over one of the 'energy centres' of the earth. These are proposed as places in which the energy of the globe itself is concentrated and augmented by an invisible vortex, an imaginary lens capturing the energy that radiates from the cosmos. The architectural scope of the utopian city projects is staggering, and yet feasible; the metaphysical aspect of their intended collaboration with the forces of cosmic energy seems like pure fantasy.

In conversation, the Kabakovs are at pains to underline the extent to which their art does not reveal their own individual

fantasies but represents an assimilation to the point of view of the potential reader or viewer. Placing the emphasis not on the point of origin of the concept but on the moment of reception has been characteristic of their installations from the beginning. The *Ten Characters* that feature in Ilya's earliest major installation are fictitious residents of a typical communal apartment. They are all average citizens, but they are simultaneously artists dreaming of invisible worlds. They include Ilya's first installation-protagonist, *The Man Who Flew Into Space From His Apartment*, a figure who first appeared, or who failed to appear, in the artist's own Moscow apartment, where the evidence for his departure was represented by a giant catapult suspended beneath a hole in the ceiling. Much of the subsequent output, whether of Ilya working solo, or with Emilia, has comprised an expansion in scale of this early scenario.

According to Boris Groys, the mysterious protagonist of *The Man Who Flew Into Space From His Apartment* is in a critical relation with the role and meaning of space flight in Cold War culture. Despite its recruitment for propagandistic purposes, and despite its links to military research, Russian cosmonautics also functions as a means of renewing the utopian trajectory of state socialism. It redeems the fatal compromise with historical necessity embodied in Stalinism, through the individual revision of a collective project for idealistic purposes, and by means of a literal transcendence as uplifting as the imaginary flight of angels.[28] The Kabakovs' adaptations of Stalinist-era architecture in a series of maquettes and blueprints operate in a similar fashion by restoring an idealistic dimension to the monumentalist template of state-approved design.

In Wim Wenders's film *Wings of Desire* (1987), the figure of the angel serves an equivalent purpose to that of the would-be

28 See Boris Groys, *Ilya Kabakov: The Man Who Flew Into Space From His Apartment* (London: Afterall Books, 2006)

cosmonaut in the Kabakovs' oeuvre. The all-seeing, all-hearing angel – like the prophetic poet of nineteenth-century Russian literature – achieves the redemption of panoptical surveillance practices in a Germany before the fall of the Berlin Wall. But the magic realism of Wenders's fable, despite the power of its illusions, lacks the pathos of the Kabakovian tableaux presented in *Angelology*. Wenders's aerobatic guardians are counterpointed by the Kabakovs' housebound self-improvement fanatics. In *How to Make Yourself Better*, there is never any question of genuinely taking flight. As in so many of the Kabakovian projects, the sphere of operations is quite severely confined. In a crowded room not much bigger than a closet, the dreamer takes flight mentally with the aid of strap-on artificial wings. This dressing up is carried out in solitude, so that the protagonist can get away with making a large statement that would be ridiculous in the eyes of onlookers. These angelic wings are the top of the line, but they cannot be flexed and extended, they are rigid and doubly impractical. They were never intended to be anything more than stage props to the flight of the mind.

The claustrophobic dimensions of rooms in the standard Soviet apartment block both inhibit and incite free movement in space. Like the suffocatingly tight fit of the early space capsules, the Soviet housing unit has the paradoxical effect of launching its inhabitants into infinite space, in this case inner, rather than outer, space. There is nowhere else to go.

The imagination can only take flight in another dimension than the one in which our material circumstances press in on us from all sides. The existence of the *Fallen Angel* proves the existence of this dimension, since he cannot have come from anywhere else. But the very idea of this unfettered and exalted being is seen as both dangerous and shameful. The *Fallen Angel* is no sooner discovered than hidden away. In one version, his broken form, discarded like an encumbering parachute, is

cordoned off behind a police line, as if his aberrant condition can be explained away as a mistake, an interference in the normal routines, a crime statistic. In another, the explanations seem to have been rejected: whatever angels exist for is unknown; continues to resist the techniques of forensic enquiry; remains an enigma that cannot be disposed of. The evidence continues to haunt the authorities and is both screened off and made the object of intense curiosity. It raises more questions than it answers.

The poverty of the materials used to quarantine the *Fallen Angel*, cheap wooden fencing that can be assembled quickly, is in marked contrast to the sublimity of the being inside, a visitor to our world of shoddy workmanship, bad designs, substandard materials, the world of historical time. According to Walter Benjamin, the Angel of History has his face turned towards the past: 'Where we perceive a chain of events, he sees one single catastrophe that keeps piling ruin upon ruin and hurls it in front of his feet. The angel would like to stay, awaken the dead, and make whole what has been smashed. But a storm is blowing from Paradise; it has got caught in his wings with such violence that the angel can no longer close them. The storm irresistibly propels him into the future to which his back is turned, while the pile of debris before him grows skyward. This storm is what we call progress.' (Walter Benjamin, 'Ninth Thesis on the Philosophy of History')

Many of the Kabakovs' installations that look back on the history of Soviet civilisation reproduce the effects of a pile of debris growing skyward, and they hint at the catastrophes wreaked in the name of progress. But although their *Fallen Angel* is a casualty, he is also an imperishable being; amid the temporary screens that will fall to bits sooner rather than later, and under the eyes of a degenerating humanity, he represents an idealism that looks beyond the movement of time. It is only because humanity cannot imagine existence under these terms

that it associates such perfection with the future, since nothing in the past has succeeded in bringing it about.

The Kabakovs' response to the backward-looking Angel of History, caught up in increasing despair, is the forward-looking individual of *How to Meet an Angel*, stretching every sinew in his attempt at the fingertip transfiguration, Michelangelo-style, seemingly on offer from a graciously condescending angel who happens to be cruising past. It is a project that depends on the existence of angelic holding patterns, flights of angels with an eye on the radar for the individual launch attempts of humanity's die-hard idealists. The idealist does not look behind him, does not see or does not remember the unreliable and rickety substructure of his dreams, he has reached the acme of home-made theory, the do-it-yourself kit of ideas that has never worked when the plan has been collectivised; his is a backyard utopia, a domestic paradise, not streamlined, not gleaming, not technological, the product of an individual resourcefulness, a trial-and-error accumulation of the best of intentions.

None of the Kabakovs' installations avails itself of state-of-the-art equipment or expensive fabric: quite the opposite, it evokes the concept it is intended to illustrate by means of the humblest materials, those that are quickest to hand in any workshop or tool shed: paper, wood, glue, string, pins. It is striking how the free-standing paintings in *Angelology*, with their hauntingly precise echoes of the style and subject matter of Soviet socialist realism, a state-approved aesthetic that brackets the debris of progress, and which endorses the belief in humanity's total control of its environment, do not employ the reverse side of the canvas to tell the truth about a false idealism, but to gesture towards the true idealism of the angelologist, the dream of a better future which is not embodied in the super-reinforced heat shield of a space capsule, but in the papery insubstantiality of a pair

of miniature cut-out wings. Perhaps Conceptualism itself, a movement born partly from the paucity of materials and the public invisibility of experimental art in the Soviet era, is the most viable messenger of Russian idealism.

The parabola of Russian art in the twentieth century, as interpreted in the Kabakovs' 'alternative' history, first installed in Cleveland in 2005, reaches away from realism and reflection in the direction of idealism and projection. The Kabakovs stress the superiority of unrealised projects to all those conceptions that were actually given concrete form. In political terms, fantasy-production is preferable to the spatial embodiment and temporal performance of ideas. For the artist working in three dimensions, the best solution is the maquette, and in two dimensions, the sketch. For the curator, the goal should be to reinvent the museum or gallery as a storehouse for fantasies.

After even a cursory examination of the *catalogue raisonné* of the Kabakovs' installations, one is made aware of the accumulation of desires, not just of individual sensibilities, but of an entire culture, the symbolic deposits of a way of life that dominated half the planet not so long ago, but which already seems strangely remote. The majority of the installation-plans are for projects never to be realised. They tap into a reservoir of dreams that were the myths of at least three generations. Many of the works have a narrative element, particularly the albums where the visual focus is qualified by a literary elaboration, but also the installations which involve the viewer in a sequence of movements and reflections. Despite this, the initial germ of each new phase of work, in what Ilya has described as a daily practice (in conversation, 2005), is a visual idea that becomes the basis of a 'virtual tour of the head'. Grasping the size of the work and refining its detail is consigned almost entirely to the business of mental preparation, so that the actual, physical realisation of the work is regarded as little more than a 'reproduction' of the work already finished in the head.

This prodigious investment in the work of the imagination, rather than of the hand or the eye in their engagement with matter, has deep roots in the experience of *samizdat* culture. Soviet art is not only the subject matter of much of the Kabakovs' work and the source of its inspiration, it also projects what many Russians still carry round in their heads and live through on a daily basis, whatever the material changes in the world around them.

ANSELM KIEFER: WATERWORLD

Anselm Kiefer is a builder of systems: a painter who has had to retrieve from oblivion entire mythologies, rescuing the coordinates of half-forgotten narratives, retracing the map references for the cultural imaginary. Litanies of divine and heroic figures, supernatural genealogies, star charts, the names and agencies of classical and Germanic mythology, the stratified levels of being dreamed of in the Kabbala – all have become the means by which the infinite expansions of space and time have been negotiated. They remain beyond human reach, but assimilable to human ambitions, to the trajectories of desire and fear that make them both tantalise and repel us. There, at the boundary of human understanding, is the beginning of a knowledge of the world that must always remain ambiguous, cryptic, oracular.

Given these preoccupations, Kiefer's fascination with the figure of Velimir Khlebnikov seems inevitable. The Russian 'Futurian' is best known as an experimental poet, but his work includes various writings that elaborate several theories about the structure of the universe and the laws of time. Of all the texts that comprise Khlebnikov's strange oeuvre, the 'Tables of Destiny' have held the strongest appeal for Kiefer. They represent Khlebnikov's attempt to understand history as a system of correspondences, as a series of mutually defining events that echo one another across different measures of time. The periodicity may vary enormously but, according to Khlebnikov, it always reveals the operation of the same mathematical proportions: 'opposed events – victory and

defeat, beginning and end – are united in terms of powers of three ($3n$).' The more data Khlebnikov fed into his system, the greater the complexity of the calculations needed to make the theory work, with the result that a greater variety of multiples was required. Nevertheless, Khlebnikov managed to stabilise his equations around multiples of three and two ($3n$ and $2n$). This precision was, of course, absurd – Kiefer has referred to it as Dadaist. The central paradox of the entire system, and of the obsessive rigour with which the theory was applied, lies in the non-scientific basis of its inspiration, in the form of an overwhelming desire to control the movement of history. Khlebnikov's initial motivation was a highly personal response to Russian defeat in the Russo-Japanese War: 'I wanted to discover the reason for all those deaths.' Kiefer's fascination with this quest for the rationale of history appears to stem from at least two related causes.

In the first place, it arises naturally from the chronic responsiveness of his work to the pressures of history. Kiefer goes much further than most contemporary painters in his use of a spatial medium to capture the experience of time. He is less interested in the simple effectiveness of attempts to freeze the movement of time, or to accentuate its passing, than in the less immediate, but more far-reaching, drama involved in trying to evoke the relations of past, present and future in a two-dimensional plane. Thematically, his oeuvre has branched out constantly to incorporate speculations about the mythologies and traditions of thought of various separate cultures, but the different series of paintings that have been generated in this process all coalesce in mood and in conceptual structure, in their common anxiety about the origins of specific historical episodes and the ends that they seem to imply. If Kiefer is haunted by the past, he is equally haunted by the future, by the subterranean continuities of thought and feeling that transform a decisive military defeat – or victory – into a means

of discomposing the balance of power, in a way that projects a desire for closure into the future simultaneously with a fear that closure will never occur.

In the second place, although Kiefer has been aware of Khlebnikov's theories since the mid-1970s, his work has engaged directly with its programmatic potential in two distinct phases separated by an interval of nearly twenty years. The earlier phase of activity took the form of a series of gouaches, composed during the late 1970s / early 1980s, on the theme of 'The little mailed fist of Germany' and 'The big mailed fist of Germany'. These formulae refer to the events of 2 September 1870 and 11 July 1915: to the Franco-Prussian War and the First World War; the entry in the 'Tables of Destiny' reads: 'Germany's iron fist, which once threatened only France, now threatens the whole of Planet Earth.' The later phase of activity is represented by the paintings in the 2005 White Cube show and by an extraordinary installation at Barjac, Provence. This ensemble of works, entitled *Velimir Chlebnikow; die Lehre vom Krieg Secschlachten ereignen sich alle 317 Jahre oder diren Vielfachem*, is organised around a central, lead-lined tank, filled with water containing a sunken battleship; to one side of this cistern are seven wheeled frames from which rusting ships are suspended by wire, with an eighth ship hanging from the ceiling, and a ninth listing on the floor; to the other side is a wheeled frame holding a massive canvas, against whose background of greys and ochres eleven ships are wired upright, with lumps of shattered terracotta resting on their decks.

Although Kiefer's development as an artist has been characterised by a practice of circling back round to the same themes and motifs, sometimes after intervals of several years, the two periods of time when he has focused on Khlebnikov's ideas seem to reflect external developments in the sociopolitical world, almost as if Kiefer himself is detecting a pattern of

historical cycles. In the late 1970s / early 1980s it was political turbulence in Eastern Europe that galvanized attention, while in the first few years of the twenty-first century, it was the radical disturbance to the balance of power that was the defining feature of military conflicts after the fall of state communism.

All of the Khlebnikov paintings are dominated by the iconography of the sea battle, and this decision to concentrate on the history of naval conflicts has decisive repercussions for the viewer's understanding of Kiefer's engagement with Khlebnikov's ideas. From Homer onwards, literate culture in Europe has recognized the sea as the most appropriate emblem for everything that is most difficult to control in the human sphere. In Euripides' *Hippolytus*, it is the sea itself that metaphorises precisely those elements in the human psyche that are least predictable and least governable. The sea's capacity for sudden and complete transformation, its very fluidity, is what renders it a particularly apt symbol for history as lacking any order or pattern, as unmanageable, as something that always eludes the grasp. Kiefer's ironic use of Khlebnikov's predictive models reflects his conviction that history can never be programmed or given a fixed form, but is like mud that can be given an entirely new shape with the lightest touch. This allusion to mud as the primal material for creation is converted almost literally into the textures of Kiefer's seascapes, where oceanic depths are never translucent or crystalline, but opaque, thickly layered, encrusted. The constant evocation of history in representations of the sea, with its irresistible associations of changeability, of hidden depths, of the unknowable, was anticipated by Khlebnikov himself, in the preamble to the 'Tables of Destiny': 'The fate of the Volga may serve as a lesson for the study of destiny. The day the Volga riverbed was sounded was the day of its subjugation, its conquest by the powers of sail and oar, the

surrender of the Volga to mankind... In the same way we can study the fissures and shifting shoals of time.' The steady confidence with which Khlebnikov unfolds this analogy belies a fundamental misgiving over the tractability of future time and the extent to which it can be guided.

There is little doubt that Kiefer's ongoing preoccupation with the imagery of ships and seafaring recapitulates an earlier phase of German art in which representations of voyages and wrecks abounded as political metaphors. This was during the period of intense political upheaval that followed Napoleon's defeat of Francis II in 1806 and the failure of the Congress of Vienna in 1814 to achieve German national unity as a means of resistance to French rule. Perhaps the most important German painter of this period, and one to whom Kiefer is consciously indebted, was Caspar David Friedrich, who included depictions of ships in over fifty of his canvases. Friedrich covers the gamut of moods in these compositions, ranging from the idyllic buoyancy of *On Board a Sailing Ship* to the grim pessimism of *The Wreck of Hope*; in the former, the viewer contemplates the backs of two voyagers facing the bow of a ship that is heading towards a far horizon, expressing a deep yearning for a distant utopian goal; in the latter, a whaling ship is seen dwarfed by the elements, in the process of being broken up by Arctic pack ice. There are few horizons in Kiefer's seascapes that are not obscured, or shadowed by foreboding, and on occasion the relation of sea to sky is literally inverted; one way or another, the horizon functions as a place where weight descends, not where pressure is released. Only a few of Kiefer's ships are overturned or foundering on shoals, but there is an almost uniform sense of futility in the isolation of these vessels amid worsening weather conditions, and a paradoxical sense of claustrophobia deepened by the use of a severely restricted palette.

There are no deliberate landfalls in the Kiefer scenario, although several of his vessels drift close to the shore or end

up beached on spit or sandbank. The method of display, which joins together individual canvases in a single rectangular tableau, gives the impression of multidirectional passages, of ships wandering aimlessly, of voyaging without navigation; in a post-Ilium world of suspended destinations, of open seas crowded with echoes of the *Flying Dutchman*, or the ocean of *Solaris* filling up with the contents of a nightmare. This post-diluvian projection is the reverse of a history that can be sounded, mapped and steered through.

It is also a reminder of Kiefer's earlier tributes to Virgil, the imperial poet whose epic turned the end of one cycle of history into the beginning of another, with the departure from Ilium and the journey by sea being the prerequisites for the founding of Rome. The composition *Fur Vergil* blocks out the expected ship with an open book, placed squarely against a seascape background, the rusting pages of the text corresponding to the great corroded welts of a dying ocean. The *Aeneid* gives the prehistory of an origin, the voyage into the unknown that must be endured before roots are put down in the future, but that future is already marked by its own terminus, by the inevitability of decline and fall. The works associated with the Virgilian theme and the Khlebnikov series are also linked directly by the repetition of the Italian phrase '*odi navali*', used by D'Annunzio as the title of his *Marine Odes* of 1892–1893. These militaristic texts are identified with D'Annunzio's proclamation of the resurgency of Italian power through the consolidation of its navy: 'Italy will either be a great naval power or a nonentity.' This desire to programme history in advance and to plot its course in terms of naval confrontations meshes precisely with the terms of Kiefer's reimagining of the 'Tables of Destiny'.

The '*odi navali*' paintings form the largest subset of the Khlebnikov series, but equally significant are those inscribed with the word 'Aurora'. This historically resonant name bridges

two separate episodes of Russian history. The cruiser *Aurora*, the most famous ship in Russian history, not only fought at the Battle of Tsushima, in the Russo-Japanese War (providing the stimulus for Khlebnikov's theories) but also triggered the events of the Bolshevik Revolution by firing a single shot at the Winter Palace on the night of 25 October 1917. The ship is now preserved at St Petersburg, but in Kiefer's rendition, the dilapidation of those values it once stood for is reflected in the condition of a battered submarine stranded among burned and blackened seas; or in the damaged and misshapen vessel in trouble beneath a blotchy and ailing sun whose distorted appearance seems to be punning on the Greek origin of the name; this apocalyptic sunset or blighted dawn provides an ironic commentary on the idea of history as a grand narrative composed and transmitted by those in political power. But perhaps the most haunting of these images construed in response to the challenge of history is buried deep in the hillside at Barjac. There, the largest of Kiefer's leaden ships, with buckled superstructure and twisted gun barrels, sits on a sea of sand inside a cave dug out of the rock. This hollow in the earth has several false portals, out of one of which the ship seems to have emerged. It represents the complete inversion of land and sea, inside and outside, surface and depth, and seems to argue that although the so-called laws of history could never be externalised and made to impinge on a shared reality of space and time, they remain no less powerful for being embedded in the deep interior of the twenty-first century mind. Kiefer provides a model for the political unconscious as something anachronistic, redundant, battle-scarred, yet irreducibly militaristic in the stubborn persistence of its attempts to translate the rest of the world into its own obsessive terms.

INSIDE THE WHITE CRYPT

Ariadne, the mystic spider, has escaped from Amiens, leaving only
the trace of her web on the paving stones of the choir...
— Fulcanelli

Most people think of Kiefer as a painter, but his name cannot
be coupled to any version of the activity of painting that makes
us think primarily of oil paint or acrylic, stable compounds that
have been produced industrially. Kiefer's materials are far more
rudimentary; it is as if they have been scraped off the surface
of the earth, or quarried, harvested, gathered, rather than
manufactured. They are animal, vegetable or mineral; belonging
less to the categories of art history than to those of natural
history. And although they are shown in galleries, Kiefer's
canvases are not really indoor objects – they are often encrusted
in mud, impressed with poppies, sunflowers, brushwood, stalks
of straw, and left outside the studio, to freeze, bake, take their
chances with the rain. They leave the hand of the artist at an
early stage in a long process of physical change, affecting their
appearance, texture and consistency. We are speaking here of a
painter for whom even pigmentation is volatile, whose forms
are subject to deformation, whose materials are unresolved. The
elements of Kiefer's art are not harmonised but brought into a
reaction with one another, and at the centre of this process is
the exposition of its side effects; the painting becomes its own
residuum, an accumulation of waste materials, left over from an
obscure laboratory experiment.

And yet, despite this commitment to base materials, this
identification of painting with the production and incorporation

of debris, the prevailing themes of Kiefer's work have shown a fascination with the rarefaction of meaning, with the metaphysical alibi of physical process, with the transformation of material into spiritual values. And the self-conscious allusiveness of his art has involved frequent recourse to universal knowledge systems, of a kind whose parasitical relation to the major religions more often than not takes the form of occulted or cabbalistic traditions, whose guardianship of privileged access to enciphered meanings equates value with obscurity. It is perhaps inevitable that alchemy should hold a special place in Kiefer's oeuvre, since its fundamental obsession with the conversion of worthless materials into an exalted condition might stand as metaphor for the activity of painting itself.

Kiefer has shown an unfailing curiosity about the history of alchemy, but in the inaugural exhibition (2011) for White Cube's new gallery in Bermondsey, he turned his attention for the first time in twenty years to the mysterious figure of Fulcanelli. The name is a pseudonym, and Fulcanelli's true identity remains unknown, although the most plausible candidate is the painter Julien Champagne, whose most famous work, *Le Vaisseau du Grand Oeuvre* (1910) was a symbolic representation of the 'Great Work', the ongoing, collective project of the alchemists, the 'mystery of mysteries'. In the Bermondsey exhibition, Kiefer's 2010 sculptural ensemble of snake and egg was installed as an evocation of the idea of the 'Magnum Opus'. (According to Fulcanelli, this combination of elements symbolised the procedure that would render the 'universal medicine'.)

The rumoured connection with painting offers a tantalising clue to Kiefer's interest in Fulcanelli, although the most important work attributed to this elusive figure was the book *La Mystère des Cathédrales*, published in 1926, which has provided Kiefer with the overall title to the Bermondsey show: *Il Mistero delle Cattedrali*. Fulcanelli's thesis in this text is that the great cathedrals of France (Notre-Dame de Paris,

Amiens, Bourges) are themselves encryptions of the 'Magnum Opus'. Their builders, the original 'freemasons', are supposed to have incorporated into the statuary and stained glass of their porches and windows encoded instructions concerning the successive stages of the alchemical process. Perhaps the chief value of this text as a correlate for Kiefer's own preoccupations as an artist is its double focus on the weight of meaning carried by every detail of the workmanship involved and its emphasis on the bafflement experienced by the uninformed. The division between those who are included within the circuit of meanings generated by the work, and those who are excluded, relates to the transmission of hermetic symbols and doctrine as far as Fulcanelli is concerned, but for Kiefer it begs fundamental questions about the scope of contemporary art in relation to intellectual history, about the extent to which the language of visual art carries an intellectual message, and the extent to which that message is or is not legible. Fulcanelli identifies the motif of the labyrinth on the floor of Notre Dame in Paris as the symbolic crucible for these issues, both in terms of performing the alchemical task itself, and in terms of understanding the full scope, the widest possible implications, of the task for the alchemist himself:

> The picture of the labyrinth is thus offered to us as emblematic of the whole labour of the Work, with its two major difficulties, one the path which must be taken in order to reach the centre – where the bitter combat of the two natures takes place – the other the way which the artist must follow in order to emerge. It is there that the thread of Ariadne becomes necessary, if he is not to wander among the winding paths of the task, unable to extricate himself.[29]

29 Fulcanelli: Master Alchemist, *La Mystère des Cathédrales*, translated by Mary Sworder (Las Vegas: Brotherhood of Life, 1984) p.48

Emergence from the labyrinth, extrication from the web, is a matter of survival for the alchemist. But the artist who truly emerges from his labour has not preserved his individuality but sacrificed it. The artist who comes away from his work convinced of his own greatness, aware of his power and of the ways in which he might exercise it, is a failure. Success lies in recognising the unimportance of the individual artist, in coming away from the work with a feeling of being unequal to the power it has channelled. The individual artist can never be in complete control of the meanings he awakes by drawing on the language of symbols with a long history of previous usage. And the viewer of Kiefer's art is also drawn into a labyrinth, holding on to one thread of meaning or another, aware that the artist's own thread has been rewound in a way that is now irrecoverable; and just as well, since the artist's thread is only one among many.

Fulcanelli unwittingly sponsors Kiefer's activation of ancient symbols, of dormant mythologies and half-remembered narratives. And yet Fulcanelli was something of a rogue, a maverick who has been accused of plagiarism. According to André VandenBroeck, Fulcanelli borrowed and plundered the writings of R.A. Schwaller de Lubicz before publishing his own version of the ideas they contained.[30] Fulcanelli's subsequent reputation was founded on the revelations detailed in *La Mystère des Cathédrales*, but the possibility that this document is bogus has not deterred Kiefer from basing a series of works on its speculations. Kiefer has suggested more than once in interview that he never takes seriously the impossibly grandiose schemes of the alchemists or inventors of knowledge systems that have triggered his own epistemological meditations. In conversation, his habitual response to questions about their

30 André VandenBroeck, *Al-Kemi, A Memoir* (New York: Lindisfarne Press, 1990), pp.80–81

influence is an amused dismissal of their ways of thinking and working. But there is no doubt that his own paintings and sculptures take very seriously the scale of their ambitions, the intensity of their commitment, and the insatiability of their desires. When we stand in front of Kiefer's own work, we are not put in mind of an ironic distance from the impassioned research of the alchemists, but of a poignant regret that their experiments are doomed to failure. The tonality of Kiefer's work emulates the high seriousness of a spiritual calling whose beliefs it cannot ever assimilate itself to. In this connection, we should not take for granted the seriousness of Kiefer's claim not to take Fulcanelli seriously.

Kiefer's habitual tendency to situate his work in relation to long traditions of thought, and the compulsion he evidently feels to return to a shared interest in certain key figures and themes, suggests a deep-seated attraction to the idea of participating in a collective project bearing at least a formal resemblance to the idea of a 'Magnum Opus'. He is clearly fascinated by the collaborative impetus of the alchemical tradition while proclaiming his independence from it, and this sense of having to negotiate his own role in relation to cultural history is an important part of what makes him a 'modernist' painter, in the sense that accrues to that overused word in the context of literary history. There is no underestimating the status of the literary in relation to Kiefer's work as an artist; he has stated that the vocation of writer has always held an attraction for him equal to that of painter. Many of his canvases include a textual element, and when this is not limited to descriptors of objects or scenes, it often alludes to literary authors or texts (such as 'Vergil' or 'El Cid'), or consists of quotations (e.g. from Celan, Marinetti, Khlebnikov). It was very telling that Kiefer chose to inaugurate his *Jericho* installation at the Royal Academy, London, in 2007, with a quotation from T.S. Eliot's *Four Quartets*, steering perception of his wrecked twin towers

away from associations with the Manhattan disaster of 2001, insisting that they be seen in a much longer tradition of ruined cities. Eliot above all epitomises literary modernism understood as an assertion of continuity with ancient spiritual traditions. He also provides a crucial means of linking literary modernism with esoteric science, magic and occultism. Modernism's aesthetic conception of history as a process organised in terms of recurrent patterns or cycles is partly an inflection of a desire to be able to control and predict the movement of history. It prompts Eliot himself to install the importance of prophecy at the centre of 'The Waste Land', with his note on Teiresias, and his epigraphical allusion to the Sibyl of Cumae being parodied in the fortune-telling antics of Madame Sosostris; it motivates Pound to open his *Cantos* ('a poem about history') with Odysseus consulting Teiresias about the shape of his own future; and it drives Yeats to conceive of the pattern of history as a series of gyres, and to transcribe a series of texts that he believed to have been dictated to him by spirits.

In the terms provided by literary modernism, the work of art is never simply the conception and execution of an individual artist, but the embodiment of ideas and values accumulated by a tradition that speaks through the individual artist. And these terms are very close to those employed by Kiefer when articulating his own experience of painting. He has described the outcome of the process of painting as radically divergent from its original conception, and the process itself as a series of possible choices always involving a loss of control.[31] This sense of navigating between different currents of impulse and influence has both a practical and a conceptual dimension, and it is clearly a tension that Kiefer chooses to engage with on

31 See interview with Tim Marlow, December 2011, http://whitecube. com/channel/in_the_gallery_past/anselm_kiefer_il_mistero_delle_ cattedrali_2011_1/

a regular basis. It involves a degree of adaptation to existing templates of thought and expression that is very close to Fulcanelli's understanding of his own theory and practice:

> Besides, language, the instrument of the spirit, has a life of its own – even though it is only a reflection of the universal Idea. We do not invent anything, we do not create anything... What we believe we have ourselves discovered by an effort of our intelligence, exists already elsewhere.[32]

This is both an apology for plagiarism and a vindication of tradition, which allows almost no margin for individual expression, and identifies the medium itself (in this case, language) as the bearer of collective memory and aspiration. It echoes Kiefer's own accounts of the dynamic limitations and permissions of both his thematic materials and his daily practice of painting.

The works in the Bermondsey exhibition circle around five enormous paintings with no direct connection to the Fulcanelli theme. They are all studies of the interior of the abandoned Tempelhof building in Berlin. Kiefer's work has shown a chronic fascination with monumental interiors, making him perhaps the ideal recipient for Fulcanelli's treatise on the secret meanings of church architecture. But the history of Tempelhof might be thought to offer a counterpoint to that of the French cathedrals in its receptiveness to a succession of different historical and ideological narratives. Its name derives from the belief that the airport was built on land originally belonging to the Knights Templar, a fortuitous association that lends itself to Kiefer's preoccupation with hermetic lore. Initially set up in 1927 as the world's first terminal with its own underground railway station, it was soon conscripted

32 Fulcanelli, op. cit., p.43

by the Nazis into a new role as hub of the coming world empire, 'Germania'. The redesigned airport became part of Albert Speer's masterplan for the reconstruction of Berlin, but was actually the work of Ernst Sagebiel. The main terminal building, with built-in hangars, remains one of the world's largest architectural entities, forming a quadrant 1.2 km long in the shape of an eagle's outstretched wings. Paradoxically, it was rarely used for take-offs and landings during the Second World War, but its warren of underground tunnels was put to use as a factory for military aircraft, particularly Stuka dive-bombers. These tunnels were booby-trapped at the end of the war, when the airport was captured by the Soviets, as a result of which the lowest three levels of the complex have remained flooded until now. The airport's tainted association with the Nazis was redeemed when it became the focus for the Berlin Airlift of 1948–1949. A long post-war history as the main civil airport for Berlin was finally brought to an end in 2008, when it was scheduled for use as a People's Park.

Kiefer's Tempelhof imagery shows the stripped-out main terminal building, emptied of any visible signs of its historically imposed meanings, a receptacle for symbolism that is withheld. Resting on the surface of the canvases are various portentous objects whose supplementary status suggests that symbolism in this context is only ever a superimposition, an excrescence, not an integral part of the building's design, as Fulcanelli would claim for the medieval cathedral. The most conspicuous aspect of the painting beneath the superimposed objects is the extraordinary composition of the materials on the surface, typically a mixture of oil and acrylic with the generous admixture of salt, resin, lead, copper and terracotta. Like an alchemical recipe, this combination is designed to set off a series of reactions, a slow but sure alteration of form and colour that will change the appearance of the canvas in a long-term process of transformation.

Both Kiefer and Sagebiel himself have deprecated the idea that the eagle imagery of Tempelhof's architectural plan and of the sculptural group over its entrance derive from Nazi iconography. Kiefer introduced the same imagery into the Bermondsey exhibition by including his work of 1988–1989, *Sprache der Vogel*, and this had two consequences. In the first place, it provided an interface between Kiefer's own fascination with the protean cultural identity of Tempelhof and the alchemical belief in the existence of a language that 'teaches the mystery of things and unveils the most hidden truths'[33], the 'language of the birds', so-called because Jesus revealed it to his apostles through the Holy Ghost, conventionally portrayed as a dove. In the second place, it exemplified Kiefer's practice of drawing together works created at different times (for the Bermondsey exhibition, works from 1988, 1989, 1990, 1991, 1998, 2007, 2010, 2011) with the aim of revising their meanings, immersing them in a new configuration, a new set of associations, in order to release their potential for transformation. Both in terms of their symbolic content, and in terms of their material properties, Kiefer's works, which always seem to claim so much for themselves; always give every appearance of being definitive statements; in reality, they claim nothing more than their own instability, their own impermanence.

And in this respect, it is fitting that the most direct and emphatic reference to Fulcanelli in the Bermondsey exhibition should have taken the form of the most fragile embodiment of his ideas. The most mysterious and surprising section of Fulcanelli's text concerns the search for the 'universal solvent', the 'condensation of the universal spirit', known to alchemical tradition as the alkahest. In a remarkable passage, at the end of his commentary dealing with the cathedral at Amiens,

33 Ibid, p.44

Fulcanelli dwells on the necessity for the alchemist to work in the dark, and enumerates a range of examples of fecundation and generation reliant on darkness. He assembles several illustrations of organic process before culminating with one, very modern, example of an inorganic process: photography. His only interest in photography is what happens in the darkroom: 'when two gases, chlorine and hydrogen, are mixed, each preserves its own integrity as long as darkness is maintained; they combine slowly in a diffused light and with a violent explosion in sunlight.' It depends entirely on the presence or absence of light whether the salts of silver remain in an inert state, or whether they acquire an active, sensitive state. Kiefer has taken this incidental observation on the production of the photographic image and placed its implications at the centre of his sculptural ensemble *Alkahest* (2009). Kiefer's *Alkahest* upturns a crude vessel in order to pour out what is technically a liquid, lead – the alchemist's most notorious ingredient – in the form of a strip of film, a series of images printed directly onto the metal. The chemical properties of lead ensure that the images decompose at a rate much faster than is the case with the photographer's standard media; and the images are all of the sea, the most common solution of all, symbolically the most unfixed, uncontrollable, unpredictable of all elements. It is also the chief source of Kiefer's iconography in his previous two shows at White Cube, *Fur Khlebnikow* (2005) and *Das Meeres und der Liebe Wellen* (2011).

All of Kiefer's works accelerate the usual process of change to which the materials of art are subject, but the strip of film which is his substitute for the alchemist's alkahest is the most spectacularly degenerative of all his creations, and the more its images fade, the more ghostly they become, the greater their power to haunt the artist, and the greater magic they hold for us.

ALBERT OEHLEN: STORM DAMAGE

Albert Oehlen belongs to the generation of German artists that includes Martin Kippenberger, Georg Herold and Werner Büttner. Early in their career, they shared exhibition spaces, publications and jointly conceived projects. Iconographically and stylistically, there are many points of contact among their different bodies of work: an expansiveness of gesture, compositional energy, rapid execution, collision of abstract and figurative, raids mounted on both high and popular culture, an absurdist use of text. But what starts off looking like a group sensibility gradually disentangles into quite distinct attitudes towards German culture and the history of art. Institutionally, Oehlen and Büttner were exposed to the influence of Sigmar Polke, who taught them at the Hamburg Academy of Fine Arts in the late 1970s and early 1980s. Polke's mixing of registers, art-historical revisionism and systematic derangement of focus were all extremely attractive to Oehlen, but the extracurricular influence of Jörg Immendorff – whom Oehlen first met at the age of fifteen – seems to have had a more far-reaching impact on his work. Immendorff represented a systematic devaluation of the conventional means of producing meaning: a crudeness of technique, banalisation of subject matter, routine whimsicality and linguistic inconsequence. Oehlen's motivation in wanting to follow this line of experimentation was largely political; his early interest in anarcho-syndicalism was deepened through the absorption of Situationist ideas and an awareness of the work of Asger Jorn; the demystification of art and its interpolation into the practice of everyday life could only be achieved through

a deliberate lowering of standards and a constant adaptability to popular iconography. The decisiveness with which Oehlen has used painting politically as a medium for dialogue between what is culturally dominant and what he sees as emergent has necessitated abrupt changes of direction; this has resulted in a kaleidoscopic oeuvre that a conventional approach to authorial development would see as the product of indecision. Fabrice Hergott encapsulates this attitude in her formulation: 'Oehlen is not the master of a single style, unless, perhaps, it is that of shuffling the deck.'[34] The vocabulary of mastership is particularly apposite in this context; Oehlen's changing camouflage is the inevitable outcome of following the logic of history, but our sense of history arises always through interpretation, and so the most vital task for an art that is politically inflected must be to engage with the representations of those whose interpretations seem the most masterful.

Oehlen's work has been anchored regularly in allusions to the most pivotal figures of German art, particularly those of the twentieth century. A number of self-portraits align themselves with Beckmann and Dix; satirical motifs are taken directly from Grosz and John Heartfield (Heartfield is also a clear presence behind Oehlen's style of collage); anatomical reversals invoke Baselitz. But by the far the most revealing parallels are those established through the more sustained meditations on issues raised crucially in the practice of Kiefer and Richter. Oehlen's earliest paintings show a commitment to the kind of tonality found in Kiefer's work, although the historical weight bearing down on the older painter's imagery is deflected in various ways. The 1982 canvas, *The morning light shines into the Fuhrer's headquarters*, displays the kind of architectural interior now associated readily with the Kiefer repertoire, but in place of a

34 Fabrice Hergott, 'The Silent Hand' in *Albert Oehlen*, ed. Burkhard Riemschneider (Koln: Taschen, 1995) p.37

sense of occlusion and confinement, of historical entrapment, the aerated corridor of Oehlen's projection suggests a deserted space, an abandoned signifier, the possibility that history has moved elsewhere. The closely related work, *Space for imaginative ventures* (1983), superimposes an alternative geometrical arrangement of lines over the rigid perspective of the same architectural venue, but also includes the disturbing detail of arms reaching up in implied suffering from the surface of the floor. If the Kiefer interior suggests the entombment of the German psyche, Oehlen's variation stresses the permeability of thresholds and barriers, the seepage of history into the spaces of everyday life, its escape from the stereotypes in which it is too often confined. Several of Oehlen's early canvases do exist in an atmosphere whose composition matches that of Kiefer's. *Agricultural Museum* (1981), with its receding exhibition hall bisected by the landscape vistas of paintings on its walls, conjures up very powerfully the bicameralism of Kiefer's perception of German culture in terms of an imponderable past and a dreaded future; the present is experienced as no more than an interval of suspended animation, waiting for the future to stir from the roots of the past. There is an equivalent recognition of the present as elision, merging aftermath with anticipation, in *Storm Damage* (1981), where the wreckage of botanical forms is deeply paradoxical, suggesting a powerfully sprung resilience, as if catastrophe should be understood primarily as a challenge to renewal. Most graphically of all, *The dismantling of a military dictatorship* (1984) is almost physically clogged with menace; the toppled statue seems like a sideshow that does nothing to divert apprehension of a total environment of subjugating anxiety; an ecology of oppression. In this canvas, Oehlen comes closest to a use of Kiefer's palette, ranging narrowly between rusts, ochres, blacks and browns.

But the chief purpose of these melodramatic gestures emerges in their businesslike juxtaposition with obsessive

studies of objects and scenes in which we do not expect history to collect and distil. The same intensity and a brooding suspicion of cryptic meaning infuses the utilitarian settings of *The washing and changing rooms under the engine factory in Rosenberg* (1981) and of *Carpet Store* 1 (1984), which focus visually on principles of replication and uniformity, and on the products and facilities of an unstoppable momentum which is absent, but which subjects its unseen producers and consumers to forms of discipline other than the merely visual. Perhaps the most powerful of these displacements of the threat of history are *Fence* (1982) and *Hair* (1986). In the first, the psychic divisions of the post-war settlement seem more insurmountable in the image of a garden fence than they do in the overinvested iconography of the Berlin Wall. The horizontal columns reproduce those of *Carpet Factory* 1, implying the ubiquity of estrangement in the industrial, commercial and domestic spaces of German daily life. History comes from within, from within the home, and even from within the body, imprinted with a cultural legacy that transforms the hair into an alienating screen that completely blocks out the rest of the world, and that resembles nothing so much as one of Kiefer's ploughed fields in which nothing is ever likely to grow. Kiefer's scale of significance is that of imperial grandeur, while Oehlen's is that of microscopic reduction and of the negotiations of everyday life, in an arena where history is not simply reflected but perhaps meant to be tackled, and even reimagined.

Oehlen's relationship with the work of Richter post-dates the latter's composition of his notorious sequence of paintings 18. *Oktober* 1977, which includes portrayals of the bodies of members of the Baader-Meinhof Gang found dead in their cells in Stammheim prison on the date in question. The paintings were completed in 1988, and are all based on black-and-white press and police photographs. Richter's decision

to make his canvases so obviously treatments of photographs is partly a comment on the general historical significance of photography as a development which simultaneously gave painting a greater autonomy and freed it more readily to follow the path of pure abstraction, while also condemning it to a corresponding loss of relevance or function in sociocultural terms. By making the paintings adhere more or less to the forms given by the photographs, Richter is proposing that the avant-garde autonomy of art is an illusion, while at the same time his painterly distortions stress the constructed nature of the images created by the photographer. A little less than ten years later, Oehlen began a series of oil paintings which use exactly the same restricted palette in a deliberate attempt to test the limits of Richter's experiment: 'He conceived the gray works by wondering what Richter... would do if the space of the painting took off in all directions.'[35] Richter's paintings are elegiac, in an eerily impersonal way; they are also still lives (quite literally, *natures mortes*). Their premise is a moment of stasis which reflects the photographic illusion of capturing a moment in time. The blurring of outline is intended primarily to subvert the authority of the photographic image as the culturally dominant medium for recording historic events. Oehlen's blurring, much more energetic and sweeping, produces a similar effect to that of a multiple exposure. His paintings subvert the tradition of fixing coordinates, stabilising the image, securing the outline, that misrepresents the reality of perception. It is only art that introduces an artificial stasis into the dynamic process of apprehension and cognition; an art whose history predates the photograph by thousands of years, although the camera both accentuates and renews the authority of historical practice. Oehlen's canvases seem to allude directly to Richter's motifs in

35 Bonnie Clearwater, in *Albert Oehlen: I Know Whom You Showed Last Summer* (Miami: Museum of Contemporary Art, 2005) p. 11

several ways: in *Untitled* (2004) one or more anthropomorphic forms seem to be cloaked in a flag inscribed with the letters FRA, possibly anagrammatic for *Rote Armee Fraktion*, while *Dying Chrysanthemum* (1999) is typical for its deployment of a radiological attitude towards the layering of imagery; a bunch of flower heads is transformed obscurely into a group of death's heads, at once revitalising the paradox implicit in the idea of 'still life', and illustrating the tendency of art to settle institutionally for the most conventionally assimilable forms of visual technology. Oehlen superimposes different methods and planes of perception, refusing to allow the radical potential of an X-ray-style vision to be fully recuperated. Canvases such as *Bread* 1999 and *The Red Cloud* (1999) bring out the true scope of this stratification of the picture plane; details of domestic interiors and incomplete human forms collide and dissolve, failing to fuse together in the same dimension; they are curiously reminiscent of early twentieth-century experiments in psychical research; attempts to capture the visible forms of the spirit world. And the motivation is not dissimilar; Oehlen trains his conceptual focus on the uncanny elements of the overfamiliar; on the unexpectedly routine habitats of the spirit of history. At the same time, the starkly disjunctive titles imply the fundamental, ubiquitous and deceptively inconspicuous scope of this politicisation of everyday life. If Kiefer and Richter are concerned primarily with representations of the symbolic moments in German history, Oehlen's role has been to trace the multiple and minuscule formations of sensibility by means of which ordinary people see, think and feel within their particular place and time. If the older generation resembles a cadre of state historians, Oehlen must be an historian of the cultural phenomenology of German life, of the way people walk and use their hands, of how they inhabit their bodies and their apartments.

Oehlen has continued to paint in a spectrum of greys, but in

his polychromatic work of the last ten years he has gone even further in communicating the experience of constant change that his early work casts in a largely political light, but which is now the focus of a more broadly based epistemological radicalism. Once again, a contrast with the recent work of Richter, this time of his large abstract paintings, provides a means of navigation. Richter's spilling and spreading colours are methodically flattened and laminated, built up with an almost archaeological sense of complexity. However, the palimpsest is only ever seen from the same point of view, as a subject of contemplation, and nearly always assumes the character of a series of screens, with a greater or lesser number of tears and openings in the fabric, although these are never located in a pattern that allows one to see right through, even in the imagination. There is more depth and volume, more space around the individual marks in Oehlen's recent work, although these are so teeming and polymorphic that they almost touch and fill the space, like vapour about to condense into more solid form. There is nothing like the strict regulation of horizontal and vertical found in Richter; in fact, the overwhelming impression in Oehlen is of particles travelling in all directions, either to converge or to diverge endlessly; it is as if the formation of matter is about to take place or has just been thrown into reverse, in an irresistible implication of the infinite capacity for transformation of artistic form. These are paintings whose final condition is accidental yet precisely determined by the velocity and trajectory of elements whose relationship is unique in time and space. Any one of them could form a world, the significance of which it is the viewer's responsibility to shape, guide and inform with value; always bearing in mind that the scope of this responsibility is precisely a questioning of mastery.

LAURA OWENS: AGITPOP

Laura Owens was born in the Midwest (Euclid, Ohio) and studied first in Rhode Island and Maine, before moving in 1994 to the California Institute of the Arts, at Valencia. She has been based in California for nearly three decades and it must be said that the environs of Los Angeles seem like a natural habitat for the styles and concerns of her work. It is precisely because California is an artificial landscape, an oasis constructed out of a desert, importing trees and plants from all over the world to create an eclectic terraformed background to its iconic suburbs, that it accommodates so readily the scope of Owens's work. Many of her paintings use landscape elements as a major part of their subject matter, but in a breezily oneiric manner. They reflect certain aspects of the familiar world, but at the same time offer blueprints for an entirely imaginary one. This is not a distortion but an accentuation of a southern Californian reality in which every view out of the window is a reminder of invented geographies and of uncontrolled climate experiments. Characteristic works such as *Untitled*, 2002, which collates freely examples of the 'wrong' fauna and flora (bears, monkeys, owls, rabbits, squirrels, tortoises, bare trees and blossoming flowers), amount to a denial of the Western tradition of landscape painting, which is closely allied to the projects of taxonomy, mapping, measurement: all forms of laying claim to territory through the medium of precise knowledge. The essential subject matter of this tradition is *natura naturata*, nature recast by man's desires: a California of the mind. Owens's paintings abandon this schedule and

these desires altogether, clearly preferring the possibilities inherent in the concept of *natura naturans*, the concept of a nature still unfinished and developing creatively, in a way that is unpredictable and beyond humanity's control. This Edenic alternative, while seeming to reflect a West Coast hybridity, actually subverts the conditions of landscape design in a celebration of non-human forms of coexistence. Owens's transformation of the idea of the Fall, of a natural history guided by human history, is suggested in a key painting, *Untitled*, 2006, in which an Edenic couple do not reconfigure the world around them through sexual knowledge, but are absorbed into it as much as they are absorbed in each other. The iconography of this lavish tableau is tellingly borrowed from Hindu traditions of representation, from a culture that thinks in terms of a common purpose for humanity and nature. Owens's quirky pastorals have a characteristic legerity and a seemingly inadvertent disrespect for evolutionary logic, but their diverting quaintness is actually fuelled by a very serious interest in principles of deregulation and of insubordination.

If the city of Los Angeles is remarkable for having pioneered the destruction of public space in the process of serving the security interests of corporations and middle-class residents, this is precisely the kind of encroachment on the possibilities of interaction, and on the opportunities for free play, that Owens's work might have been designed to flout and undermine. According to Mike Davis, in his classic analysis, *City of Quartz* (1990), post-war development in Los Angeles has been geared progressively towards eliminating the possibilities of mixing classes and ethnicities, through the creation of gated communities, fortified institutions and panoptical shopping malls. This privatisation of public space has been matched by the safeguarding of electronic space in evermore sophisticated provision of passwords, firewalls, virus detectors, etc. Revealingly, it is the totalising system

of the internet that Owens would like to break apart and cannibalise in her characterisation of American social politics. In a remarkably explicit essay, 'A Painter's Vote', published in *Art US* in 2004, she made clear the degree of her political activism, emphasising her vehement opposition to the imperial politics of Rumsfeld and Cheney, and nailing her colours to the mast of what she described as Howard Dean's 'bottom-up organizational structure [that] found its partner in the inherently DIY, rhizomatic, *social* structure that is the internet'.[36] The connection with her painting that is inherent in this overt commitment to micropolitics lies in the essential porousness of her imagery and stylistic repertoire. Laying aside the usual array of cultural markers by means of which artistic identity is determined by geographical and historical means, Owens provides a calculated disarray of motifs and techniques, quite deliberately mixing a variety of the 'wrong' art traditions: non-Western, non-urban, ethnically diverse. This systematic browsing among mutually estranged traditions should not be confused with a postmodernist form of bricolage, where the experience of difference is replaced by the commodifying of cultures whose distinctiveness is subsumed in their equal availability for consumption. Owens's allusion to Deleuze and Guattari's concept of the *rhizome* indicates her approval of non-proprietorial, non-hierarchising forms of attention, of an attitude towards multiplicity that sees it as the fundamentally animating principle of an art that could offer resistance to contemporary forms of social control.

The mixing of styles and motifs is not limited to ethnic and geographical assortment, but is equally insistent on transgressing boundaries between 'high' and 'low' culture; much of the vitality of Owens's work comes from its fascination with

36 Laura Owens, 'A Painter's Vote', *Art US* (January – February 2004) p.39

the colloquial registers of folk art, handicrafts, sign painting, etc. Of course, it is often very difficult to weigh the meanings of these different elements; but that is an important part of the reason for including them. Individual motifs that might be emblematic in one context, are given another context, or even several, by means of constant juxtaposition with competing claims for the attention. The difficulty, and even the impossibility, of knowing what to focus on, is a carefully cultivated aspect of Owens's aesthetic that is reflected at the level of technique in paintings such as *Untitled*, 1999, where the problem of discrimination (of identifying the cultural source of any given element) is pre-empted by the use of abstract forms. But if the heterogeneousness of canvases like this one seems merely formal, the task of subordinating certain elements to others is still obstructed by the inconsistency of technique, whereby paint is sprayed, washed, spread, brushed, squeezed and inscribed onto the surface of the picture, playing havoc with one's received ideas about how to relate to one another the many different layers of mark-making. The separate incidents in the painting are like objects swimming on the retina; the moment one tries to fix them in view, they change their place in the whole ensemble. The 'molecular' painting *Untitled*, 1998 and the 'numerical' painting *Untitled*, 1999 dramatise a parallel effect, in a more schematic, though elegant, form. Owens destabilises the figurative elements in her paintings by constantly dislocating the relations between them, instigating a devolutionary campaign against the history of Western aesthetics. And she destabilises the abstract elements in her work through a structural hesitation, leaving us permanently uncertain which parts of the composition are more load-bearing than others.

In her subsequent exhibitions, Owens has shown an enthusiasm for using paint to interpret the conventions of other media, such as tapestry, embroidery and printing.

Many of these recastings have a surprising anecdotal power. Although she is not a narrative artist – and even when she borrows from narrative art, this is always with a view to producing an extract, or abstract, that contradicts the basis of narrative form – her choice of images often evokes historically specific uses of visual culture for storytelling purposes in what was basically an oral culture. The most obvious example of this would be the 2006 painting of one section from the Bayeux Tapestry. Although there is an element of nostalgia in this recapturing of the scope and appeal of the language of visual representation, accentuated by Owens's magnifying of the dimensions of the work, its chief impact is to restore a sense of the desirability of a community of interpretation that is not exclusive or privileged. Storytelling art assumes or proposes a stock of knowledge and techniques that will both elicit and confirm the communal nature of the world it constructs. Owens's resort to clear and decisive uses of forms of vernacular art suggests a desire to reverse Walter Benjamin's diagnosis of the shift from the position of the storyteller to that of the novelist; the shift from orality to literacy means an expansion in the size of the audience, but equally an atomisation of the audience into a host of solitary readers, while the scenario of the storyteller in direct communication with those who listen to the unfolding of the tale, reflects a very similar sense of scale to that of the grassroots local politics that Owens hopes to see coming alive in the heartland of corporate America. The Bayeux tableau has a strikingly modern freshness and audacity, but is still very distant in cultural historical terms. Much closer in time, and more familiar, are those residual forms of a popular culture dependent on a close and active relationship between artist and audience; many of Owens's subsequent paintings siphon off images from the visual repertoire of the circus, vaudeville, fairground attractions and theatrical set-painting. These are the scenes of improvisation and intervention, of a

carnivalesque potential to cross the boundaries of genre, of decorum, of the imagination's apartheid. Owens's festive comedies of cultural identity have the same iconoclastic scope as the kind of vulgar performance celebrated by Mikhail Bakhtin in his seminal text, *The Dialogic Imagination*: 'at the same time when poetry was accomplishing the task of cultural, national and political centralization of the verbal-ideological levels, on the lower levels, on the stages of local fairs and at buffoon spectacles, the heteroglossia of the clown sounded forth.'[37]

In some ways this description of Owens's working practices makes her sound like one of Nicolas Bourriaud's 'semionauts', whose artistic endeavours consist of clearing original pathways through a forest of existing signs. Bourriaud's conception of 'postproduction', whereby contemporary art is characterised by the production of new artworks on the basis of work created already by others, has currency at the moment, not least because of its amenability to comparison with ways of using the World Wide Web. The contemporary artist operates like a DJ engrossed in sampling and pasting together a range of different recorded sounds, or like the web surfer who devises a series of links through the plethora of data supplied by different search engines. And yet, despite Owens's own attraction towards the idea of blogging her way into the history of art and bookmarking her way out of its conventional sequences and filiations, her handling of paint and collaging of different materials gives her work a texture, a grain, that places it simultaneously in relation to much older traditions of fabrication, and of artisanal craft. In fact, the more her work seems correlative to contemporary theoretical developments,

37 Mikhail Bakhtin, *The Dialogic Imagination*, edited by Michael Holquist, translated by Caryl Emerson and Michael Holquist (Austin: University of Texas Press, 2001) p.273

the more she seems to take pleasure in the handling of different materials and in an increasing versatility of technique. There is more than one sense in which her prodigious output makes this artist look like her own workshop. Laura Owens converts the idea of the individual artist into an entire team of her own assistants. The principle of collaboration extends beyond the scanning and revising of pre-existing visual conventions to include active participation in the visual predicates of work already hanging in the spaces where she has exhibited. During her residency in 2000 at the Isabella Stewart Gardner Museum in Boston, she exploited the Art Nouveau decorative backgrounds to the salon paintings of the same period, while a commission in the same year for The Royal Botanic Garden in Edinburgh involved triangulating her own work with that of the botanical teaching diagrams of John Hutton Balfour, and the designs of the gardens themselves. This is not so much 'postproduction' as creative interference; even a kind of interpellation that contributes to something already in process while also disturbing it. Owens has the reputation of a rather light-fingered entertainer, but this appreciation of the seductive qualities of her work does not always register its agitpop dimensions, or its subtle but steady tendentiousness.

MARC QUINN:

THE (IN)COMPLETE WORKS OF MARC QUINN

The prosthetic imagination is the most overworked faculty in the history of Western sensibility. The sculptural ideal has been transmitted through images of truncation; the perfection of classical modelling has been understood by means of a crude platonism; the viewers of the *Venus de Milo*, for example, project the unmaimed original of the historical remnant.

The title of Marc Quinn's series *The Complete Marbles* (1999– 2001) in itself issues a challenge to preconceptions, since it contends that the dynamic relation between the presentation of the work and its reception supplements what is missing, projects a wholeness that is not dependent on merely visual or physical evidence.

The contemplation of a sculpture of one blind from birth (*Mirror for the Blind: Anna Cannings*, 2005; *Mirror for the Blind: Bill Waltier*, 2005) helps the viewer to realise the necessity for reading its volume, material composition and reference to an individual history as well as, or perhaps before, its surface appearance.

A marble statue, no matter how finely rendered, is a cold, blockish substitute for the warm tissue it represents. It is the nature of the hard, smooth material, rather than its mass and the space it occupies, that enhances the disbelief we are otherwise willing to suspend in reading the likeness it gives promise of. We are acclimatised to marble as an alibi for flesh almost as completely as we take for granted the desirability of a physical symmetry that cannot be attained in nature. Marble

has played a unique part in our cultural evolution. It was the selection pressure that enabled beauty of form to predominate over expression of function.

Perhaps the two most remarkable groups of figurative sculptures produced in Britain in recent decades have appeared contradistinctive while being directly complementary. The biological fantasies of Jake and Dinos Chapman have included single and conjoined figures equipped with various supplementary organs that satirise the prosthetic impulse in Western attitudes towards the human form. The sculptural portraits of Marc Quinn have arrested that impulse by the provision of living referents for the aesthetic reception of body parts and incomplete torsos. Their candidness is both physical and conceptual, a reflection not simply of carving and polishing but also of documentary adequacy. The Chapman brothers are indebted to the traditions of the grotesque and the carnivalesque, with their emphasis on the body as a system of appetites, caught up in a perpetual transaction with the material world through a variety of forms of ingestion and expulsion. Marc Quinn has subverted the alternative tradition, that of the self-contained classical body, literal embodiment of the will to order, monumentally asphyxiated by the thin air of the ideal.

His uncanny simulation of a hyper-classical perfection nonetheless involves a kind of displacement of the artist from tradition, since the actual carving is performed by Italian stonemasons, working from casts provided by Quinn. The artist's removal from the final stage of fabrication seems to locate his primary responsibility in this act of casting. The cast is the medium in which the classical tradition was most often experienced before changes in museum practice during the twentieth century. Several major galleries still retain at least one room crowded with nineteenth-century casts. The Victorian enthusiasm for plaster was not confined to preserving the remains of antiquity, but was equally vigorous in its desire to

cast from the life. The three-dimensional freeze-frame that captured the vital statistics of an unrepeatable individual was especially popular during an era that embraced the capacity for the mass production of the work of art. This paradox is central to the composition of *The Complete Marbles*, since the mechanical fidelity of the cast is succeeded by the necessary adaptations of the individual craftsman. The issue is resumed in twenty-first-century form by the implications of cloning, for art no less than for medical ethics. Casting is an integral component in some of the most eloquent and authoritative artworks of the last two decades, ranging from the congestion of architectural space in the work of Rachel Whiteread to the engorging of bodily forms, especially in the signature projects of Marc Quinn.

≈ GENETIC SCULPTING

The remarkable impact of Quinn's work inheres partly in the organising paradox at the centre of his activity: he is an experimental, conceptual artist whose work is almost exclusively figurative. His working within the parameters of figuration seems to ensure the readability of individual sculptures, although these always turn out to be operating to a greater or lesser degree at subtextual levels. The enhanced legibility of the human form has enabled Quinn to enter the art world, and the art market, and to re-enter periodically the atmosphere of critical reception, with a series of *coups d'œil*. The first such intervention was the presentation of *Self* at the *Sensation* exhibition in 1991; this mould of Quinn's head, filled with nine pints of his own blood, was both visually stunning and psychosomatically unsettling. It was echoed in 2002 by the portrait of the artist's son, Lucas, which used a mould of the child's head as a container for his own placenta.

Equally as dramatic was the use in 2004 of the vacant plinth in Trafalgar Square for a scaled-up version of one of Quinn's marble studies of Alison Lapper, the disabled artist with no arms and unusually shortened legs. But in many ways the most provoking assault on audience expectations came from Quinn's decision to install his most celebrated non-figurative work, *A Genomic Portrait: Sir John Sulston* (2001), in a gallery dedicated entirely to figuration, the National Portrait Gallery.

This visually muted composition bears no immediate resemblance to its subject, but is nevertheless a portrait in a true sense, since it consists of several strands of DNA in agar jelly. It represents the identity of an individual not through attention to visible signs of character, or to social and cultural markers, but in terms of basic cellular structure. In this it is a more authentic representation than examples of a figurative tradition which rely on conventions of interpretation frequently discredited. There is no guaranteed way of reading a face or body, since interpretative codes are subject to historical change. Quinn's change of focus is in line with our growing awareness of the extent to which microstructural and macrostructural pressures on the formation of the self are of no less significance than factors of race, nationality, gender, class and age. Sulston's genetic signature is both an index of uniqueness and a reminder of the overwhelming degree of physiological overlap between all humans. Quinn's related work *DNA Garden* (2002) includes among its bacteria colonies seventy-five examples of different plant species and two of different humans, extending still further the basis for identification of the self by emphasising the broadly genetic similarity between humanity and other forms of life.

The extraction of Sir John Sulston's DNA is in itself a cultural marker of his claim to celebrity as the inspiration behind the Human Genome Project. But the mirroring by art of a scientific procedure is an appropriate gesture during an

era in which both discourses and activities have been drawn towards the philosophical and ethical status of the replica. We are still possessed of the Romantic conception of the artist as original genius whose works acquire value in proportion to their uniqueness, despite the development of mechanical means of reproduction which flood the market with exact copies. When the relation between replica and point of origin is questioned, identity is diluted and value is undermined. If the extraction of DNA is the first step towards cloning, then Quinn's artwork appears to reverse the usual relation between original and replica, since his portrait is a kind of vertical petri dish conserving the means with which to cultivate a new original. There is an analogy here with the function of simulacra in contemporary culture, whereby constructions of the self are influenced by models circulating in the media that do not refer back to actual, lived existences as much as to daydreams of what people would like to be. Crucial in fuelling the circulation of these models is the value invested in celebrity. Quinn's study of replication resembles a living reliquary; by placing it in a shrine of celebrity, the National Portrait Gallery, he is arguing for the total nature of our contemporary fascination with the recomposing of the self, in a process that has reached critical mass as a part of our cultural evolution.

≈ THE NATURE OF ARTIFICE

Garden (2000) mounts a challenge to evolutionary theory, in a spirit equivalent to that of the touring exhibitions of so-called 'happy families' so popular in Victorian Britain. Cages were filled with a variety of birds and animals, deliberately mixing predators and prey. The point of the exhibition was to demonstrate the untroubled juxtaposition of creatures that would normally be in fierce competition in a natural setting. The peaceful coexistence

of these blatantly incompatible species appeared to defy the understanding of nature in terms of constant rivalry and victimisation. But, of course, the point was lost without tacit confirmation that nature really was 'red in tooth and claw', and that evolution was a narrative of power struggles. Quinn's *Garden* conveys a similar effect, but without the crass showmanship. Plants from a range of diverse habitats are introduced into the same environment without adverse reaction. This adaptation is primarily a revision of the conventions of the traditional still life that assembles a medley of dead animals and freshly cut flowers; Quinn's refinement occupies the interval between life and death, between the incipient decay of the *nature morte* and the false vitality of the 'happy family'. This interval is the limbo of suspended animation, of cryogenic removal from the effects of passing time. The vividness of the colours and the resilience of form are entirely dependent on refrigeration. If this control over organic process, this retarding of the gradual but inevitable fact of degeneration, seems unduly artificial, then its reliance on technology is nothing less than a sign of its complete assimilation to the ever-changing conditions of evolution. As Quinn's work keeps on showing, with an increasing versatility, the evolution of humanity has been in symbiosis with the machine; for both good and ill, the prosthesis is second nature. Perhaps the most complex issue that arises from the technologising of human biology is the question of agency, of the balance between active and passive, voluntary and involuntary, in the scope of humanity's involvement in the process. Closely associated with the Edenic removal from history that Quinn achieves through freezing his specimens, are the several paintings of 'impossible' gardens making use of specially developed 'permanent' pigments that will fade at a fraction of the rate of conventional paint. The natural history of art is a record of the gradual disappearance of colour. It is appropriate that Quinn's most ambitious work in this genre, *The Overwhelming World of Desire*, an enormous

representation of the orchid variety Paphiopedilum Winston Churchill, should have been erected high on the South Downs at the Goodwood Sculpture Park. The Downs makes an ideal habitat for various natural varieties of orchid: the Early Purple, the Pyramidal, the Lesser Spotted. These are all attracted to the thin soils, the paucity of rich nutrients, the relative lack of competition from other species. The point about the Winston Churchill is that it is an artificial hybrid, a contrivance whose real habitat is the imagination of its creator. In plant-breeding, as in sculpture, the fake is often the real thing. This is spectacularly the case in the world of orchids, where the artificial varieties outnumber the natural by about six to one. What this suggests is that humanity has taken over the orchid and changed its character. But the opposite might be the case. The fact is, the orchid has been phenomenally successful in evolutionary terms. It is one of the earth's oldest flowering plants, and its astonishing popularity during the nineteenth and twentieth centuries might be a reflection of its ability to attract and employ ever more efficient pollinators: once, the desires of insects, now, the desires of humans, are under its control.

This ambiguity affects the way we react to the size of Quinn's sculpture – it is no less than twelve metres high. Standing among ash trees and rivalling them in height, *The Overwhelming World of Desire* looks Jurassic both in dimensions and in its aggressive colours. This could be the result of *braggadocio* on Marc Quinn's part, or it could be proportionate to the balance of power between humanity and a plant which so brilliantly utililises human desires, often in an alarmingly direct fashion. Quinn's plant has disturbing echoes of several human sexual characteristics, including a vast yellow tongue emerging from a red cup fringed with dark hairs. The flatness of this gigantic cut-out in stainless steel belies the fundamental complexity of response it urges on the viewer.

Quinn's major publication, *Incarnate* (London: Booth–Clibborn Editions, 1998) includes two photographs of *macchine anatomiche* in the Cappella Sansevero in Naples. These are skeletons festooned with hundreds of ramifying blood vessels reproduced in the form of delicate metal tracery. The veins have been cast by means of pouring hot metal into the arterial system and then allowing it to cool. Each *macchina* has been placed inside a gilded frame as an example of the anatomist's 'art', and is displayed in the company of paintings and sculptures in more conventional media. The method and materials clearly anticipate Quinn's use of blood and other bodily fluids in his representations of the self, especially in the first half of his career. The stripping away of the body's outer coverings, the focus on underlying substance and structure, form part of a gesture towards universality, both by echoing the motifs of the *memento mori* tradition, and by emphasising materials that can be exchanged, transfused, transplanted, without apparent loss of individuality. The first face transplant at Amiens in France (2005) raised questions about the extent to which identity is invested in corporeality precisely because it involves a grafting of surface details. But the Cappella Sansevero houses other artefacts of equal significance for the understanding of Quinn's practice. Far more numerous, and in their different way equally as engrossing, are the examples of eighteenth-century Neapolitan sculpture epitomised by Giuseppe Sanmartino's *Il Cristo Velato* (The Veiled Christ). Commentators on *The Complete Marbles*, and on Quinn's subsequent series, *Chemical Life Support*, have referred to the work of Antonio Canova as a basis for comparison with the British sculptor's evident desire for an almost glacial flawlessness, for embodying his figures inside an exquisitely impermeable membrane. But Canova himself sought to emulate Sanmartino, whose *Il Cristo Velato*

he wanted to buy. This extraordinary composition shows the body of Christ covered entirely with the representation of a veil so fine as to appear diaphanous. Its airy lightness has a profoundly ambivalent effect, accentuating the contours of the underlying figure but functioning also as a metaphor for the provisional nature of physical existence. It seems to suggest that the skin itself is no more than a veil, that the concerns of the individual are no more than a superficial wrapping around the more fundamental reality of a common condition and a common fate. Quinn's later sculptures in marble and polymer wax have achieved a similar resonance.

Both materials seem to absorb light, especially the polymer wax, whose slightly translucent quality resists the play of light and shade and blanches out the record of individuating detail. The surfaces of these immaculate bodies lack any visual basis for differentiation, returning an effect of uniformity to the viewer's gaze. Although clearly derived from information about age, gender and medical history that makes their subjects unrepeatable in all kinds of ways, the sculptures themselves are unnervingly generic. Twentieth-century sculpture showed extensive engagement with ideas about the standardisation of humanity, but mostly in terms of the social and political pressures for uniformity. One of the founding texts of this tradition of thinking about modernity was Heinrich von Kleist's *Treatise on Marionettes,* echoed in Bruno Schulz's *Treatise on Tailors' Dummies.* The mannequin became the vehicle for representations of loss of agency, alienation, replaceability, and was particularly evident in Eastern European art, in the work of Tadeusz Kantor, for example, and of Mirosław Bałka. A Western variant can be seen in the photogenic exactitude of Robert Gober's wax models, whose hyperrealism renders particularly disturbing their disclosure of estrangement within the everyday. But Quinn's twenty-first-century meditations reconfigure the lines of stress

between individual and collective identities. The scope of his work is marked out by attention to the opposing perspectives of species awareness and microbiological fingerprinting. From one perspective, individual divergence from type is virtually infinitesimal, while from the other, the self is a meeting place for chemical reactions that have no exact parallel. The fundamental axiom of *Chemical Life Support* is that each sculpture should be created using the precise combination of elements found in the body of the named subject.

The chemical composition of each sculpture is precisely unique, despite the uniformity of finish and tone. It is these hidden differences that ensure the survival of those being portrayed, while also allowing them to pass as unremarkable, the same as anyone else. Quinn has deepened the sense of paradox that governs the viewer's experience of his work by posing his subjects in ways that make them available for inspection while hinting at obliviousness; they are undeniably exposed but also self-communing. Undoubtedly, the most troubling visual element of the sculptures is their horizontal posture. The bodies are not subject to gravity. Although they rest on plinths, there is no physiological rationale to the elevation of limbs or the way that relaxed muscles appear to resist the pressure of body weight. This makes them seem unfettered and free-floating, but also vulnerable; unconscious or lost in reverie, they have substituted pharmaceutical for umbilical dependence. Although relying on medical science to build their lives, they are constructed no less movingly by the perceptions and attitudes of those who surround them.

There is a genuine complexity to the growth of Quinn's oeuvre, whereby every apparent diversion into new techniques, forms or subject matter ends up contributing to a resumption of many of the same themes and ongoing concerns. To track the succession of projects is to see an accumulation of weight behind the meditation on completeness and incompleteness, surface and depth, originality and imitation, nature and artifice, the animate and the inanimate. It seems entirely appropriate that the next phase of this development should itself be concerned with the logic of the return. The bronze sculptures derived from casts of frozen animal carcases struggle with the invasion of meanings that assail them from the history of art. But the viewer's attempt to stabilise the meaning of each work through the context of tradition makes them complicit with a violent wrenching of the abject into contact with the desirable, and of meat into contact with spirit. Quinn's *Flesh* series, shown as a group at the Irish Museum of Modern Art in 2004, is firmly in the tradition of Ovid's *Metamorphoses*, a text that consolidated, if it did not actually inaugurate, the prehistory of artistic speculation about the relation between the material and the immaterial. The imagining through myth of the coexistence of spirit and flesh produced a congeries of scenarios in which various gods inhabited the physical forms of animals, birds and trees. The secular extension of this tradition endowed the same objects with a metaphorical freight of qualities recognisably human rather than divine. This anthropomorphising of nature had become so routinised by the mid-nineteenth century that Ruskin would complain bitterly in *Modern Painters* of how the spread of the 'pathetic fallacy' was almost beyond recall. And yet the bronze menagerie of Marc Quinn embraces the dilemma with a constantly renewed strength of purpose.

The butchering, manipulating, freezing and casting has not removed a sense of alien existence despite the very human persistence that is seen willing these animal remnants into their choreographed afterlife. The viewer cannot ignore the art-historical matrix from which these gestures of reclining, cradling and balancing have been taken. And yet to accede to the invitation of these echoes is to connive at a form of appropriation that turns these pivotal tableaux into spectacles of power. If *The Complete Marbles* plays on the subtle insinuation of criteria of selection and rejection that relegate the value of lives lived without conventional abilities, the *Flesh* sculptures advertise the use of sheer force. Thus, the *Mother and Child (Rabbit and Lamb)* (2004) seems grotesquely abandoned by the compassion that is ordinarily correlative with this prototype of care and tenderness. *Standing Figure (Rabbit)* (2003) proposes, quite astonishingly, a relationship with Rodin's portrait of Balzac, whose authorship of *La Comédie Humaine* – deliberately contrasted with the title of Dante's epic *La Divina Commedia* – emphasised flesh rather than spirit. Quinn's rabbit is made to emulate the earlier statue's monumental posture, suggesting the undeniable weightiness of Balzac's analysis of the weaknesses and failings of humanity. And yet its greatly magnified scale only serves to underline its own vulnerability, its incongruency as shadow to an icon of cultural authority. The extraordinary energy bound up in the original networks of muscle and sinew seems to emerge in bronze as a form of resistance to the unnatural constraint reproduced for symbolic purposes by the artist's exertions of stretching, compressing and wrestling meat into shape. It is precisely that resistance which imbues these tortured figures with nobility, despite their conscription in a parody of heroic form that is exclusively human in conception. Quinn is attuned to the various grounds of humanity's symbiosis with an environment whose increasingly technologised character

makes it ever easier for the non-human to be placed at humanity's disposal. If the themes of his art are the perennials of art history, they are also urgently topical, not least in judging that humanity's intrumentalisation of nature has already gone beyond crisis point.

Quinn's most extravagant sculpture, his enigmatic portrait of Kate Moss, *Kate Moss, Sphinx* (2006) is an intriguingly hybrid work. It distils the fascination with celebrity as stimulus for replication, while relaying the artist's virtual obsession with the unimpaired surfaces of classical statuary. At the same time, its dramatic configuration of limbs is not very far removed from the torsion with which the animal forms of the *Flesh* series have been stripped of their self-possession. The flamboyant equilibrium of the yoga-like pose suggests an extreme degree of self-control, and yet the specific combination of angles recalls the energetic restraint of the 'Laocoön'. Moss seems almost to be wrestling with her own body, struggling to break free from the limitations imposed by fashion. Lessing's famous essay on the classical ensemble of figures emphasised its qualified expression of pain, using it to illustrate the nature of the divergence between poetry and the visual arts; unlike poetry, sculpture was unable to represent the experience of time. And yet Quinn's complex figure captures precisely a moment during the transfer of energy that conjures up a clear impression of the physical movements that must have preceded it, no less than those that will follow it. Strangely akin to the vitrines that rely on freezing, Quinn's composition renders the turbulence underlying the static condition of sculpture. It is as if all his works come equipped with a conceptual lever, by means of which three-dimensional objects in space are guided into a fourth dimension of history, tradition and the cumulative changes of evolution.

DORIS SALCEDO: 'FAILING BETTER'

Up until 2002, the work of Doris Salcedo consisted largely of installations in galleries, assemblages of objects whose relationships of part to whole could be transferred from one place to another. In the main, these coordinated objects were relics of a kind: fragments, sometimes very large fragments, of furniture torn from its original context and function; fractions of tables, cupboards and chairs, all compacted together; uncertain components, interlaced, pressured and cajoled into various forms of precarious mutuality. The prosthetic inventiveness with which Salcedo combined and recombined the same motifs and materials turned a succession of installations into a ritual sequence. The ritual concerned was that of commemoration, the testing of memory whose proportional relationship to the risk of forgetting was constantly challenged and reconfigured. The objects of recall were the victims of the protracted violence afflicting Colombian society for the last five decades. The research that Salcedo always conducts for each project traces the histories of individuals, gauges the effects of their loss on others and makes use of extensive interviews with survivors. Yet despite this concentration on specific identities, Salcedo's work rarely evokes the singular; it quite literally homes in on the communal aspects of daily life, reminding the viewer of what is lost when an individual is subtracted from the community. Social structure is undermined and social bonds are weakened; state force and guerrilla and paramilitary violence all contribute to the chronic destruction of the social.

A significant number of the objects hybridised in Salcedo's work of the 1990s utilised sets of tables and chairs. This powerful use of metonymy – employing motifs that do not merely symbolise social relationships but which are materially involved in them – provides the most concise expression of the bond between the individual and the social unit. Single chairs evoke and stand in for single persons, while their placing around a table is a primary instance of what draws the individual into the social group. In the work of the 1990s, strange versions of both chairs and tables were forced into unnatural and disturbing combinations.

In 2002, the usual ensembles were abandoned and Salcedo moved dozens of chairs out into an open, public space which dwarfed these objects conceived of on a domestic scale. The occasion was the seventeenth anniversary of the events of 6 and 7 November 1985, when the supreme court in Bogotá was seized by leftist rebels. In the subsequent counteroffensive by government troops there were over 100 fatalities. Salcedo's performance, entitled *Noviembre 6 y 7*, conveyed a sense of the scale of the massacre by using 280 chairs, lowering these piecemeal over the façade of the new Palace of Justice, during a fifty-five-hour period that corresponded to the length of the original siege. The dual temporality of the performance subjected the viewers to a real-time experience of duration inflected with a sense of historical displacement. Siege and artwork were implicated in the same historical narrative as complementary events. The simultaneous experience of a length of time unfolding in the present and of an equivalent amount of time folded up in the past is a crucial element in Salcedo's conception of the function of art. There has always been this duality in her work, which relates to history as to a condition of viduity. (The word is central to Samuel Beckett's *Krapp's Last Tape*, which is a classic instance of the art of commemoration in all its postmodern ambivalence.)

For Salcedo, viduity is not confined to specific individuals but is the underlying general condition of society as a whole. One of the most important works of the early 1990s was *La Casa Viuda* ('The Widowed House'), a title that renders widowhood as an environmental condition. For the widowed society, history revolves around the moment of loss, which the imagination returns to with obsessive intensity across ever-increasing intervals of time. The general experience of time is thus one of simultaneous convergence and divergence, at a level and to a degree that a normally functioning society could not tolerate.

Less than one year later, for the duration of the 8th International Istanbul Biennal, Salcedo created her largest installation yet, a huge stack of 1,600 chairs occupying the vacant space between two buildings on a commercial street in the centre of Istanbul. The chairs were piled anyhow, in a spectacle of chaos that was nonetheless subject to rigid controls. The installation formed a huge rectangle, with the side facing the street rendered perfectly even by twisting, altering, fastening. The combination of human chaos, engineering precision and the sheer size of the operation prompted comparison with the intimidating paradox of the mass grave. Salcedo has confirmed that the work is in some sense an epitaph to historical atrocities. The contradictory structure of the installation, which meant that each of the 1,600 standard units was placed in an intricate, unrepeatable relationship with those surrounding it, echoes the tension between commemoration and anonymity that has always problematised the social psychology of cenotaphs and graves of unknown soldiers. The temporary nature of the installation underlines the fragility of commemoration. Modern arts festivals, like the Dionysian festival of ancient Athens, provide a means for art to question the presiding values of any given ideological formation. The most enduring works of art,

irrespective of the time it takes to perform them, are those that do not defuse the questions they address, but keep them open. Salcedo's work always agitates the relation between art and history, between performance and pretext, occupying a temporality that does not end with exit from the gallery or with the dismantling of the installation, but which brings up to the surface a process of psychological resistance that is deeply embedded in the social consciousness.

Embeddedness and emergence were literal components of *Neither*, Salcedo's 2004 project installed at White Cube's Hoxton gallery. Industrial quantities of chain-link wire fence appeared to have been embedded into the gallery wall, although they were in fact pressed into a skin of plasterboard standing inside the gallery. The entry into this wire compound did not match exactly the outline of the entry into the gallery's main exhibition space. Two of the dozens of panels that comprised the work's continuous mesh had been lifted away slightly from the plasterboard substructure. They suggested a possible escape route from the perimeter fence and might have been loosened in an escape attempt. However, any attempt to puncture the barrier was met with denial. Beneath one layer of wire was another, firmly ensconced in the plaster.

The predominant material in this installation was the commonest type of fencing still being produced in unimaginable quantities by manufacturers in the security industry. It has been seen increasingly on our television screens, as a means of confinement in concentration camps, as in Bosnia and Guantanamo Bay, and in various parts of the world in the form of holding pens for illegal immigrants. However, a more widespread although less spectacular use has been as a means of exclusion from private property, in an increasingly paranoid insistence on non-permeability. From the back-garden fence to the border between Israelis and Palestinians, the twenty-first-century understanding of security renders increasingly

ambivalent the relationship between inclusion and exclusion. This ambivalence was present in Salcedo's wire cage, which reversed the architecture of the White Cube building, shifting the barrier between exterior and interior from the outside wall to the perimeter of its innermost recess. This hesitation of thresholds, rendering uncertain the point at which security is an issue, suggests the extent to which the contemporary self has interiorised a defensive posture. The precise degree of emergence from plaster that Salcedo had established for the wire mesh posits the security fence as symbolic structure for our everyday habitus, deeply embedded in homes, workplaces, minds.

The interfusion of wire and plaster also invokes the tension between opacity and transparency. Foucault has argued that the carceral imagination of the late twentieth century originated in the early nineteenth-century investment in panoptical systems of control. Restraint of the individual prisoner was ensured not by physical force but by perspicuousness. In a panoptical society, subjectivity was formed by awareness of exposure to the gaze of power, and provoked resistance in the form of inscrutability, of unamenability to surveillance. Salcedo's hybridised barrier both obstructs transparency and suggests the degree to which it has been psychologised, rendering solid walls permeable to ideas, perceptions, fears of control. The predominance of surveillance in nineteenth-century society was commensurate with the development of other forms of visual culture, including the origins of modern museum practices. Display became a means of imposing taxonomies of order. The gallery predisposes its visitor to understand the work of art as part of a specific history and topography whose connection with more explicit forms of power and control can be made more or less obscure. *Neither* was aptly titled in the context of an exhibition strategy which reverses the polarities of inside and outside, of implicit and explicit.

It is not unusual in the contemporary art world to encounter works for which a radical meaninglessness is claimed. But it is extremely rare to engage with works whose resistance to meaning is subject to such specific historical constraints. Salcedo has spoken of the degree to which this resistance seemed to mount in proportion to the effort required to produce the work. The installation period proved to be insufficient, requiring ever-increasing amounts of assistance. But the more time and effort given to the project, the less it seemed to give back. 'This is a piece that I don't understand,' Salcedo concluded, at the end of a process of dehumanising work that involved its creators in progressive isolation from anything that did not contribute directly to its installation. The more sinister undertones of the end result call to mind places in which the rhythms and interactions of daily life are completely suspended. But the incongruous overtones of the gallery space all too often obliterate evidence of the ways in which the process of composition can involve a parallel form of suspension. This work which empties the gallery and forces the viewer's imagination outside it returns ultimately to the history and conditions of its own construction, which is paradoxically one of collaboration and communality. One remaining sign of the human cost expended on this recasting of the space of art is the uneven suturing of the individual wire panels, patched together in slightly varying configurations that hesitate the viewer's sense of horizontal and vertical hold. These marks of fabrication contrast with the high technological finish of the overall design. The inhumanity of the material is offset by teamwork and individual variation.

But perhaps the most disturbing form of intervention in the conditions of contemporary art production is that which gives no clue to its temporality. As the simulacrum of concentration camp confinement, *Neither* evokes those spaces in which nothing is done except waiting, time is suspended,

the prisoner's life is on hold and history unravels into an interminable present tense. The visitor to White Cube can step in and out at a moment's notice, but however brief the visit, she or he can never be certain of the length of time required to make the work begin to speak, or to realise it will say nothing. If the temporality of the postmodern is that in which the relations of past, present and future cannot be made coherent, then *Neither* is the epitome of the postmodern interval, grasped and recognised for what it is, as something produced by the ruthless logic of history, in which the meanings of history are all lost.

SALCEDO'S UN-FORMS

The work of Doris Salcedo is typically a junction point, a crossing place for different objects, forms and meanings. In her 2007 White Cube exhibition, that convergence was often made startlingly literal, with chairs, tables, beds, wardrobes, cabinets being divided and customised, converted into ingredients for the composite sculpture that never reverts to any of its original uses. In a similar way, the traffic of meanings in her sustained practice of bricolage involves the assembling of artefacts produced in a particular time and place, united in a work of art that could be shown anywhere in the world, any time. The usages of a local culture are left behind in this transformation, and yet the global setting of the international art scene is forever touched by their remote pressure. This is international regionalism, in which the postmodern gallery circuit becomes the medium for a specifically rooted cultural politics. At the same time, Salcedo's placement of her work within a context of intellectual history – citing Bataille, Blanchot, Celan, Deleuze and Guattari, Derrida, Foucault, Girard – activates another set of conditions that insists on the anthropological dimension of these dislocated ghosts of the domestic interior, these traces of an absent way of life. In terms of the horizon of the moment of production, Salcedo's work is irrefragably local; in terms of the horizon of the moment of reception, it is international. The two horizons are aligned by a creative and critical energy that is constantly thinking through the cultural politics of form.

In some respects, this means the exploration of *un*-form. Perhaps the most notorious of Georges Bataille's entries

in the *Critical Dictionary* published in serial form in the *Documents* project he edited in 1929–1930 was his definition of formlessness: 'A dictionary would begin from the point at which it no longer rendered the meanings of words but rather their tasks. Thus *formless* is not only an adjective with a given meaning but a term which declassifies, generally requiring that each thing take on a form.'[38] Salcedo's practice removes meaning from things by declassifying them, wrenching them out of one form without supplying another, since the hybrid condition they end up in leaves them suspended in a permanent state of formal hesitation.

The primary act of assemblage that comes before the secondary activity of deciding which fragments to join together recalls the procedures of Arte Povera – a deliberate search for exhausted, lived-in or lived-with materials that can be given an entirely new role, subjected to a new task. But whereas the salvaging of Arte Povera often resembles beachcombing – showing an appreciation for shapes and textures whose original purpose has been worn down or washed away – Salcedo's eye is always on second-hand materials that come with a story attached, even if its narrative is silenced. The power of these works is in their capacity to stand as a form of mute witness, the truncations and elisions that lock them into a set of formal relations always involving a sense of violence against aesthetic judgement, a judgement that is not segregated from questions of social function but centred in them. If for Plato a table is only ever a poor substitute for an ideal form, while for Bergson it represents

38 Georges Bataille, 'Formless', in *Documents*, Vol. 1, no. 7 (December, 1929), translated by Dominic Faccini, in *October*, Vol. 60 (Spring, 1992) p.27

a perceptual challenge to the constantly changing subject, for Salcedo it is a cultural document; and if it is hybridised, a document that bears witness to trauma.

Standing in a room with one of these sculptures is to enter into a negotiation for which there is no outcome. The separate elements of each individual work have been forced into parasitical relationships. The question of which is the host and which the parasite is unanswerable. Prolonged contemplation cannot settle the issue, only compound it. On the other hand, if the conflict is unresolvable at the level of structure and design, it almost evaporates in the kind of attention we pay to the different materials. We are drawn almost instinctively to the texture and appearance of the wood as opposed to the resistible monotony of glass, steel and, to a lesser extent, cement. This is because the wood is more receptive to human presence, it bears the traces of our passage, acts as a palimpsest for the rhythms of days, weeks, entire lives. We impress it, make it legible in complex and stratified ways.

In the 'Interior' section of Walter Benjamin's great unfinished *Das Passagen-Werk*, there is a reflection on the relationship between the domestic interior and the human 'trace' that carries various implications for the understanding of Salcedo's work:

The original form of all dwelling is existence not in the house but in the shell. The shell bears the impression of its occupant. In the most extreme instance, the dwelling becomes a shell. The nineteenth century, like no other century, was addicted to dwelling. It conceived the residence as a receptacle for the person, and it encased him with all his appurtenances so deeply in the dwelling's interior that one might be reminded of the inside of a compass case, where the instrument with all its accessories lies embedded in deep, usually violet folds of velvet. What didn't the nineteenth century invent some sort of casing for! Pocket watches, slippers,

egg cups, thermometers, playing cards – and in lieu of cases, there were jackets, carpets, wrappers, and covers.[39]

The end of this extract has some bearing on Salcedo's methods of encasing everyday objects and personal possessions in cow bladder and sheepskin in her *Atrabiliarios* sequence. The provision of individual receptacles suggests a revival of the spirit of dwelling as the ultimate medium for expression of individual histories, while the arrangement of the objects in niches turns them into relics, in a dispirited recognition of the loss of this general condition. While Benjamin's meditation on the perfect fit between the house, or room, and its inhabitant suggests a Dickensian literal-mindedness, as if the physical relationship between the individual and his furniture turns the latter into the constituents of a shell, or body cast, it is of course the whole range of different activities, different forms of contact, that enriches the relationship and that Benjamin is regretting the loss of. And for this, the prime necessity is for enough space to allow for the expression of taste, experience and conscious memory, as Edgar Allen Poe's very nineteenth-century 'The Philosophy of Furniture' (1840) makes clear.

Poe's essay is concerned with the need for harmony in the relations between different pieces of furniture, as an epitome of the desirability for mutual support between the inhabitants of the space in which they are arranged. But that possibility is forfeited in the violent collision of elements – the stalemated result of an attempt at mutual displacement – that characterises Salcedo's furniture pieces. With Salcedo, the idea of dwelling has fallen into a black hole. With each suturing of unlike materials, space is cancelled out; these objects that

39 Walter Benjamin, *The Arcades Project*, translated by Howard Eiland and Kevin McLaughlin (Cambridge, Mass: Belknap Press, 1990) pp.220–221

try to inhabit several different spaces simultaneously, cannot inhabit any. If wood is used traditionally to construct forms of dwelling inside the house, while cement is used as cladding for the outside, it is that distinction between inside and outside that collapses with Salcedo's adhesion of the one to the other.

The hybrid structure disturbs the function not just of individual items of furniture but of the entire taxonomy of dwelling. It recasts the organisation of domestic space, in which tables, chairs, beds and armoires ordinarily occupy separate zones in the household; and it disrupts the temporal measures of everyday life by joining together objects that are normally used at different times of day. It also recasts the mutual exclusion of private and public areas. Benjamin's understanding of Kafka's spatial imagination rests on a fundamental distinction between private and public, solitary and social:

> Why does the glance into an unknown window always find a family at a meal, or else a solitary man, seated at a table under a hanging lamp, occupied with some obscure niggling thing? Such a glance is the germ cell of Kafka's work.[40]

In a sense, the Salcedo sculpture is the fullest realisation of this germ, which develops into an awareness that nothing is obscure, hidden from the eyes of others, and that conversely, nothing is truly shared, free from the taint of alienation, with the loss of a regulated space and time that allows for a freedom of movement into and out of the grounds of the social.

If the use of public space in a modern capitalist economy involves an encounter with 'authoritative command and prohibition' (Bataille) and the need to 'defend a piece of ground' (Benjamin), then the reports on our use of space issued by a

40 Ibid, p.218

Salcedo exhibition suggest a *fait accompli*, of a sensibility under siege, outflanked, defences overcome. Perhaps this is why her work is so reticent about the content of the missing stories it is built around, aware of the extent to which the personal has been expropriated by the most commonly available forms of display and narration. When we tell or show our own stories, on what do they rely for their effects, do they catch the attention through idiosyncrasy or through their use of imposed models? Salcedo's suspicion on this score might account for her radical refusal of the opportunity to *exhibit*. It is precisely that genre of furniture that provides an opportunity for the exhibiting of taste, the curating of individual choice, the editing of a life – the cabinet – that is smothered in Salcedo's practice. The element of display is replaced by its opposite, by enclosure, secretion, introversion. The space in which to arrange objects – the traces of an individual history – is filled up, walled in. The resulting structure carries associations with entombment, and bears a superficial resemblance to certain signature works by Rachel Whiteread. But whereas Whiteread's memorialising casts actively replace their originals, Salcedo's are splinted onto them, the direct contact sustaining a greater affective charge, a more intensely melancholic attachment to the object of commemoration. Like everything else in a Salcedo installation, even when the materials are inorganic, the mode of contact between the constituent parts gives them a visceral immediacy, turns them into unfinished business of the most provocative kind.

AGNÈS THURNAUER

thurnauer: *vt* and *vi*, to paint in the second person

The museum installations of paintings by Agnès Thurnauer (Angers, 2009; Nantes, 2014) are a making manifest of one of the most important organising principles of her work: its persistent approach towards, its adaptations of, its conviviality with the canonical art-historical genres, motifs and gestures of the past. Her paintings are often in part like recitations in a female voice of those authoritative male formulations that have acquired the status of pronouncements on the scope and agenda of Western art practice. In her subtler, more sceptical, and more playful tones, which have changed the emphasis, the accentuation, and most importantly, the inflection of these resonant statements – once so mobile and mobilising but now a little stiff and uncooperative – she has opened up a new space for the woman artist. Equally importantly, she has opened up a space for the critical viewer of a field in which the historical contexts for these acts of painting have been lost, in the repetition of torn-off shreds, bits and pieces of the original embodiments, fragments that have been inserted between quotation marks and launched on a separate career of their own. Thurnauer reminds us that the perception of art is often clouded, shrouded even, by an atmosphere that is filled with these particles we breathe in without thinking, without remembering that they were once created out of nothing, that there was a time before they existed; that they might have been conceived, and performed, and perpetuated, to very different effect.

Thurnauer is an historical artist in a post-historical situation, restoring a sense of perspective to these relics of a lost history, these parings and clippings that have been caught up by the hot air of publicity and now float in a kind of timeless dimension. But although her work is always posterior to the history of art it is also anterior to it, and in this doubleness it is not timeless but folded back on itself. In her short text 'Aujourd'hui Lascaux', Thurnauer describes her studio practice as taking place in an environment equivalent to that in which the history of art is anticipated and inaugurated while being wholly reconfigured and transformed:

> Lascaux is the place I happen upon in my work, when I hold myself back in the face of what arrives on the canvas, when what is revealed there is all questions, uncertainties, sudden illuminations. Lascaux is where I am when I'm in the studio, in this space closed off from the world, where all silences and all noises alike reach me amplified to an extreme, more naked and much clearer even than at the point of emission. There, everything can be heard, just as everything can be said, through painting.[41]

This return to the imaginary moment before the creation of all painting – all that has survived and been recorded, all that is now part of the history of art – is the situation of the contemporary artist enabling the work that has never been seen before: it is separated from Lascaux by 17,000 years, but it mirrors, in a 'sudden illumination', the same moment. The artist carries the knowledge of art history forward to the present, but that present is also the point before the inception of an alternative history, one that may be precipitated by her work.

This fascination with the historical achievements of art, in the very act of imagining how differently their messages

41 Agnès Thurnauer, 'Aujourd.hui Lascaux' (2001), my translation

might have been formed, how differently they might have been 'heard', is behind the artist's continuing preoccupation with the 'matrices' that she has been working on for the past several years. These resin casts of alphabetical letters are the building blocks of language, but they are disposed in arrangements that make no linguistic sense; they exist in a state before grammar and syntax have been imposed, before even a recognizable language (French, English, Italian…?) has been chosen for them to be part of. Their capacity for the endless combination and recombination of elements corresponds to that of language itself.

Thurnauer herself regards the 'matrices' as the shoals, reefs and sandbanks of language, using a vocabulary suggestive of submerged and hidden meanings in a medium that is inherently fluid and unstable. She merges language and art in proposing the inaccuracy, the unreliability of our existing conceptual grids, our maps and charts, to make readable a set of materials that are always changing shape, always changing the relationship between depth and surface, and above all, always challenging our sense of being in control of the medium, always testing our ability to grasp and manipulate its elements. In conversation, her own way of characterising her relationship to the practice of painting is to say 'I'm swimming', and she describes the act of abandoning herself to the medium as one that produces the strangely comforting sensation of being buoyed up by it. In French, she uses the verb 'traverser', both actively and passively, to evoke the experience of mental and physical immersion in the work. The relationship between the embodied subject and the process of painting, therefore, involves the artist observing the way her own body behaves in reaction to the evolution of the project, as well as observing the way her understanding of the work involves a defocusing of her subjective vision, and a refocusing, adjusting to the expanded vision the work itself seems to insist on.

The relationship between language, in its condition of constant organic change, and its rules, which also change but at a much slower rate, provides a dynamic parallel to Thurnauer's understanding of how the activity of painting relates to the institutional and discursive contexts that frame it. Her 'predella' series gives the parallel an essential structural role, through the frequency with which imagery is conditioned by text and vice versa. The 'now' paintings epitomise the handling of this relationship. The word 'now' preserves its meaning despite being incarnated in different fonts, one for each painting, while the range of different cloudscapes that surround the word offers a model for the way that each enunciation of the word 'now' must refer to a unique moment in time, a unique set of conditions. The word has a seemingly permanent use value but its referent changes with every single use in historical time.

The inability of conventional framing – of institutional and discursive frameworks – ever to capture or contain the experience of painting for the artist, or the experience that the finished painting offers to the viewer, is rendered in material terms, and even theatricalised, by the use of the physical frame, of the edges of the painting, to show how painting always exceeds the limits devised for it. Many of the predellas consist of pairs of canvases that share a single verbal message, insisting on the lack of synchronisation that inheres in any attempt to make the textual message function as a translation of the painting's meaning. Thurnauer herself has used the prosodic term 'caesura' to describe the suture, both binding together and separating, the divided halves of these binary works. The relationship between text and image is not one of commensurability, but of parallel activities in which performance always moves beyond established criteria: beyond the available conventions of meaning. The words divided between canvases include 'id / ea', 'soli / tude', 'ran /

dom', 'fig / ure', 'win / dow', and 'pain / ting', while ready-made phrases include 'not / yet', and 'prime / time'. The latter two examples help to clarify what is stake when the artist chooses to paint serially, when she sets out systematically to make the individual work porous, open to the influence of other components in the assemblage as a whole. Two works are enough to make a sequence, to hesitate the boundaries of the individual painting, although Thurnauer has experimented also with threes and fours, and has exhibited large numbers of these fissile paintings in a way that appears to give a cellular structure to the overall predella project. The breaking up and distribution of the textual messages is the clearest signal of the conditional mood in which these paintings exist, but the use of imagery contributes equally to the realisation of the open-endedness that is fundamental to Thurnauer's practice of painting. The spatial porosity of this work, the permeability of its boundaries, is actually a form of recording its response to the flow of time – its acknowledgement that time is one of the tools used in painting; time as a medium of change and transformation. As the artist herself has observed, 'your arm is not the same each day'. The artist's body and mind move through time, leaving behind a set of provisional answers to a series of minutely adjusted questions.

Perhaps increasingly, Thurnauer's work performs as a visual expression of the poetics of the version, where the proliferation of versions represents an exponential increase in the distance travelled from the very idea of an original. The slippage of meaning between versions becomes increasingly busy and compulsive, acquiring particular intensity in the beautiful 'winged' predellas painted between 2007 and 2009. Here, the imagery has been generated to a significant extent from the slippage between the French words and phrases 'predelle', 'pres d'elle' and 'pres d'aile'. The homophony of the French language allows the word for a series of small paintings to be

moved conceptually and literally into proximity with female subjectivity and then further into proximity with the idea of a wing. The image of the wing outspread then turns it into a visual metaphor for a palette, and the palette is literalised by the application of a spectrum of colours to the spreading feathers. Feathers or 'plumes' are traditional writing instruments, and their presence in the language that refers to writing has outlived their practical use. 'Ecrire au courant de la plume' refers to a kind of writing where the pen itself appears to do the thinking. Thurnauer's painting allows the medium of language to do the thinking in the choice of visual content, but her own use of that content has placed the emphasis on slippage and distance, on allowing the work to take flight when it has been fully transformed, when the relationship between original and version, between literal and metaphorical, between figurative and conceptual, has been rendered vertiginous. The viewer's experience of the painting is governed by a sense of movement between different possibilities, of only ever being able to grasp fragments of meaning, parts that come away from a whole, just as the images of wings are of anatomical parts, limbs detached from bodies. The painting articulates quite literally the underlying bone structure of these wings, just as a painting in the *nature morte* tradition would do, but the painting also articulates metaphorically the language which joins the wing to several different bodies of meaning.

These are wings that could grow a new body which would exist in a gravitational field determined by the mind of the viewer. In the *Grande Predelle* series, each painting includes a used palette, attached to the painted surface of the canvas depicting a wing. Although the palette is superimposed on the wing, making it appear an afterthought, it also takes precedence over the wing, since its use is a precondition of the image ever taking shape on the canvas. The appearance of the wing, with its graduations of colour, is a strong pretext for

the addition of the palette, while the end to which the palette is the means suggests that all palettes have the ambition of wings in the first place. Neither palettes nor wings are used as elements of description but of metaphor, of substitution and metamorphosis. In the hands of Thurnauer, the identity of painting is not to be lodged in any one body or form but in the movement from one to another.

The predellas incorporate key linguistic signs as part of their visual content but activate language at a conceptual level for the most part. In the 'Origine du monde' works, and in more recent paintings such as *Les Lecteurs*, written language appears as part of the material fabric in which the human figures appear. The textual elements are not superimposed on the figures but appear to exist in the landscape, requiring the painter to relate figure to ground in a process of interlacing. When the viewer's eye traverses the painting it falls under the magnetic influence of the text to the extent that viewing must succumb in some degree to the operations of reading with its specific rhythms and expectations. In *Les Lecteurs*, the figures included in the visual field are themselves engaged in the act of reading. They are clearly removed from different points of origin and drawn together, bringing with them hints of the different times and places from which they have been disengaged. The engagement of reading brings them into the same – or a very similar – experience of time, which is comparable to that of the viewer, for whom reading the painting is a hermeneutic exercise that cannot be terminated. The relation between the text the viewer sees and the texts the readers see is inscrutable, while the relations between the separate parts of the text available to view are innumerable in character, since they have ceased to belong to the bodies of meaning they derive from, yet remain withheld from bodies the reader wishes them to have.

In *Les Lecteurs* and *Reflexion on reflection*, the individual letters that provide the textual dimension of the work are

capital letters shorn of the diacritics that would confine them to French or any other single language. They are arranged in a grid pattern that stays on the same plane despite the changing angles of the tables, costumes and backdrops that share the same space. In both paintings there is one figure whose gaze is directed out towards the viewer, although in *Reflexion on reflection* the gaze is supplemented by projecting camera lenses, trying to thrust beyond the front of the canvas. Many, perhaps most, of the figures in these paintings who fix us with their gaze have been borrowed from the work of Manet, the artist who organised so many of his most important paintings around this face-to-face confrontation of viewer and work. Although Thurnauer herself speaks of the need to 'take the canvas by surprise' while in the throes of composition, the viewer meeting the finished work is likely to be taken unawares by this unwavering regard. The sense of disadvantage the viewer experiences forestalls their capacity – perhaps readiness – to eye these female figures with the expectancy of a customer or consumer. The painting returns the viewer's gaze with total impartiality, making us see our own motives and investments more than the illusion that the figure in the painting will accommodate them.

In the recent *Exécution de la peinture*, a naked artist with her back turned to the viewer takes on the central role we might expect to be given to a nude model facing the viewer. However, the figure on the canvas being painted by the artist is another version of the barmaid from the Folies Bergère, taken from the painting that perhaps undermines the position of the viewer more than any other canvas by Manet, since its manipulation of the arrangements seen in the mirror behind the barmaid does not correspond to the view a mirror would give in reality. The viewer seems to usurp the place of a top-hatted customer who is seen, from the wrong angle, in the mirror's reflection. And this substitution renders her glance at the viewer an especially

complex one. Who is she actually looking at, and what is her attitude to their reciprocal gaze? Thurnauer has added extra layers to these questions, surrounding the barmaid with an array of press cameras, and providing the viewer with a new gaze to mediate their own perception of the girl: the imagined, but unseen, gaze of the female artist. The cameras are directed not at Manet's barmaid but at Thurnauer's artist, or that is our initial assumption, until we realise that, like Manet's mirror, they are actually pointing in another direction, straight past the naked artist to connect more directly with those for whom their images are intended. If Manet's painting represents the arrival of the social being organised by the dynamics of the spectacle, Thurnauer's painting captures the extent to which the spectacle has engrossed almost all the space available for representation. Encrypted within this space – existing within the same space but operating according to a different code – is the closed circuit of the reciprocal gaze that connects the female artist and the girl at the bar. This is the artist of a critical painting that comes into being with Manet; the critical artist is composed by the gaze of Manet's painting, although she holds in her hand a brush that authors anew the girl who was once Manet's subject. The critical artist is posterior to an art history that hinges on the experiments and disclosures of Manet, anterior to another history in which the artist is either female or one who stands in the place where a female artist should be.

In a recent conference at Yale University, Thurnauer specified how her painting had arrived at a point which shares in Manet's discoveries while also departing in another, twenty-first-century direction. Her response to Manet's *Olympia* turns on the complexity of the gaze: 'Olympia is the painting taking visual stock of me. It is not so much its own nakedness but more me being stripped naked by the fact that it is staring back at me… Olympia's nakedness strips me bare.' In her own,

twenty-first-century version of the painting, the figure of Olympia is held within the field of a text consisting of all the words synonymous with 'woman' in the history of the French language, from the twelfth century to the present. By bringing together this multitude of definitions, Thurnauer's painting emphasises the poverty of definition, the impossibility of a definitive version of woman: 'The word is a definition, a frame, but the figure escapes all definition... Olympia cannot be reduced to a definition. She is naked and free like painting. She is eternally looking at us and eternally brings our eyes to life.' This beautiful idea, that the painting looking at us is what brings our eyes to life, proposes a utopian freeing of our vision, but it also necessitates a critical painting that must be resumed and maintained, and renewed in each successive work.

Three of the four cardinal points of the Nantes installation were occupied by the Manet-inspired paintings *Olympie*, *Reflexion on reflection* and *Exécution de la peinture*, but right at its centre were the three female portraits that reflect for Thurnauer three essential facets of painting that have to do with the language of cognition, the language of desire, and the language of feeling. The title given to each of these canvases is *You*, since the gaze directed at the viewer by the painting is enlarged, dilated, more than in any other work by Thurnauer. Just as the three female subjects cannot represent individually only one of the three separate languages of cognition, desire and feeling – since all three women exist in the realms of all three languages – so the viewer cannot be constructed exclusively by the gaze of only one of the three figures: they can only be brought to life by all of them.

The intensity with which Thurnauer insists on the reciprocal gaze in her work, and the passion with which it has been sustained, reflect a deep and resourceful critical awareness of the social politics within which contemporary painting operates; but it also has deep roots in her own experience. As a

child, her earliest awareness of the obligations that come with reciprocity, together with a realisation of how relationships are mediated by language, took form in the company of an autistic brother who did not speak. The lack of verbal response, the silence of the interlocutor, places a responsibility on the one with language to imagine the thoughts and feelings of the one for whom language does not do its work in the open. The language of the first person is therefore always implicated with language that is stored in the second person. In Homeric Greek, it was possible to speak with a 'dual voice', but this grammatical possibility has not survived in fossilised form in modern Indo-European languages, except in Slovene. There is a profound sense in which all of Thurnauer's painting communicates itself with a 'dual voice', but it does so most dramatically in the series of paintings entitled *Big-Big and Bang-Bang*, whose characteristic iconography greeted the viewer at the entrance to the Nantes exhibition in the trio of paintings *Now, When, Then*.

The two enigmatic figures that cross from one canvas to another in this trio of works can be found crossing the whole of Thurnauer's oeuvre. Their symbiosis is often associated with the genesis of representation through being contained within an outline that evokes traditional depictions of both the *sindone* and the handkerchief of Veronica. Both were supposed to have preserved the perfect impression of the body of Christ, through chemical transformation, although which came first and which second in this chemical process, which took the active and which the passive role, is precisely the question behind Thurnauer's dual personages. The juxtaposition of the three paintings with titles that obscure the relationship between them in the very act of seeming to offer temporal markers, borrows its authority from the temporality of autism, an experience of time in which linearity makes little sense, in which the relationship between events is not felt as a chain

of connections but as an amplification, an intensification of something that floats freely in a time without measure.

Thurnauer's dual figures populate her output recurrently and cannot be tied to any particular phase of her development as a painter. As the one with language, she now addresses her work as if it were the silent but eloquent interlocutor in a relationship of intimacy that she conducts in public. Written language is an integral part of that relationship, not solely through its incorporation into the visual information on the canvas, but through the parallel activity of keeping a diary, requiring the painter to turn her back on the canvas in order to use a word processor. She describes her method of composition as one of 'pouring' words onto a screen, without ever pausing to make corrections, transferring to her language-work the methods of free expression more common to painting and, vice versa, transferring to the use of paint the kind of editorial oversight more common to verbal language use.

In her painting *Les Lecteurs*, the two figures, one male, one female, both chosen from the history of painting, share the space with a framed map of the world. The world is represented by the familiar image achieved through the systematic distortions of the Mercator projection; this is how we perceive the world although we know its image is an artificial one. Both visual and verbal languages provide us with maps of the same territory; and Thurnauer's hybridised representations argue that the world can only be rendered through a dialogue, an interlocution of different forms, genres, media. When we approach her work, it is not as viewers whose function is predicated through a gaze regulated according to the distorting demands of consumption or control, but as readers engaged in a critical activity that sees around the edges of historically produced versions of the self. While we look for the subjects of Thurnauer's paintings, we are the subjects that they construe; there is no priority in this exchange, and

no way of coming to terms with it; rather, it is in the territory without maps, in the uncertain borderland between the first and second persons, that strangely familiar no man's land, a female *terra nullius*, that the voice of twenty-first-century painting is both lost and found.

The ancient Greek word for the chicken means 'the awakener', the announcer of day, the herald to humanity of returning consciousness. Koen Vanmechelen has organised his work around the renewal of this meaning, around the need to revive awareness in the human species as it sleepwalks into a future of globalised industry and culture. It was in fact the intensive farming of broiler chicks and battery hens that led to the monopolising of the poultry business and the expansion of fast-food chains – market leaders in the development of a global consumer culture. The purpose of Vanmechelen's art is an experimental reversal of the recent history of the chicken, in a conceptual demonstration that offers humanity itself a different way forward in future. While the poultry industry has concentrated on breeding programmes that denature the animals at its disposal, delivering a crippling obesity in meat chicks and mechanical rates of egg production in laying hens (geneticists at the Hebrew University of Jerusalem have recently bred a completely featherless chicken), Vanmechelen's *Cosmopolitan Chicken Project* is geared entirely to continuous cross-breeding.

The practical aim of this long-term project that requires ever-varying combinations of breeds through successive generations is the assisted evolution of cosmopolitan genetic material. The welfare benefits of such a programme include the rearing of chickens with naturally enhanced immunity, fertility and adaptability. The results have been of genuine interest to scientists, whose involvement has been prominent in the

symposia and publications constituting a significant part of the output generated by the project. It is important to understand the extent and range of this discursive activity subtended to a practice that is simultaneously scientific and artistic in its readability and ethical in its motivation. The ethical aim of the project is to confront the homogenising culture of global modernity with the necessity for difference. With the values of diversity increasingly threatened by technological, political and economic incorporation, social behaviours and cultural practices originated by specific communities are threatened with extinction. Vanmechelen's interventions in the art world ensure that the *Cosmopolitan Chicken Project* becomes a tool for reflection on the values of diversity in the human sphere. The artistic aim of the project is to confront humanity's own representations of the chicken since these are of course representations of humanity's stance towards the natural world and of its own place within it. The focus on the chicken, of all species that might have been chosen, is logical given the longevity of humanity's relationship with this, the first avian species to have been domesticated (c.5500 BC). And the history of art is a history of changing perceptions towards animals where the kind and degree of change has been more dramatic and shocking in respect of the chicken than of any other animal, whether mammal, reptile or avian. The chicken is now the most domesticated and consequently the most denatured of animals; the greater use we can make of it, the more deliberately we abuse it.

Vanmechelen regards the pejorative nature of our current attitude towards the chicken as a more effective cage than the metal bars confining battery hens. He combines the political activism of organising meetings and discussions with the performance of humane farming methods and the very literal iconoclasm of an assault on the prevailing image of the chicken as an animal we refuse to take seriously. The

imagery at the centre of his own exhibits and installations is remarkable. If the twentieth-century and twenty-first-century chicken is readily identified with a lack of intelligence, a comic bearing and gait, and a propensity to hysteria, the pre-twentieth-century chicken was more commonly linked to the virtues of foresight, vigilance, courage and loyalty. Both hens and cockerels were given influential roles to play in ancient mythologies and were feared or cherished figures of folklore in most parts of the world. Vanmechelen recovers that sense of auratic power through the manipulation of scale, point of view, medium and genre, erasing the derogatory associations of more recent popular stereotypes.

During the Venice Biennale of 2011, Vanmechelen installed a mixed-media demonstration of the *Cosmopolitan Chicken Project* in the Palazzo Loredan, fifteenth-century seat of the Istituto Veneto di Scienze, Lettere ed Arti. The interdisciplinary nature of the institution was perfectly suited to the versatility of the installation, with its interactive workshops, live incubation procedure and streamed broadcasts, but its contemporaneity was hinged with the antecedent cultural history of Venice through an audacious intervention in its collection of portrait busts. Placed among the likenesses of distinguished figures from the Venetian past was the head and crest of a rooster, scaled up to the proportions of a human head and shoulders. The cockerel's bust and plinth were fashioned from the same ennobling material, marble, as that of the human worthies. The inscription, 'The Cosmopolitan Mechelse', used the same design, font and font size, to assert equal status for its representative of the animal kingdom. Vanmechelen's icon of cross-breeding was itself a means of crossing human and animal pedigrees, not in order to parody the Venetian lineage of achievements but in order to elevate its own claim to respect and emulation.

The genre of portrait painting has a central place in Vanmechelen's recuperation of the relations of humans and animals as focus for the comprehensive revaluing of biocultural diversity. Every chicken engendered by the cross-breeding project is given identity documents that replace their utilitarian equivalents in the world of human bureaucracy with artefacts of high cultural value. In terms of pedigree, the passport photo is poor cousin to the profiles, frontal and three-quarter views of each chicken that are magnified, enlarged to a grand scale and almost invariably mounted within gilded baroque frames. The formality of repeating the same poses only serves to underline the details of individuation in each depiction, the natural luxuriousness of the plumage and the infinite variation in colouring. These are photographic portraits that belong generically alongside paintings commissioned to pay homage to persons of distinction or fame, often surpassing them in splendour. But Vanmechelen also portrays the chicken as a being of mythical stature and implicit power in paintings that employ pigment, feathers and other body parts in stylised representations seeming to portend obscure moments of crisis in a cycle of destruction and creation. Without referencing any belief system in particular, these works evoke the gestures and materials of certain kinds of painting connected with devotional practice in the traditional cultures of native peoples. They have a dynamism and decisiveness of execution giving them a freshness and spontaneity but also a deep resonance with attitudes of reverence towards the natural world. They are expressive both of the artist's immersion in the moment of composition and of buried cultural memories of the totemic meaning of animals. The shamanistic obsessiveness with which these works return again and again to the image of the chicken without exhausting its meanings – without ceasing to add to its meanings – is if anything redoubled in Vanmechelen's pictorial and sculptural meditations on the symbolism of the egg.

The egg is one of the most familiar objects in everyday life. We all know what to expect upon cracking open its thin shell, and yet what it holds is one of the central mysteries of creation: the chicken and egg conundrum of which came first. Viewed scientifically, the answer is almost certainly the chicken, since eggs are produced by proteins found within the hen's ovaries; but viewed philosophically, the question itself has value by focusing reflection on the common ancestry of all living species, and on diversity as the pattern of evolution to the present day. Vanmechelen's constantly varied depictions of the egg are layered with real feathers and scumbled pigment that looks like it has been applied with feathers, insisting that the chicken comes first in the fabrication of the artwork, even if the initial creative impulse is the idea of the work conceived in the mind. This double focus on different stages of growth in the avian species has been underlined by the addition of textual material. In one painting that features twin eggs, the phrase 'abo ovo' is superimposed in vividly glowing neon. The phrase refers back to Horace's *Ars Poetica* which advises other poets not to begin their work with the beginning of the storyline but to commence 'in medias res'. The beginning of the story of the Trojan War would be the birth of Helen and her twin Clytemnestra from a 'double egg', according to the Greek myth linking human origins to the reproductive system of another species. Vanmechelen has stated of his work that it is 'a multifaceted experiment to grab the past in the present and tell tales about the future', asserting the need for action in the present to be governed by an awareness of the past it has evolved from, as well as the precise nature of the future it must shape.

In the wild, chickens build nests, and the desire to nest is common to all hens, despite the malformation of their living conditions during the past century. Nesting is the most fundamental of those natural impulses frustrated by factory

farming. Vanmechelen's nests are like impregnable fortresses, aggressively defensive structures large enough to protect giant birds – they compensate symbolically for the eradication of natural habitats in a biosphere controlled by human priorities. In works such as *Carried by Generations*, fossil eggs are enclosed by nest-like structures woven from avian legs and feet. These materials may excite considerable aversion in viewers, yet the impulse to turn away is complicit with the tactics of an industry that destroys mobility in live animals and deletes the evidence by packaging meat with extremities removed. What we turn away from is what we conspire to ignore. The monstrous nest is like the transformation of a guilty memory, the more unsettling the more it has been repressed. Some of Vanmechelen's most hauntingly beautiful works have involved nest installations, such as the dimly lit eyrie virtually entombed in a disused ammunition depot in Nieuwpoort. Here the nest is completely filled by an enormous stone egg guarded by live owls; their presence endows the egg with a dormant potency even though its petrified state is suggestive of having been laid in earliest times. What and when it might hatch is dependent on the nurture it has received or been denied. The neon caption for the installation '(R) EVOLUTION' is indicative of its latent ambivalence in this regard.

The displacement of limbs into nest material connects with other kinds of disjunction between form and function, especially when transmutation is the result of conjoining human and animal body parts. There is a significant number of inter-species hybrids in Vanmechelen's oeuvre, raising questions about partnership, common ancestry and ecological responsibility. The exploitation of one species by another involves the appropriation of biological resources; humans take what they need from chickens and other farmed animals, devaluing what remains. Recent history has shown the facility with which such manipulative relations can be

transferred from our treatment of animals to that of other humans. Vanmechelen's joint practices of grafting and cross-breeding work towards the confusion of such discriminatory mechanisms and towards the clarification of grounds for mutual respect and mutual gain. The momentum with which this artist sustains his extraordinarily wide range of activities is one measure of the urgency with which the tipping point between a history of ecological disaster and its reversal must be attained. Perhaps the most lucid exposition of this reversibility is the film projected as part of the installation *Darwin's Dream* which appears to record the methodical consumption by one man (the artist) of the meat of an entire chicken. The film is in fact shown in reverse so as to create the illusion of a chicken being made whole rather than being devoured. It provides the most economical illustration of the way Vanmechelen's work prepares us for the future by drawing us back to the past, mirroring the dawn: a moment of true awakening.

LET THERE BE LUCY

In early 2018, I travelled to the studio of Koen Vanmechelen in Genk, at a time when the Limburg district of Flanders was gripped by the news that a wolf nicknamed Neya had crossed the German-Belgian border, and was now in hiding, whereabouts unknown. The wolf had not actually been seen by anyone, but was being remotely tracked by a German scientist. Its invisibility made this heavily populated area seem suddenly more wild than the inhabitants had assumed. It was possible that other wolves had been in the area before; and might be there now. One theory, half-serious, half-joking, was that Neya had heard the rumours of a safe haven for wildlife being constructed on the grounds of the old Limburg Zoo that had closed down in 1997. And it was indeed the case that Vanmechelen, who remembered visiting the zoo as a child, had moved onto the site, and had such a project in mind, installing a large aviary for jungle fowl at one end of his studio, with plans to de-domesticate a number of different species and install them in the large tract of land between the studio building and the national park that lay on the other side of the perimeter fence. Those species with a long history of domestication would be located close to the studio; those with no history of domestication would be furthest from its walls; those in the outermost area of the property would be wolves.

The main objective of Vanmechelen's scheme is not to replace one zoo with another, although the outcome of the experiment might be a kind of human zoo. Contemporary culture is such that our perception of animals is governed

largely by the terms and conditions of the spectacle, and a primary function of the zoo is to place other species at our disposal in a form of display case that has no regard for their intrinsic connection to habitat. Vanmechelen's project involves returning the animals to a natural habitat within the grassland and woodland extending beyond his studio. The human component within this scenario will be contained within corridors that take up only a fraction of the total space. Humans will be herded, or shepherded, by fencing arrangements while other species will be given much more freedom to roam. Visitors will exercise their natural curiosity, but the fact is that other species may keep them under watch with ease while taking cover themselves. This will be less a case of people watching animals than of animals watching people. How the animals see us is an impossible question to answer, but it remains an important principle that humanity should exercise its imagination to consider the impact of its behaviour on other species. And Vanmechelen regards it as an ethical imperative that we should put ourselves imaginatively in the animal's place and draw the appropriate conclusions.

Why Genk? Vanmechelen explains that he is drawn to this locality because it is a 'wounded place' crying out to be healed. The wounds he refers to are social and economic in the main, although the economy and social structure of this area were for several hundred years intertwined with coal mining, with the corollary that the landscape itself has been scarred, and the environment degraded by the creation of slag heaps and industrial pollution. The region of Limburg included the biggest coal mines in Europe, which attracted large-scale immigration into the area. The population had increased by a factor of ten, with the majority of the population dependent on the industry, when the mines were closed in the 1960s. This replaced an ecological catastrophe with a social and economic disaster. In Genk, the problem was offset by the establishment

of a big Ford plant in the 1960s, but this closed in 2014, creating widespread unemployment and an urgent need to decontaminate the area in the vicinity of the plant. Genk is still living in the shadow of this environmental ordeal.

Limburg is a region that cannot be mapped with reference to modern state boundaries. For seven centuries until the late eighteenth century it was an independent state within the Holy Roman Empire, then divided up between Belgium, Germany and Holland. Limburgish survives as a colloquial language within all three countries. Limburg is therefore a condition, a state of mind and being that cannot be identified through association with one nationality or another. According to Sean Rainbird, in his study of the Celtic dimension in the work of Josef Beuys, Beuys's home town of Cleves meant that he grew up in a Celtic and Catholic enclave within a Germanic and Protestant state. The Duchy of Cleves overlapped with the Limburg province of Holland. The significance of the Celtic connection was the emphasis found in Celtic tradition on the natural world as source of spiritual meaning. Although belonging to different generations, Beuys and Vanmechelen both retrieve the connections between humanity and the natural world that have been travestied in the destruction of habitats and the commercial exploitation of animals during the industrial and post-industrial periods. One of Beuys's most well-known and characteristic works took the form of an 'action' in which he remained for three days behind a wire mesh partition in René Block's New York Gallery, in the company of a coyote, close relative to the wolf and indigenous to North America. This performance of sorts was a reminder that humanity had evolved alongside other species while occupying the same biosphere. If their past relationship had been competitive, it was now unevenly weighted in favour of *Homo sapiens* – although an encounter between individual members of the two species might well readjust the balance.

The result was an edgy 'performance' in which nothing much happened, although it was possible to imagine several possible outcomes. This meeting of predators was both humbling and revealing in its focus on the extent to which humanity had appropriated to its own use an environment in which other species retained a right to exist on their own terms. The ethos of Beuys's art practice is very close to that of Vanmechelen. Beuys generated a number of conceptual projects anticipating the political agenda of the Green movement – he advocated the founding of a political party for animals – and also performed actions that directly challenged corporate threats to the environment: for example, by sponsoring the planting of forests.

But, by and large, Beuys's sphere of operation was the art gallery, the lecture theatre, the defined performance space. These are also essential sites for Vanmechelen's practice, but more often than not, his multivalent artworks are connected to other direct actions of a political nature, contributing to the economic viability and ecological sustainability of livestock farming in a given community. Central to his thinking and still at the core of his activity have been the interlinked *Cosmopolitan Chicken Project* and *Planetary Community Chicken*. The guiding principle of both projects has been diversity and involves nothing less than a reversal of the history of animal breeding. During the pre-industrial era, animal breeders accrued cultural capital, and secured the market value of their stock, through the preservation of exclusive 'thoroughbred' strains, with pedigrees that mimicked the priority given to 'blue blood' alliances between the aristocratic families of Europe. During the industrial era, different kinds of inbreeding were explored in order to maximise the profit to be realised from animals cultivated exclusively for excessive meat or egg yields. The chicken was to become the most grotesquely exploited and denatured of all these animals, in factory farms that

removed the animal's access to all functions apart from that of egg and meat production. Vanmechelen, recognising this as a prime example of humanity's prioritising its own needs at the expense of all other species during the Anthropocene era, uses the settings of art to provide a focus on a genuinely practical intervention in contemporary farming practices. On his own property, he practices cross-breeding between different varieties of chicken that are free to roam, with results that improve both the fertility and immunity of successive generations. This humane farming practice is then made the focus for an international network of cross-breeding projects that serve as inspiration for the spread of local, sustainable modes of animal husbandry, operating outside the factory-farming systems of international conglomerates. It is a rival form of globalised practice that both enhances animal welfare and benefits local communities.

The *Planetary Community Chicken Project* is in effect a growing network of sites where the role of art is twofold: in practical terms, it provides the foundation for a mode of farming that improves the resilience of local livestock strains; and in political terms, it identifies diversity as an essential factor in the creation of more open, tolerant and productive social relations – it forms the basis for the imagined communities of the future. In an era of mass migrations and resurgent nationalisms, it orchestrates an alternative pattern of migrations aimed at diversifying existing communities and assisting their evolution. In the process, it places art at the centre of some of the most crucial debates of our time; and dramatically widens the scope of the so-called 'creative' industries, by transforming creative ideas into direct actions – actions that interrupt the supply chains of the global corporate farming industry. At the same time as Vanmechen's art is reframing the social politics of farming, by changing the direction of its historical development; in the same proportion,

his practical interventions in the gene pool of the chicken species are reframing the language of art by giving it different registers in which to speak. The occasions to speak come out of a series of experiments: encounters with the unknown, the previously untried, the un-languaged; our understanding of other species is entirely based on observation of behaviours that do not conform with ours; we cannot translate what we cannot read; we can only imagine; and the role of art is to imagine responsibly. This is the keynote of Vanmechelen's work.

Among the works on display in the Serlachius Museum in 2018 were three large-scale drawings that resemble in style and medium the earliest examples of artwork so far discovered. In the cave paintings of Europe, human figures are rare, and when they occur, they have been sketched in as incidental details of a scene dominated by animal figures. It is the animal figures that impress and engross our attention, memory and imagination. Vanmechelen's imposing images reflect the intimate attention given by prehistoric humans to the animals in their environment – an attention compounded of fascination, fear and reverence. Using materials equivalent to those used by the prehistoric artist – grain, Indian powders, egg yolk and egg white – Vanmechelen has conjured up a being, or beings, from an earlier stage of evolution than our own: these are indefinite creatures that seem to hover between dinosaur, bird and mammal. It is their effect on us that is definite: these are creatures it is difficult or impossible to imagine as under our control and at our disposal. They are creatures that we might live alongside, but only with a due amount of respect for their power and inscrutability. They take up a commanding position within an environment we share with them, but only on terms that are never settled.

In cultures that remain closer to nature than our own, those terms are negotiated by intermediaries, known as shamans.

Shamanism has various manifestations, but invariably includes entry into a trance-like state for the purpose of intercession with the spirit world. In the traditional religions of northern Europe the spirit world included the spirits of animals as well as those of ancestors and deities. In Finnish paganism, for example, the bear was a sacred animal whose death required prayer and intercession to persuade the animal to reincarnate and return to the forest. In Vanmechelen's light-box installation that is part of the *Lucy* project, a figure clad in a shamanic cloak is seen framed in the doorway of a pigsty together with a large, feral-looking pig that he is either guiding or following. Vanmechelen has positioned them precisely on the threshold between inside and outside, clearly acknowledging the importance of bridging the gap between one state and another: between animal and human; between spiritual and carnal. The shaman's cloak, incorporating animal bones, hides and feathers is found in the surviving practices of many traditional religions. The feathers of birds were an essential component of such costumes in the Celtic tradition. In his *Domestication* (2014) ensemble, Vanmechelen has placed the cloak on a tailor's dummy, beside the plumage of a turkey placed on a glass and ceramic model of a turkey's body. The juxtaposition converts our perception of the animal as a source of meat into a conception of its place in nature, outside the industrialised food chain invented by humanity, and inside a version of the world where it might even have a sacred importance.

Another tradition in Finnish paganism has particular resonance for the avian iconography of Vanmechelen's work, and that is the belief that the world itself was hatched from the egg of a sacred bird. The enormous marble egg entitled *In Between* is a monumental tribute to the process of creation. It uses materials – Carrara marble and gold – whose prestige is unsurpassed in the history of sculpture, in order to declare the

importance of one of the commonest, and most undervalued, of everyday objects: the supermarket egg. In this particular instance, 'everyday' means precisely what it says – humanity's symbiosis with the chicken over thousands of years has so distorted the natural productivity of the animal that battery hens will now produce eggs on a diurnal basis. Consumerist demand has been accelerated through the practice of date-stamping to indicate an often arbitrary terminus beyond which consumption is considered unsafe. Vanmechelen's giant egg has been date stamped with Roman numerals – normally reserved for commemoration of portentous or historic dates – which spell out a date not to be found in the calendar. The sarcastic message of this work is that there is no time limit to the idea of the egg, which represents a crucial stage in the evolution of all species, predating and outranking the significance of the human in the history of the planet. Marble and gold are the very least among the materials that could be used to underline the egg's significance.

The history of humanity itself opens up a series of questions about the means by which *Homo sapiens* has prevailed over other species: including hominid species. The most well-known ancestor of contemporary humanity was the *Australopithecus afarensis*, nicknamed 'Lucy' by the team who excavated the fossil remains of this female specimen. But 'Lucy' represents only one of at least twenty hominid species, all of which are now extinct – apart from us. Our nearest relatives, the Neanderthals, survived until recently, roughly 20,000 years ago. They had larger brains; but without a voice box, they lacked the capacity to communicate in a language complex enough to master time – they could not plan ahead with the precision needed for attack or defence in their encounters with modern humans. By invoking a distant ancestor of humanity, and transferring her given name 'Lucy' to a new breed of pig, Vanmechelen is insisting that we recognise our original connection to other

mammal species (the pig is anatomically very close to the human, which is why its organs are used so often in life-saving transplant operations) rather than insisting on our exceptional status, based on a short-lived position of dominance that has led the ecosystem to the verge of extinction.

As a symbolic gesture of the change of attitude required, Vanmechelen has used the settings and methods of art to dramatise the issues at stake in our current mishandling of relations with other species, while also aligning his symbolic language with practical demonstrations of the effect of local changes in the social, political and economic priorities of specific communities. His *Domesticated Giant* installation references human agency as disproportionate in its effect on the environment; but suggests how its role might be as disproportionately positive as it is now disproportionately negative. His outsized bronze hands are irresistibly reminiscent of the gigantic bronze hand that, together with the stone head and part of an arm, are all that remain of the colossal statue of the Emperor Constantine that once stood near the Forum Romanum in Rome. It was Constantine who established Christianity as a state religion, sounding the death knell for pagan religions in which relations between humanity and the natural world had been sacralised. That he was able to do so was a direct consequence of the political effectiveness of imperialism. Vanmechelen's art practice its effectively summed up by its difference from the hand of Constantine, pointing the finger of authority in an imperial setting; Vanmechelen's two bronze hands are cradling models of a single, vulnerable chick, and a handful of seeds: they are the open hands of nurture – very much hands-on – contrasting with the closed hand of a remote and intransigent imperialism.

A FIXED WANDERING:

THE SCULPTURE OF ALISON WILDING

All sculptures reorganise the spaces in which they rest, even temporarily, but the works of Alison Wilding charge them with meaning. Public installations, like *Melancholia* or *Migrant*, both distil and transform the existing spatial relations and temporal measures that define a room, a garden, a clearing in the landscape or the built environment. The smaller 'chamber' works such as *Albatross* create a recess within the usual business of a gallery or office, exerting a magnetic influence on its habitual passages of space and time. In every case, there is a slender but vital connection to encompassing imagery; motifs are chosen in order to be rendered minimal, subjected to a semi-abstracting process that sets up a capillary action between the object and the space it inhabits, absorbing and converting the relevant constituents into a powerfully encrypted meditation on the emergence of form and the evolution of ideas. But if this description of a kind of orchestration of meanings suggests a denial of the force of gravity, a dematerialisation of experience, a withdrawal from the visible signs of the world, then it hints at the complexity of response demanded by Wilding's sculptures, which are extremely concentrated and secretive works, strongly implicated in contexts but taciturn about those contexts. The directness of their physical impact is equalled by their obliquity of reference.

If sculpture brings objects into the world that did not exist before, then the question arises of where they have come from: from raw materials, from the artist's imagination, from cultural

history, from geographical circumstance. Wilding's oeuvre has systematically trailed this kind of evidence, but has often implied an elusive origin, incommensurable with the merely cognitive explanations that reassure us, that we are literally at home with. This must be an important part of the reason why so many of her works have been framed by an appeal to religious or mythic archetypes, despite their obdurate physical presence. At the heart of her practice is a concern with the working of metaphor, with the substitution of one condition for another, with the transferability of meanings; and yet, her attention to the process of constructing metaphors ensures that the gap between the terms of the comparison, the distance that has to be crossed between the intelligible and the unknowable, is as significant as the affinity between the elements brought into relation. Reading a sculpture by Wilding involves a feeling of suspense, a feeling of hovering over the threshold between the understanding and the imagination, with the one constantly intimating the operation of the other without a point ever being reached of easy correspondence between them. There is no doubt that one of the most constant leitmotifs and forms of activity in Wilding's output is the production of ligatures, the binding together of materials, textures and forms that do not take naturally to one another; that one would expect to put up some resistance to being sutured or welded together; that might have been selected precisely in order to reject the graft.

Soft and hard, smooth and abraded, tensile and brittle, industrial and crafted: there is an entire spectrum of contrasts that Wilding extends and nuances in the elaboration of her work; often defusing the viewer's expectations of a binary structure with the involution of one form or material inside the other, as if the relation were one of dependence, whether trustful or parasitical. Since a part of each work is often physically encrypted, concealing areas of surface and implying hidden articulation, the perception of its meaning must

combine looking with sensing, the visible with the virtual image. The anecdotal content of the work is eliminated almost entirely, as if in direct proportion to its pressure on the imagination. Wilding's insistence on structural hesitation, on a simultaneous emphasising and eclipsing of boundaries, strengthens a tendency towards serial composition, towards the production of family resemblances in a number of her works. This commitment to successive embodiments of the same, or similar, ideas, enhances the role of the imaginary in her practice, altering the scope of its play with the resolution of form.

Largo (2002) and *Melancholia* (2003) seem to echo one another, but with subtle differences of texture and tonality. In both, a flat-topped, truncated sphere in grey concrete serves as plinth for a collection of open blooms; in the former, these are made out of silk, which catches the light and absorbs colour to luxuriant effect; in the latter, the blooms seem to have calcified, transformed into terracotta fossils, in a process that has deprived them of colour, replacing whites, blues and browns with white and different kinds of grey. These changes seem superficial, but they become the pivot enabling a major shift in the distribution of meaning. The ashen hues of the later work suggest the withdrawal of vitality, or at least the onset of desiccation, as if the second of the two works has entered into a kind of posthumous existence. At the same time, the title signals a range of associations that prevent the viewer from grasping the nature of the second work as merely an afterlife version of the first. Human physiology during the Middle Ages and early Renaissance was comprised of four 'humours': melancholy, phlegm, choler, and sanguinity. A single humour would predominate within the individual constitution, but not to the extent of displacing the other three humours. Despite its negative associations of dejection and alienation, melancholy was an essential component of the human character. Interestingly, it was often connected with

scholarship (Wilding's sculpture was first exhibited at Jesus College, Cambridge, where it remains). Although melancholic tendencies seemed antithetical to the life force, they were essential to the principle of balancing the humours that alone guaranteed health. Melancholy's relationship with the other humours was thus a paradoxical one, its identity both distinctive and yet dependent, defined equally by contrariety and reciprocity. Wilding's sculpture is located in a college garden, on the edge of a circle formed by the penumbra of a giant plane tree. Its own circularity reflects that of the tree but is also a severe refinement of it. The generic blooms allude to the cycles of growth that surround them but in a contradictory fashion, conjuring up reminders of movement and change in images of arrested development. The tree itself is ailing in parts but vigorous in others. Over 200 years old, it dates back to the period of Romantic literature, when one of the greatest of all texts about melancholy, Keats's 'Ode', was written: a text in which nearly every line consolidates the paradoxical nature of experience; in which joy can only ever be understood through its contrast with grief; fulfilment can only ever be grasped in the knowledge of loss.

Another major reference for the title is the concept of melancholia in Freudian theory, where any use of the term is immediately suggestive of a missing counterpart: the accomplishment of mourning. Mourning is posited as the stage subsequent to melancholia, implying the acceptance of loss. Melancholia is a condition whose negotiation with memory, repression and revision is unfinished business. Wilding's sculpture is clearly concerned with transitional states of various kinds: her forms are recognisable but stylised, suspended between the figurative and the abstract; her subtraction of colour suggests that the work is seen somehow with a mechanical eye, rather than human vision. This detachment from a set of naturally occurring conditions

is profoundly ambivalent, since it is the basis of an aesthetic obliged to retreat from a nature whose loss it cannot come to terms with.

A further cultural historical reference that cannot be avoided is to the spectre of Dürer's famous etching, *Melencolia*. This complex representation emphasises circular forms in a foregrounded sphere and in the arc of a rainbow, the latter alluding to the full spectrum of colour in an etching that was published in black-and-white. Much of the iconography of the picture links melancholia to scholarship, but despite the density of its symbolism, the immediate impact of its central female figure is of a dejected attitude and a deflected glance. It is a powerful image of self-absorption that implies a mood without specifying it. Like Wilding's sculpture, it is structurally oblique, identifying melancholia with a condition encapsulated by the final line of Ernest Dowson's sonnet on Dürer's engraving: 'She moves through incommunicable ways'. Incommunicability in a communicative context, self-containment in a context of transaction, performance, commerce: these are qualities partly responsible for the integrity of Wilding's work, helping it to resist easy conversion into the market values assigned to the more freely talkative work of some of her contemporaries.

For Wilding, meaning is often contingent on the relationship between works, which entails a constant slight shifting of implications, as different facets of a given sculpture are turned towards the influence exerted on them by partnership with other Wilding creations, or by orbiting close to an art-historical force of attraction. It is as if each work is placed within more than one magnetic field. *Migrant* (2003) is a composition in which the repetition of form raises questions about aesthetic closure. Sited permanently at Snape Maltings, *Migrant* consists of two identical elements, two shapes cast and riveted in bronze to resemble inverted hulls, at slightly

different elevations and in a diagonal alignment with one another. The two rhomboid shapes recall the cowls that are an architectural feature of the Maltings, but they also suggest much more tellingly the vessels that use the surrounding waterways. The title of the work evokes this passing traffic, but the suspension of the forms over a bed of reeds, not over water, and the inversion of the keels, which makes them appear to be sailing upside down in the air, proposes migrancy as a fundamental change of habitat. These mysterious vessels now travel in the same dimension as music, the dominant art form at Snape. Water mirrors the shapes of boats, but in a way that is reversed in the mirror symmetry of these streamlined lozenges. Wilding has said that this composition is 'about travelling not destination', and in its shape-changing attitude to representation and to the principles of its construction, *Migrant* seems to be premised on a systematic errancy, a fixation on wandering, reflecting an important aspect of the etymology of its title.

In cultural representations of the natural world, the albatross is the iconic wanderer. Moreover, its most well-known embodiment, in the sacrificial bird of Coleridge's poem, inserts it in an allegorical structure whose correspondences are uncertain; whose meanings go astray. Wilding's sculptural assemblage *Albatross* does not draw obviously on the imagery of pelagic flight; it is comprised of a small cutaway alabaster box housing what seems like a disproportionately large white acrylic ball. Like some giant roc's egg become a votive object, reserved like a saint's relic within its own miniature shrine, the ball is mostly invisible, trapped within a structure that opens – with a tooth-edged geometry – only at the base. The lightness of the acrylic, surrounded by the weightiness of the alabaster, plays on the imagination, as does the contrast between the spherical perfection of the ball and the angled incompleteness of the box, spiritualising

the one, and materialising the other, triggering the fancy that the ball might just float away if freed from its alabaster constraint. At the same time, the technological finish of the acrylic renders it more impermeable than the alabaster, whose uneven translucence allows the change of light to transfigure the housing in unpredictable and haunting ways. There is an affectless perfection in the machined precision of the acrylic which contrasts strongly with the manually crafted alabaster, reflecting an individualised form of attention which makes the sculpture seem archaic and genuinely assimilable to the ancient works of art and craft with which it was first shown, in the exhibition *Interruptions* at Rupert Wace Ancient Art. Wilding has made several works from alabaster, sourced from the mine at Fauld in Staffordshire which facilitated the great tradition of English religious sculpture in alabaster, at its height in the fifteenth century. The mine is now worked out, with its last remaining fragments in Wilding's care. *Albatross* is a receptacle for tradition; the scored and scratched surface enhances the luminous interiority of this most subtle of stones: the ideal medium for an art whose character is defined in the controlled refractions of its meanings as they venture into free space.

The community at Jesus College has been living with the work of Alison Wilding since 2003. Her sculpture *Melancholia* in the Fellows' Garden was first installed during that year's edition of the biennial *Sculpture in the Close* and it has remained in the same spot ever since. Now sculpture and location seem inseparable. We have got used to the sculpture, but although it is now a familiar presence, its effect on us is no less unsettling and elusive than at first encounter.

A dozen years after installation under the branches of an enormous oriental plane tree, the sculpture's circular shape echoing the penumbral shade of its foliage, a large branch detached itself from the tree and came crashing to earth. Alison took some of the wood away to serve as the basis of two other sculptures, *Tooth and Claw* and *Starcrossed*. *Tooth and Claw* is now on loan to the college and can be seen on the gently sloping windowsill in the northeast corner of the Upper Hall. *Starcrossed* was included in the exhibition *On the Edge* in the College's West Court Gallery in 2019. *Tooth and Claw* retains the form of a section of tree branch. The title's allusion to Tennyson's epitome of Darwin's evolutionary imperative (translating the survival of the fittest into 'nature red in tooth and claw') is reinforced by the apposition of a red acrylic sphere to the interior of the branch, making it reminiscent of flesh. The tree's own story of survival began with the transplanting of a seed from the site of the Battle of Thermopylae in Greece, during which the 300 Spartans lost their lives but outlasted their opponents in history and legend. Wilding's choice of

materials (wood, acrylic, language) underlines the cultural rather than the natural basis for evolutionary struggle, played out in a *theatrum mundi* in which art intervenes in the conflict of meanings.

Melancholia and *Tooth and Claw* are organised around circular and spherical forms that carry traditional associations with wholeness and perfection. In Wilding's hands they behave in ways that resist a sense of containment or completion. *Melancholia* sits on the edge of the circle made by the leaf canopy of the plane tree, and this in turn hangs over the turning circle for carriages that was the key feature of this area of the college before the advent of the motor car. Both the sculpture and its present site are, or were, crossing places, places where different forms and materials are both joined and separated; where things happen and have meaning through being on the edge.

Starcrossed is a precarious work in which the shape of a star describes an absence – a star-shaped void that has been cut out of the surface of a log held aloft by a tree trunk-shaped arrangement of looped steel wires. This flimsy plinth-like base looks hardly fit for purpose and must literally find its feet every time the work is lifted into place. The title's allusion to *Romeo and Juliet* ('star-crossed lovers') proposes a wobbly union of elements whose condition is profoundly insecure. And if we pursue the etymology of Shakespeare's phrase, it hints that Wilding's work might be edging towards a place where art is realised in the shadow of disaster.

Whervish is another work with a tree trunk-shaped form, culminating at the base in three legs fabricated from rebar. But the cylindrical shape narrows to a high waist where the roll of linked vertical slats forming the body of the work is twisted in order to splay the base. This torqueing of the structure draws on our previous experience of materials that react to being wound up by trying to unwind again. We conceive of the work

as at least potentially unstable, its form and outline under threat and uncertain. The title of the work is a compression of the familiar phrase 'whirling dervish' that runs together its two component words, ignoring the edges that normally divide them.

The other standing work in the exhibition was *With this Rock*. The title echoes the phrase in the wedding service 'with this ring', raising questions about the basis on which the two main components have been brought together and forcing us to think about their compatibility. A solid column of painted foam is paired with a steel frame that echoes its structure and dimensions, offering a spectacle of compatibility and radical difference. The small rock placed on top of the foam column is basalt, which forms more of our planet's bedrock than any other rock type. The frame and column might suggest skeleton and bodily integument; or they might suggest a relationship between underlying structure and cladding that presents only one of many possible forms of realisation. The conjunction of both forms makes us imagine a cladding for the steel frame, and a framework beneath the foam cladding. Both the outer edge of the frame and the inner edge of the column are imagined, and provoke us to consider how basic forms of relationship between substructure and superstructure other than those we are used to might also be imagined.

Foam is in any case a substance that yields to pressure. Although we know better than to tamper with the surface of an art object, experience tells us that the surface of this work could be altered at a touch, and that its edges are moveable. But if foam offers little resistance to the force applied to it, much less resistance is offered by fluff. What are the edges of a ball of fluff, and what is the status of an edge in the context of fluffiness? Wilding's inventiveness in selecting and combining unlikely materials for sculpture forces us to rethink our assumptions about the boundaries of art; about what art

is supposed to look like; about what it is supposed to do. Our assumption is that fluff is without value, without interest, and even despicable. Yet what an integral part of our lives it is – it cannot be separated from our attitudes towards architectural space; no matter how much we try to banish it, it is always ready to return, to gather, to take up space. It is the ghost in the machine of domestic economy. It is stuff that comes from everywhere and nowhere. Yet what we try to banish and forget has been given the status of an artwork. It is our impulse to render it absent, yet here it is given symbolic presence.

Regarding more traditional materials for sculpture, Wilding has shown a strong inclination towards alabaster, and the results of this preference have taken form in some of her most haunting and compelling works. In the current exhibition, *Bedrocked* and *Drone* I combine alabaster with other materials to decisive effect.

Alabaster is a soft rock that lets in a lot of light; this, combined with its mottled and striated colouring, gives it visual unpredictability and depth. In *Bedrocked*, a substantial rhomboid wedge of alabaster is sandwiched between a black silicone rubber lozenge and a small grey acrylic sphere. The title twists a familiar noun into an unfamiliar participle, converting an idea of stability into something unstable – something that has been *rocked*. Although alabaster is a soft rock, it is less pliable than rubber, and easier to stabilise than a lightweight sphere. The sculpture subverts our instinctual desire to stack the three materials – stone, rubber, silicone – with the most rigid material at the base. It is our practical sense of the order of things that is *rocked* by the imaginative experiments of art.

Both *Drone* I and *Darts* are wall-works that are marked or layered with horizontal bars reminiscent of musical staves or lines of print. They resemble abstract scores for performance or stylised text-works. The dart-like shapes that give the second of these two works its name are the legible parts of

several bleached pheasant feathers, their chevrons changing direction as the eye travels down the page, 'reading' one feather after another, sometimes left to right then right to left, in the manner described as *boustrophedon* in ancient Greek. Both this work and *Drone* 1 resemble inscriptions in a language that has not yet been deciphered; the thoroughly stylised block of 'text' at the centre of *Drone* 1 being punctuated with the startlingly legible hieroglyph of a cast fibreglass plum. This is a pictograph in the form of the object it refers to. What it means is no more than the object itself. These works are emblems of the sculptural practice deployed throughout the show, in which objects explain themselves as test cases of an art in which the conditions of representation and ideation are all put under pressure and taken to the edge of familiar ground.

ACKNOWLEDGEMENTS

The chapters of this book draw on the following essays listed in order of publication.

'A Refugee Aesthetic: Eastern European Art in the 1980s and 1990s', in *Tate: the Art Magazine*, No. 20 (Spring 2000) pp.57–60

'Inner Visions: Contemporary Art and Domestic Space', in *Tate: the Art Magazine*, No. 23 (Winter 2000) pp.38–43.

'The Atrocity Exhibition', in *Tate: the Art Magazine*, No. 26 (Autumn 2001) pp.54–57

'Marc Atkins: Fleeing the Light', Introduction to catalogue *Equivalents* (Galeria FF, Łódź, Poland, 2001)

'Art: the Ultimate Hostage', in *Tate: the Art Magazine*, No.29 (Summer 2002) pp.54–58

'True Longitude', Introduction to catalogue *Marc Atkins: Equivalents* (British Council, Prague, 2002)

'Failing Better: Salcedo's Trajectory', in Doris Salcedo, *Neither* (London: White Cube, 2004) pp.9–11

'Waterworld', in Anselm Kiefer, *Fur Chlebnikow* (London: White Cube, 2005) pp.47–48

'Agents and Patients', in Ilya and Emilia Kabakov, *The House of Dreams* (London: Serpentine Gallery, 2005) pp.19–30

'The (In)complete Works of Marc Quinn', in *Marc Quinn: Recent Sculpture* (Rotterdam: NAI Uitgevers and Groningen Museum, 2006) pp.126–137

'Nel Ponte: Interview with Marc Quinn', in *Marc Quinn*, ed. Achille Bonito Oliva and Danilo Eccher (Milan: MACRO and Mondadori Electa, 2006) pp.162–195

'Storm Damage', in *Albert Oehlen: I Will Always Champion Good Painting* (London: Whitechapel Gallery, 2006) pp.60–63

'Agitpop', in *Laura Owens*, ed. Beatrix Ruf (Kunsthall Zurich, 2006) pp.24–29

'Doris Salcedo's Un-forms', in *Doris Salcedo* (London: White Cube, 2007) pp.25–27

'Frostworks', in Ilya and Emilia Kabakov, *Under the Snow* (Koln: Verlag der Buchhandlung Walther Konig, 2007)

'A Fixed Wandering: the Sculpture of Alison Wilding', in Alison Wilding, *Tracking* (London: Ridinghouse, 2008) pp.45–51

'Jake and Dinos Chapman and the Surplus Value of Hell' in Jake and Dinos Chapman, *Fucking Hell* (London: White Cube, 2008) pp. 36-41

'Body Count', in Antony Gormley, *Between You and Me* (Kunsthal Rotterdam, 2008) pp.31–44

'Visible Entropy', in Antony Gormley, *Ataxia II* (Salzburg: Galerie Thaddaeus Ropac, 2009) pp.15–22

'Like a Hinge: John Gibbons interviewed by Rod Mengham', in *Mapping Form: Drawing and Sculpture* (Cork County Council Library and Arts Service, 2009)

'The Flight of the Artist', Ilya and Emilia Kabakov, *Flying* (Paris: Galerie Thaddaeus Ropac, 2010) pp.3–38

'The Inscapes of Tony Cragg', in *Tony Cragg* (Ljubljana: TR3 Gallery, 2010) pp.25–29

'Holding Patterns', in Ilya and Emilia Kabakov, *Angelology* (Sligo: The Model, 2010) pp.12–16

'Film of Folly', in *Memory Labyrinth: Faces of Evil* 1939–2009 (Ars Cameralis: Katowice, 2011) pp.30–43

'Lessness', in Jake and Dinos Chapman, *In the Realm of the Senseless* (Ars Cameralis: Katowice, 2011) pp.4–17

'Inside the White Crypt', in Anselm Kiefer, *Il Mistero delle Cattedrale* (London: White Cube, 2012) pp.37–41

'Spinning the Compass', in *Artists Laboratory: Stephen Chambers, The Big Country* (London: Royal Academy, 2012) pp.6–17

'Thurnauer: *vt* et *vi*, peindre a la deuxieme personne', in *Agnès Thurnauer, Now When Then* (Lyon : Fage editions, 2014) pp.10–13

'Art & Language: Feasibility Study For A Large Object Across Art History', in Art & Language, *Made in Zurich: Selected Editions* 1965–1972 (Zurich: Galerie Bernard Jordan, 2014) pp.9–15

'The Awakener', in Koen Vanmechelen, *Awakener / Lifebank* (Hasselt: Open University of Diversity, 2015) pp.62–69

'Maintaining Transmission', in John Gibbons, *The Messengers* (Dublin: Hillsboro Fine Art, 2017) pp.3–9

'An Island Romance', in Stephen Chambers, *The Court of Redonda* (Venice: Ca' Dandolo, 2017) pp. 27–31 ISBN 978-1-911247-06-7

'Let There Be Lucy', in Koen Vanmechelen, *It's About Time* (ed. Timo Valjakka), (Helsinki: Parvs, 2018)

'Implicated in History', in Art & Language, *Devinera Qui Pourra (Figure It Out Who Can)* (Michael Janssen: Berlin 2019) no page numbers.

'Butterfly Affect', in Damien Hirst, *Mandalas* (London: White Cube, 2019) pp.4–8